THE STEAMPUNK GAZETTE

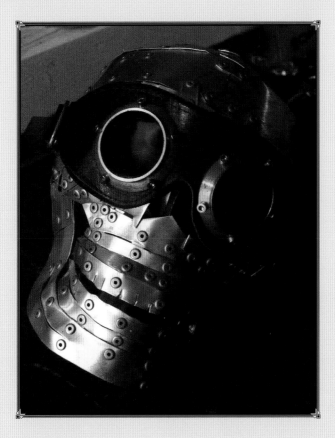

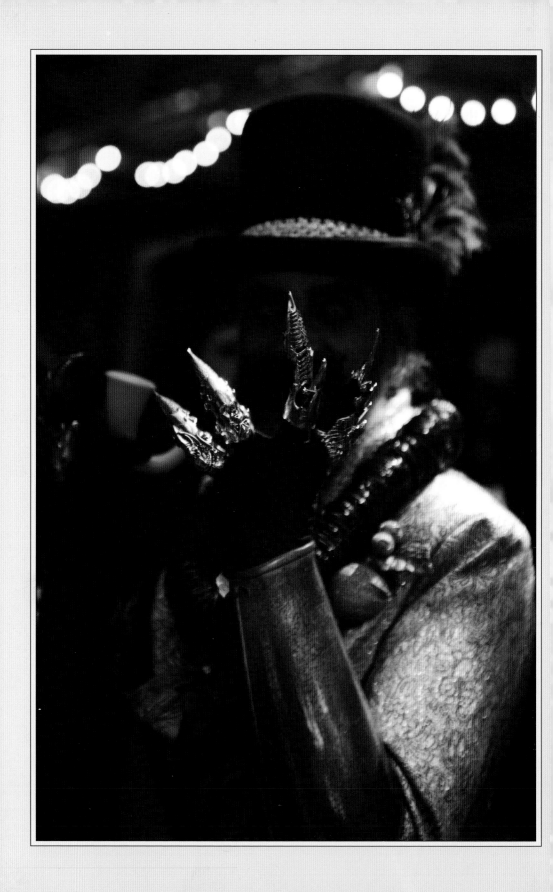

THE STEAMPUNK GAZETTE

MAJOR TINKER

BARRON'S

First edition for North America published in 2012 by Barron's Educational Series, Inc.

First published in the United Kingdom in 2012 by Fil Rouge Press Ltd, 110 Seddon House, Barbican, London EC2Y 8BX

All inquiries should be addressed to:
Barron's Educational Series, Inc.
250 Wireless Boulevard
Hauppauge, NY 11788
www.barronseduc.com

ISBN: 978-0-7641-6556-6
Library of Congress Control Number: 2012939074

Conceived, edited, and designed by Fil Rouge Press Ltd, 110 Seddon House, Barbican, London EC2Y 8BX

CORRESPONDENTS
Furnishings: Bruce Rosenbaum
Gear: Thomas Willeford and Sarah Herrick
Academe: Mike Perschon

FIL ROUGE PRESS
Publisher: Judith More
Editors: Mike Evans, Julia Halford
Designer: Janis Utton
Picture Researcher: Sally Claxton

Printed in China by Imago
9 8 7 6 5 4 3 2 1

CONTENTS

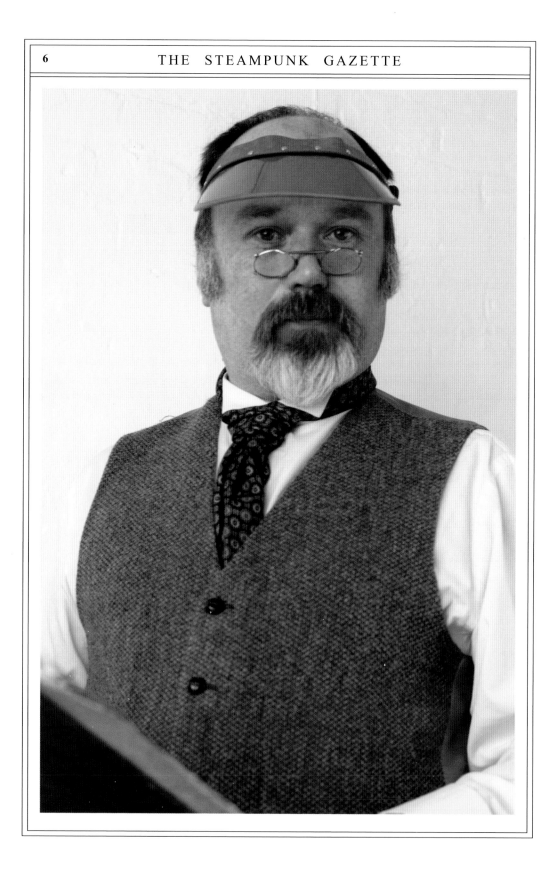

PREFACE

In an exercise to "explain Steampunk in a sentence," a group from across the world came up with: "Steampunk is a creative social movement that draws inspiration from Victorian and pre-war history in an anachronistic mix of science fiction, modern values, and a sense of fun." While this doesn't explain it all, it is a fine place to start and gives a good idea of what Steampunk is about.

To begin with, we should clear up the name. "Steampunk" started as a joke. There was a movement in science fiction to write in a genre known as "cyberpunk." When writers began exploring similar concepts but setting them in a pseudo-Victorian world, one of those writers, K.W. Jeter, jokingly coined the term "Steampunk." The term does not define the genre. Nor is the year 1987, when Jeter coined the name, the genesis of the scene. Steampunk has been a feature of Western culture since the Victorian age itself. Jules Verne, H.G. Wells, and even Mary Shelley and Bram Stoker have contributed to the wealth of imagery and ideas Steampunks enjoy. Later influences include movies such as *Chitty Chitty Bang Bang* (1968) and *Wild Wild West* (1999). What Steampunks should thank Jeter for is coming up with a name that serves as a signpost to help them find people with similar interests and tastes.

Steampunk has developed into a highly creative, artistically inclined community that includes writers, musicians, sculptors, model makers, costume makers, and a host of other disciplines and skills. Steampunks usually try to take some of the very best parts of the past and make them part of a vibrant future. Punk in the '70s was a rebellion against contemporary society. It is evident that Steampunks are rebelling, but theirs is a stand against a throwaway society, poor manners and antisocial behavior, homogenization, and crude commercialism. Steampunks value good manners and politeness and think things should be made to a high quality to last, thus helping the environment.

While much in their universe is set in a pseudo-historical world that harks back to our Victorian heritage, Steampunks do not promote any of the inequalities of that past. Indeed, theirs is very much an all-inclusive community. You will find Steampunks of all ages, genders, ethnic backgrounds, and abilities. They come from all walks of life too—from students and academics, to truck drivers and railway engineers, and from comedians to lawyers.

Steampunk started as a science fiction genre, but it is now a community. It has its own fashions, music, and tastes. It is a community that enjoys socializing, often dressing in distinctive Steampunk styles. You are just as likely to see Steampunks shopping or visiting historical sites as enjoying music gigs and performances. The DIY ethic is very strong, as creative Steampunks often make or modify everyday objects to fit the neo-Victorian aesthetic. This could be making a wood and brass cabinet for your PC or a mock ray gun suitable for an adventure with Jules Verne.

Defining Steampunk is an impossible task. Steampunk is a very personal thing, and everyone's idea of what it should be is individual to them. There is no definition and no boundaries to Steampunk other than the imagination of the individual. There is, however, one rule: be nice to one another. This in itself should suffice.

Tinker, 2011

BE SPLENDID!

A rallying cry for Steampunks, BE SPLENDID has three simple tenets. Be splendid in how you interact with others; polite respect makes the world a better place. Be splendid in how you look; no need to fade into the background. And be splendid in all you create in art, fashion, music, literature, or even cuisine. In this book you'll find splendid examples of this from around the world.

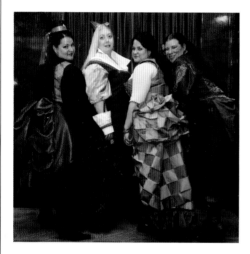

BEYOND SIZE ZERO

Be splendid in how you present yourself means you need not worry about fitting the stereotypical shapes pushed by various sectors of the press and media. Indeed, the shapes and silhouettes found in Steampunk fashion usually mean that more is most definitely more.

PARENT & CHILD

The Steampunk community attracts all ages. Young and old share a common interest, in a scene that parents and children can enjoy together.

INCLUSIVE BUT STILL COOL

Steampunk is undoubtedly a little geeky, but it is happy to flaunt its geek credentials to the world at large. It is a scene where age, gender, ethnicity, ability, sexual orientation, and social background are never seen as barriers. Indeed, since Steampunk is basically a fantasy that promotes creativity, it is one where various differences are often perceived as advantages rather than a hindrance. It is a constant delight to come across people enjoying animated conversation about a shared passion, regardless of the different daily lives and backgrounds of the individuals. And, the essentially social nature of the Steampunk scene cetainly facilitates this. Above all, however, in its own characteristically quirky fashion, Steampunk somehow manages to retain an air of being both cool and sophisticated. This, perhaps, can help explain its wider appeal.

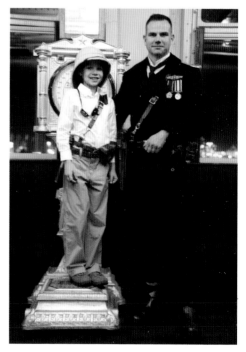

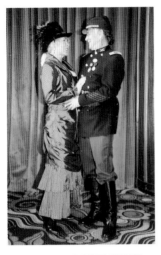

LOW COST

Thrift shops, yard sales, and craft and DIY stores all yield their treasures to the less well-off Steampunk, who makes up for necessary economy with imagination and creativity.

NO BARRIERS

Disability can be adapted to advantage; the gentleman here has modified his chair to be an integral part of his ensemble.

FALL IN LOVE WITH STEAMPUNK

The social nature of Steampunk makes it ideal for sharing with a partner, but it can also be a place to meet that special someone. A shared interest will always strengthen any relationship.

OK AT ANY AGE

Age isn't a barrier. In every aspect elders are full and active members, often highly valued for their experience and skills.

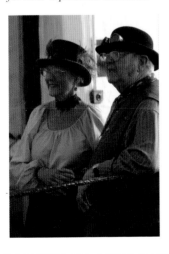

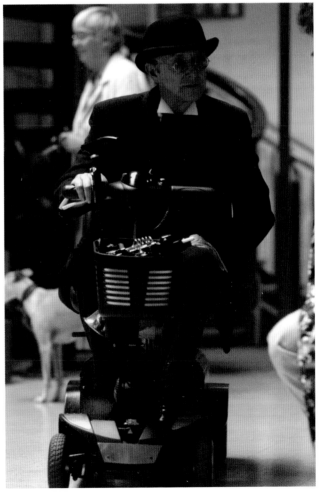

CHAPTER 1
THE FRONT
PAGE

The eclectic features in this chapter give a taste of trends in the Steampunk world. Sci-fi fans often see Steampunk as a genre, while social Steampunks are often from the Goth and reenactment worlds, and for them Steampunk is more of a social scene. The aethernet (internet) has enabled people to get to know one another, and the virtual community has begun to transfer to the real world, where all sorts of gatherings have attracted the media, raising the profile of the Steampunk community. So what are we aiming for with that community? First and foremost, all views and ideas are equally valid. The Victorian aspects are just a basis for whatever we aspire to. Secondly, we feel that good manners are key to making people feel at ease and valued. This underpinning of social values instantly makes us accessible, and the pseudo-Victorian framework again produces great results. It facilitates and informs what we do, but we are most definitely new. So, genre, scene, or indeed community? Steampunk is most definitely the former two, but it is at its best when it represents the latter. The Steampunk community is a great one to belong to, and may it prosper for a long time.

MUSEUM EXHIBITIONS

There have been a number of temporary exhibitions around the world of Steampunk artifacts, including at the Oxford Museum of Science; Kew Bridge Steam Museum, London; and Bradford Museum, England. And in North America, museums from Boston and Ontario to California and the Hamptons, have staged major exhibitions. Organizers have included Art Donovan, Peter Overstreet and Cat Taylor, the *Gazette's* esteemed Furnishings correspondent Bruce Rosenbaum, and our editor-in-chief, Major Tinker. A new museum of kinetic art, The Mechanical Art and Design Museum in Stratford-upon-Avon, the birthplace of William Shakespeare, intends to include Steampunk art in their permanent exhibits. In addition, some conventions are situated close by places that are of interest to Steampunks— for example, the World Steam Expo in Dearborn is near to the Henry Ford Museum.
See also page 240 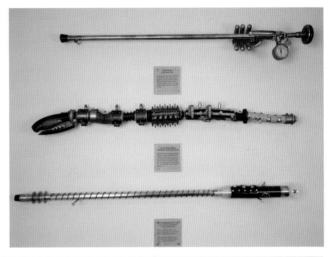 *See also page 240*

A TRIO OF CANES
Some of the many splendid canes on display at the Steampunk Imagination Exhibition. Top: Cylinder Cane by Ed Kidera; Center: Samurai Grip Handle Cane by Geoffrey Keiran; Bottom: Tesla Plasma Cane by Mark Rogers.

BEYOND STEAMPUNK

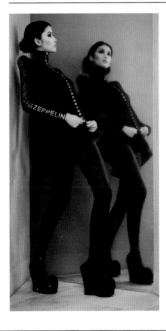

The popularity of Steampunk has spawned some time-traveling suggestions for related scenes; some are nascent and applied to fiction or intellectual theory alone, while others already exist alongside, or overlapping with, Steampunk, and have their own fashion, art, events, and the like. The prequels to Steampunk are clockpunk, which concentrates on medieval and Renaissance technology and aesthetics, and powderpunk, traveling to the 17th and 18th centuries. Sequels are dieselpunk, covering the 1930s to the 1950s; atompunk, landing in the period 1945-1965; post-modern cyberpunk; and biopunk and nanopunk, both having been inspired by newly emerging technologies. Other scenes have also been proposed, such as elfpunk, encompassing the fairy fantasy world.

DIESELPUNK
A pair of aerodynamic Zeppelin Hindenberg suits (as can be seen emblazoned along the sleeves), from the Polish designer Kamila Gawronska.
See also page 239

FANTASTICAL SCOOPS

Steampunk has enjoyed an explosion in popularity over the last five years. This has led to many more people getting involved and throwing even more fantastic ideas and imaginative inventions into the creative melting pot. *The Steampunk Gazette* strives to show the latest developments in Steampunk and signpost some of the many ways in which it is developing and maturing.

BARTITSU

Devised by Edward Barton-Wright in 1898, this martial art combines Western boxing, savate (French kickboxing), canne de combat, and wrestling, with Eastern jujitsu and judo. A revival is underway, sparked by the 2009 *Sherlock Holmes* movie. For more information, contact the Bartitsu Society.

See also page 239

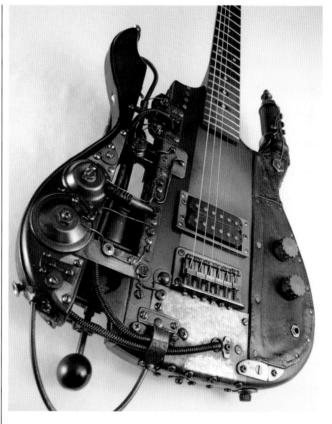

THE FAMED BOOSTERCASTER: STEAMPUNK OR HYPERELECTRIC?

Acquired by the US National Guitar Museum, artist Tony Cochran's Boostercaster has a backstory: found under the floor of a former mental sanitarium in Louisiana, the guitar had a note attached warning not to touch the booster when playing. Cochran calls his work hyperelectric, though he likes the Steampunk aesthetic and the irreverence of punk.

See also page 239

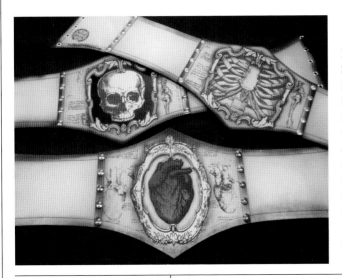

CORSELETTES

Emanating from her celebrated Steam Lab, the latest additions to Professor Maelstromme's Mad Science range include these fine leather belts or corselettes, which make a comfortable and daring alternative to the corset or waist cincher. They are offered with an etched insignia framed at their center, and buyers can select from three designs: Anatomical Heart, the Gothic Skull, or the Creepy Ribcage.

See also page 239

THE LATEST ANALOG PHOTOGRAPHIC APPARATUS

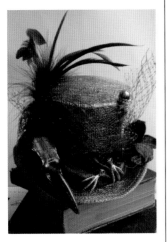

Named for the legendary 19th-century Wild West outlaw from Oklahoma, the Belle Starr model La Sardina wide-angle camera and flashgun package is created by Lomography, a company that in their mission statement call themselves "a global community whose strong passion is creative and experimental analogue film photography." The camera has an oxidized metal body inspired by a humble sardine can and is elaborately decorated in the manner of the Old West. True to its pre-digital origins, film for the unique device is available in both black-and-white monochrome and color emulsions.

TAXIFAKERY

Also among the latest lines from the famous fashion laboratory (see the corselette items above) of Professor Maelstromme—sometimes known as British designer Amanda Scrivener—are a range of miniature top hats using faux cat and crow skulls, taking as inspiration the current surge in interest in taxidermy.

See also page 239

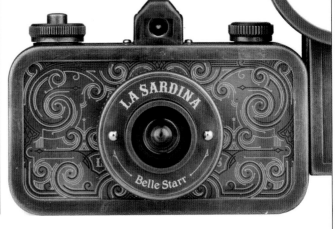

A PAINTED VISAGE

Not all masks these days are fashioned from leather, fabric, or metal. A growing number of daring individuals are using the latest cosmetic powders and paints to replicate a mask effect. Not only does this allow them to alter the design on display on a daily basis, or even with more frequency, it is also refreshingly light to wear. Painted masks are particularly appropriate and popular with young coglings, who often find the traditional material versions too constricting, and face-painting has become a regular attraction at social gatherings, Steampunk or otherwise. The design shown here covers the bottom half of the visage, but the whole face is a potential canvas.

See also page 35

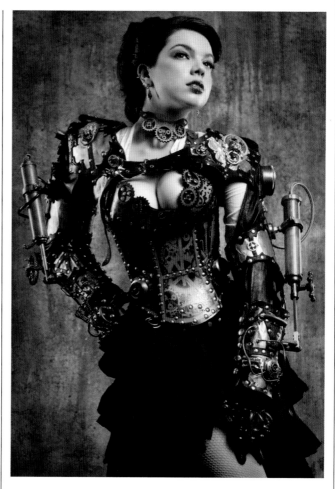

DEFENSIVE LADIES' CORSET WITH STEAM-ASSIST POWER ARMS AND RIDING SKIRT

Steam-arms, leather corsets, cog motifs, the glow of polished brass. Over the last few years, to many people these elements have essentially come to epitomize what Steampunk is all about. In this case, it has all been executed exquisitely and to the highest standards by one of the leading Steampunk leatherworkers in North America. The result is an inevitably eye-catching and attractive image. The outfit was designed by Thomas Willeford of Brute Force Studios for model Sarah Hunter's Steampunk alter ego Lady Clankington, and originally commissioned by F.J. Westcott Lighting for the 2011 Adobe Photoshop World Expo in Las Vegas, NV. Lady Clankington is infamous for having an insatiable appetite for adventure. *See also page 239*

THE GREAT WETHERELL REFRACTOR

Putative space travelers can observe the heavens and plan their voyages to other worlds with the use of this magnificent 8 ft (2.5 m) refractor. Both a sculpture and a fully functioning telescope, the refractor combines an up-to-date electronic remote control (though cased in hardwood and brass) and coated optics with a riveted construction and the engraved brass circles of earlier telescopes. The work led to the commission of similar astronomical pieces for creator Tim Wetherell, like a Sidereal Clock, and the replacement telescope for the historic Oddie Refractor destroyed in the 2003 bushfires at the Mount Stromlo Observatory, Australia.

See also page 239

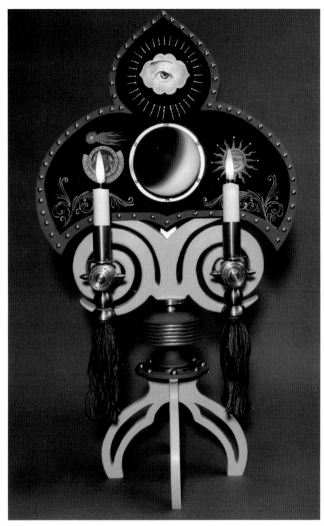

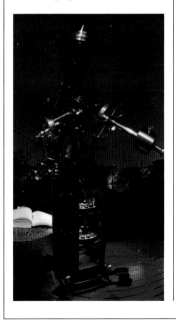

THE MOST EXCELLENT RUMI REDUX

The most recent design from the renowned lighting designer Art Donovan shows the oriental influences appearing in his latest work. The piece is directly inspired by the medieval Persian poet, Rumi, and the scientist, Al-Jazari. The painted detail, on the other hand, is evidence of other equally diverse influences. The single eye is taken from an early 19th-century painting originating with an English masonic lodge, while the flaming comet is based on an image in a 16th-century German book of miracles. The solid mahogany base is painted pale gray and adorned with brass and silk tassels.

See also pages 103 and 239

← CHAPTER 2 ←
NEWS FROM EVERYWHERE

The 19th and early 20th centuries were a new age of travel, when large numbers of traders, tourists, and emigrants journeyed around the globe thanks to the many new marvels of modern engineering. Proud steamships plied the oceans, and iron horse trains steamed across the continents. And a few years later, balloons, airships, and dirigibles took to the skies, as well as the heavier-than-air devices pioneered by the Wright Brothers, Louis Blériot, and other magnificent men in their flying machines. And now, retro-futurism is traveling with a similar speed and gusto, with Steampunk spreading out from the US to Europe and beyond, as covered later in the chapter on Extravaganzas, so Steampunk explorers can meet like-minded folk at conventions and festivals around the globe. In the next few pages, travelers are given a taste of Steampunk bars, cafes, and restaurants in America, and are introduced to a Zeppelin museum in Germany, a submarine-style metro train station in France, and a goggle maker's general store in Australia, among other steamy sights. Inspiration is also given for dressing in multicultural Steampunk style.

AROUND THE WORLD IN 80 DAYS

Although the technology and commercial development of transport had spread rapidly in the preceding years, in the latter half of the 19th century any kind of international travel still involved arduous, months-long voyages that few could afford the time, or indeed the money, to undertake. The story by Jules Verne, published in 1873, took Philias Fogg and his valet Passepartout in a then-rapid circumnavigation of the globe by steamship and rail, with the pair involved in many daring exploits and adventures along the way. It is said to have been inspired by the journey of the American railroad magnate George Francis Train, who declared publicly that he could travel around the world in eighty days or less, though it took him almost twice that time on his first attempt in 1870, and he finally achieved his aim in 1890, when he managed to make the trip in 67 days. Train began and ended his historic journey in Tacoma, Washington, while, in the novel, Fogg started his trek at the Reform Club in London, England. Following the book's success, in 1889 US journalist Nellie Bly made the trip in 72 days, meeting Verne himself in France. It has been adapted many times for films, comic strips, cartoons, and anime, and has led to works by other writers—for example, Philip Jose Farmer's *The Other Log of Philias Fogg*. There is even an amusement park in Kansas City, Missouri, inspired by the book.
See also page 176 *See also page 176*

See also page 176

VERNE ILLUSTRATED

A 1950s children's comic book adaptation of the Jules Verne classic, published as part of an American series called "Classics Illustrated." In more recent years, French publishers have come up with graphic novel versions of the adventure.

STEAMSHIP CHIC

Steamboats still ply their trade on certain rivers around the world, to be hired out as party venues or run as regular tourist attractions, and an American-built steam yacht, SS Delphine, is available to be chartered for a Mediterranean cruise. But steam-powered sea-going liners, such as the Queen Mary, are berthed permanently in port, and visitors must travel to get to them. The steamship travelers of days gone by certainly didn't travel light—they took a good supply of day-wear and eveningwear, packed in sturdy trunks, and 18 cubic feet (around 200 pounds or 90 kilos) could be shipped at no additional charge. Highly sought after, vintage steam trunks can be sequestered for making unique coffee tables, or used as storage items in Steampunk interiors.

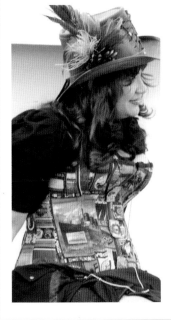

CUNARD CORSET

A traveler at Her Royal Majesty's Steampunk Symposium, held on the Queen Mary liner, wears a corset decorated with steamship baggage labels (from the days when passengers were issued special labels for each port).

UNITED STATES OF AMERICA

Follow the Steampunk trail from a historic mill near Boston to the Wild West coast, and discover a wealth of history on offer in the home of Edgar Allen Poe and Mark Twain. Refreshment is available at one of the numerous bars and restaurants, and entertainment and intellectual edification can be enjoyed at one of the many excellent conventions listed in the "Extravaganza" section of the *Gazette*.

ALL-AMERICAN ICONS OF STEAM

There is much more to Steampunk than Victorian England—indeed, the term was coined in the United States. Magnificent steamboats still sail the wide waters of the Mississippi, and the Wild West, or Weird Weird West, has inspired Steampunk movies, fiction, and a LARP game called "Frontiers," as well as costumes and various events. The great US writer Mark Twain's *Connecticut Yankee* pioneered fictional time travel along with the heroes of Jules Verne and H.G. Wells. And 19th-century American luminaries have been reimagined by later writers—Abraham Lincoln as a vampire hunter, for example.

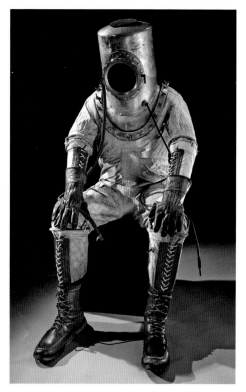

THE FIRST PRESSURE SUIT
A high-altitude pressure suit, specially made for the famed American aviator Wiley Post by the B.F. Goodrich Company in 1935.

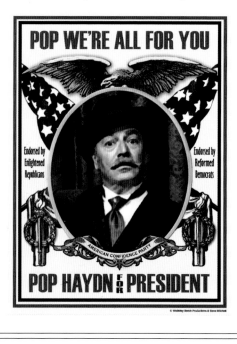

POP HAYDN
From the Gold Rush era, Pop was stranded in the 21st century. Performing magic and music, he also sells bottles of patent medicine on the side. See also page 239 *See also page 239* 🖝

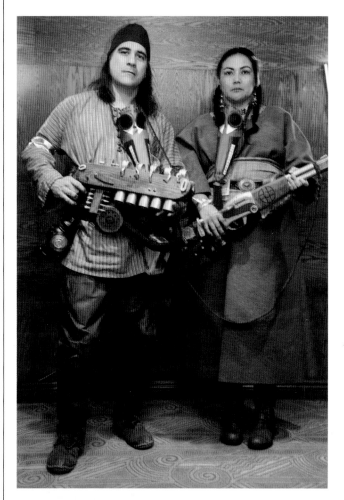

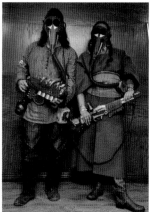

NATIVE STEAMPUNK

California isn't just for cowboys—these Native American Steampunks staked their claim to retro-futurism at a West Coast convention. Masks protect them from the incomer's diseases.

THE WAY STATION

In this Brooklyn bar, the toilet is hidden inside a life-size replica of Dr. Who's Tardis, itself based on a London police telephone booth from the 1960s.
See also page 239

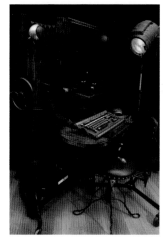

CHARLES RIVER MUSEUM OF INDUSTRY AND INNOVATION (CRMII)

Located on the banks of the Charles River in the historic 1814 textile mill of the Boston Manufacturing Company, the hands-on exhibits at the CRMII feature American innovation and invention from 1812 onward. Opened in 1980, the museum site is on the National Register of Historic Places as America's first established factory.
See also page 239

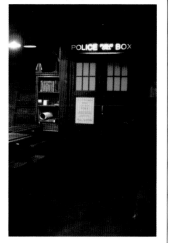

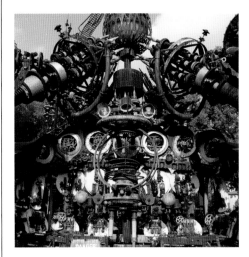

DR. EVERMOR'S FOREVERTRON

Dr. Evermor's Art Park in Sumpter, Wisconsin, is the largest scrap metal sculpture in the world. See also page 239 🖙

MERCER MUSEUM

In Doylestown, Pennsylvania, a 1916 concrete castle, built by Henry Mercer to house old artifacts. See also page 239 🖙

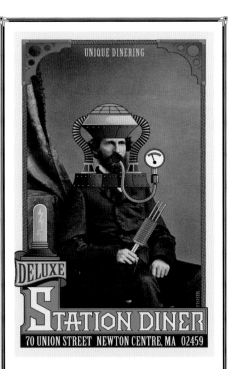

TRAVELER'S REST

A taster selection of some intriguing bars, restaurants, and places to stay.

The Edison Bar, Los Angeles, California
Deluxe Station Diner, Newton, MA
Maynards, Tucson, Arizona
The East Side Show Room, Austin, Texas
Grim's restaurant, Seattle, Washington
Scholz Beir Garden, Austin, Texas
Villains Tavern, Los Angeles, California
Apotheke, New York, NY
Ninth Ward bar, New York, NY
Salem Steampunk Sweets and Savories, Salem, Massachusetts
Elate, Chicago, Illinois
Steampunk Café, Danielson, Connecticut
The Lizzie Borden Bed and Breakfast/Museum, Fall River, MA
Jules Undersea Lodge, Key Largo, Florida
Dunton Hot Springs, Dolores, Colorado
See also page 239 🖙

CANADA

The Victorian age of steam directly fashioned the nation's history, as the great Canadian Pacific Railway forged a link from the eastern Atlantic coast to British Columbia in the west. Today, the legacy is celebrated by museums and railroad preservation societies that proliferate in towns and cities, and by the active Steampunk community that perpetuates that great tradition with gusto.

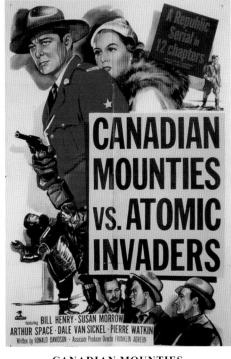

CANADIAN MOUNTIES VS. ATOMIC INVADERS

A B-movie poster advertising a 1950s' spy movie serial. Mounties could provide ample inspiration for Steampunk costumes or even a role-playing game.

SCIENTISTS AND ADVENTURERS

Canada boasts a number of Victorian engineers, inventors, and adventurers, including the inventor of the telephone Alexander Graham Bell and Canadian native Keish (Skookum Jim Mason),

who, with George Carmack, made the discovery that led to the Klondike Gold Rush. And before Mr. Benz introduced the petroleum automobile, Henry Seth Taylor designed the first Canadian car, powered by steam and capable of speeds up to 15 mph (24 kph), in 1867. The Taylor Steam Buggy is on display in the Science and Technology Museum in Ottawa. A repurposed horse-drawn carriage, it was powered by a two-cylinder steam engine fueled by a coal-fired boiler. Steam-loving travelers today can relive the golden age of steam by taking a trip through the Canadian Rockies on a steam train, or along the mighty Yukon river in a paddle wheel steamboat.

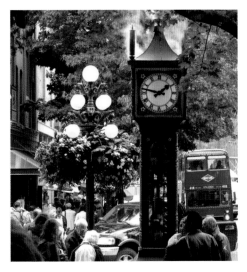

GASTOWN CLOCK, VANCOUVER

Designed by the Canadian horologist Raymond Saunders in 1977, the steam clock announces the quarter-hour with steam and a whistle.

UNITED KINGDOM

Queen Victoria welcomes all Steampunks to her sceptered isles. In the land of George Stephenson's epoch-defining railway engines and Isambard Kingdom Brunel's majestic steamships, discover a wealth of architectural and engineering feats from the pioneering days of the Industrial Revolution, and explore marvelous museums and galleries the length and breadth of the realm.

ICONS OF BRITISH STEAM

The United Kingdom can be said to be the cradle of steam power, where the Englishman Thomas Newcomen developed the first successful steam power plant, for mine drainage, and Scotsman James Watt and his partner Matthew Boulton manufactured the engines that powered the mills of the Industrial Revolution. Locomotive steam first took to the rails here, too, in 1804, and the Stockton and Darlington railway, the first public steam railway in the world, opened in 1829. The engines were designed by George Stephenson and his son Robert, the preeminent builders of steam locomotives, and best known for that ultimate icon of the first age of steam, The Rocket.

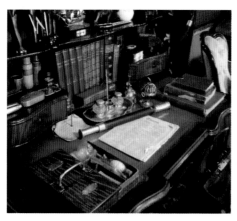

THE SHERLOCK HOLMES MUSEUM, LONDON

Sherlock Holmes and Doctor John H. Watson resided at 221b Baker Street between 1881–1904, as reported by Sir Arthur Conan Doyle.
See also page 239 🖙

BRASS PLAQUES

In the UK blue plaques mark homes of the famous. *The Steampunk Gazette* has a new (virtual) scheme, with brass plaques for places of steamy note that receive visitors. The inaugural selection is listed below.

Dr. Who Experience, Cardiff, Wales Time travelers can join the Doctor on a journey through time and space, encountering monsters and the "Tardis" interior.

Osborne House, Isle of Wight Queen Victoria's summer home was the location of the first transoceanic cable transmission.

Kew Bridge Steam Museum, London The most important historic site of the water supply industry in Britain.

Newcomen Memorial Engine, Dartmouth, Devon A revolutionary engine designated an International Historic Mechanical Engineering Landmark by the American Society of Mechanical Engineers.

Ironbridge Gorge Museum, Shropshire A group of ten award-winning museums, spanned by the Iron Bridge. See the machines at the heart of the Industrial Revolution and the products they produced.

Holmwood House, Glasgow, Scotland Designed by Alexander Thomson, this sumptuously decorated villa, constructed in 1857 in the Greek Revival style, is rumored to have influenced Frank Lloyd Wright.
For visiting details, see page 240 🖙

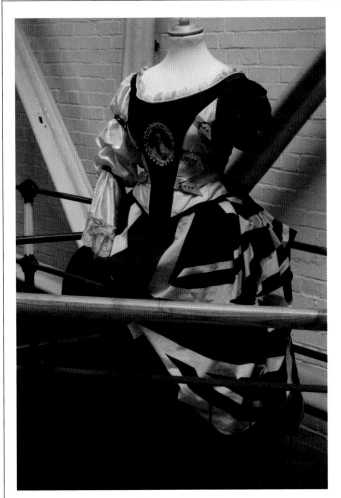

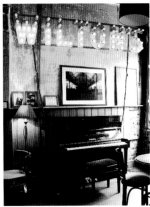

WILTON'S MUSIC HALL

A glimpse of the bar at the world's oldest surviving music hall, in London's East End, where legends like Champagne Charlie once trod the boards. See also page 240 👉

THE THOMAS WICKSTEAD

The newest steam locomotive in the UK, completed in 2009, and in operation at Kew Bridge Steam Museum in west London. See also page 240 👉

THE UNION DRESS

Fashioned from the Union flag, with the Queen's portrait on the bodice busk, and perfect for any jubilant patriot.

A CHILD OF THE JAGO

Founded in London in 2007 by Simon Armitage and Joseph Corre (from the dynasty of Dame Vivienne Westwood), this clothing store stocks exquisite retro-futurist wares. See also page 239 👉

FRANCE

The land of Jules Verne and the Montgolfier brothers deserves much attention from the traveler. In addition to historic sites such as the great engineering marvel of the magnificent tower engineered by Gustave Eiffel, visitors can experience everything from cabarets de Neant to the residence of Monsieur Verne himself—and relax in the belle epoque bars and bistros of late 19th-century Paris.

JULES VERNE

Born in Nantes, France, in 1828, Verne's science fiction adventures have made him the second-most-translated novelist in the world, and his house in Amiens can be visited today. Wander through 19th-century style rooms; view the letters, manuscripts, and memorabilia, and see the author's actual writing desk on display.
See also pages 181 and 240 🖙

LES FOUS VOLANTS

Compagnie Remue Menage parade veloplanes and portable Montgolfier balloons.
See also pages 112 and 240 🖙

THE STEAM FLANEUR

Travelers would do well to stumble upon one of these marvelous establishments:
Ukronium 1828, Lyon—RPG and science fiction store.
Vert d'Absinthe, Paris—the first store to be dedicated to absinthe.
Librairie Jules Verne, Paris—bookstore specializing in Jules Verne's works.
Au Gobelin Vapeur, Metz—Steampunk bar.
Ciel Rouge, Dijon—sci-fi/fantasy bookstore.
See also page 240 🖙

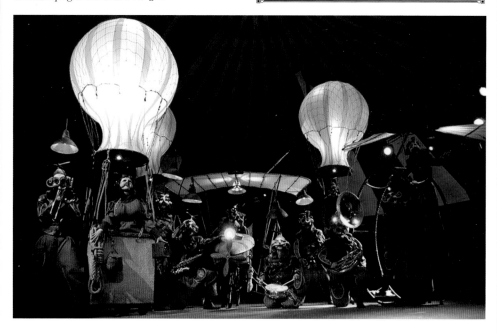

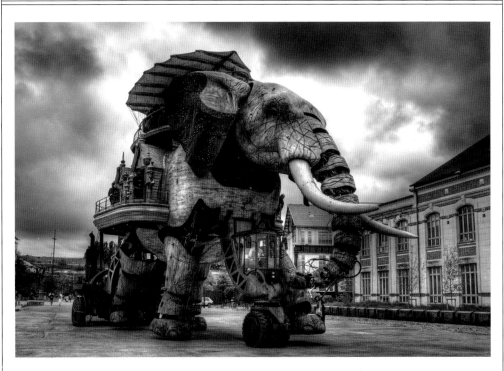

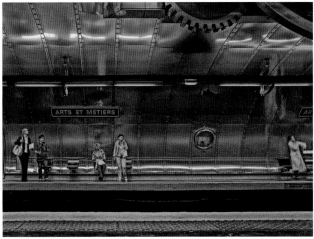

THE GREAT ELEPHANT

Made by Machines de L'Ile in steel and American tulipwood, for an event in Nantes on the centenary of Jules Verne's death, the elephant is 40 ft (12 m) high. Located in the warehouse of the fabricators, it can carry 49 passengers, with rides available. *See also page 240* ☞

ARTS ET METIERS METRO STATION, PARIS

Belgian comic artist François Schuiten turned a Metro stop into a Nautilus-style submarine, with polished copper walls punctuated by portholes, and oversize cogs aloft.

MARIE ANTOINETTE SPATS

Picturing the famous French queen, short spats in shot silk, lace, and other haberdashery, from "Eat the Freaking Cake" by Professor Maelstromme. *See also page 240* ☞

AROUND EUROPE

Sights of Steampunk interest can be found in Northern, Eastern, and Southern Europe. Contrary to popular opinion, particularly in the United States and Britain, those two nations were not the only centers of innovation during the Industrial Revolution. There are museums, old curiosity stores, 19th-century castles and mansions, and early engineering marvels to visit and explore.

THE ZEPPELIN MUSEUM, FRIEDRICHSHAFEN, GERMANY

The largest collection of airship history in the world, the museum houses models, documents, photographs, and other information about airship history and technology from German, French, Italian, British, and American manufacturers. A partial full-size model of the LZ 129 Hindenburg —which crashed in 1937 with 36 dead—allows visitors to step into authentically furnished 1930s' cabins and get to know technical aspects of the aircraft. The exhibition also includes an original engine nacelle from the LZ 127 Graf Zeppelin.

See also page 240

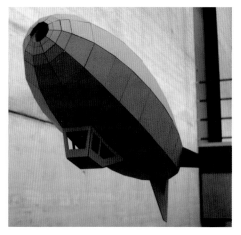

ZEPPELIN
A display at the Zeppelin Museum, which is to be found in Friedrichshafen, Germany, the town that was the location of the Zeppelin factory, Luftschiffbau Zeppelin GmbH.

A VISITOR'S PARTIAL A–Z

Just a few of the many places that celebrate the story of science and manufacturing, actual and imaginary.

Amsterdam, the Netherlands—the world's largest spectacle museum.

Budapest, Hungary—Szabo Ervin Library, a 19th-century aristocrat's furnished library enclosed within a modern library.

Como, Italy—Tempio Voltiano, a monument to Allesandro Volta, inventor of the battery.

Darmstadt, Germany—the castle that inspired Mary Shelley, Schloss Frankenstein.

Gruyere, Switzerland—museum featuring the work of the *Alien* artist, H.R. Giger.

Milan, Italy—typewriter museum.

Neuschwanstein Castle, Germany—a fantasy castle created by Mad King Ludwig of Bavaria.

Offenbach, Germany—the leathercraft museum.

Riga, Latvia—Cinevilla, a ghost town movie set complete with steamship.

Stromboli Island, Italy—the volcano celebrated by Jules Verne in *A Journey to the Center of the Earth.*

Warsaw, Poland—The Fotoplastikon, a 1905 3-D theater still in operation.

Yverdon-les-Bains, Switzerland—Maison d'Ailleurs, a significant collection of science fiction.

See also page 240

SPANISH KRAKEN HUNT
Looking for the Air Kraken at A Weekend Retirement organized by The Golden Gear forum, in the village of Cenicientos, Spain, in December 2011.
See also page 240

SLAVIC STEAMPUNK
Fit for a vampire hunter: an embroidered blouse typical of Eastern European folk dress, paired with a Transylvanian-style bonnet and veil fusion, and a bandolier of vials.

ITALIAN DEMON
A horned metallic mask gives a renaissance diabolic air to this outfit sported at a US Steampunk convention—perhaps a sighting of a time-traveling Machiavelli?

CHANNELING PHILEAS
A proxy Phileas Fogg marks Sweden's national day in Gothenburg, in a 1930s frock coat and goggles made by his wife, Sara, of Lilla Lugnet.
See also page 240

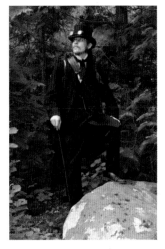

AROUND ASIA

Since the days of the British Raj, when Victoria ruled over the subcontinent as Empress of India, there has been much interplay between Occident and Orient. Those wanting to explore an Eastern alternative to Western Steampunk should start by reading blogs such as "Beyond Victoriana," "Silver Goggles," and "The Steamer's Trunk," which explore multicultural Steampunk and cover Asian themes.

FASHIONING THE EAST

19th-century trade between the West and Asia included silk and cotton textiles and indigo dye, as well as tea, opium, china, and porcelain. Steampunk costumes include oriental brocades and silks, saris or kimonos, and characters ranging from ninjas, samurai, and geishas to south sea pirates or East India company sepoys. Research is encouraged for those who wish to travel beyond these more obvious themes to characters outside the colonial or the clichéd.

THE LAST AIRBENDER

Avatar: The Last Airbender, and its sequel *The Last Airbender: The Legend of Korra*, are an award-winning animated TV series set in an Asian-influenced fantasy world with Republic City at its major center—fueled by Steampunk technology, the city is inhabited by people of all nations.

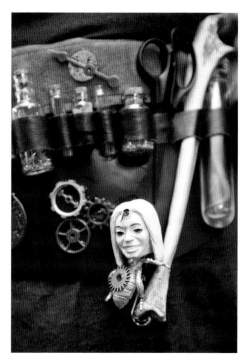

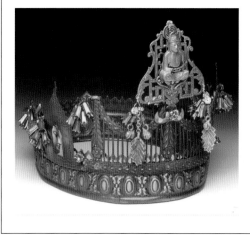

MEDICINE BELT
Inspired by traditional Chinese medicine, this curative collection of potions is displayed on a leather sash cinching an oriental silk robe.

CROWN PEARL OF THE LOTUS
A wearable crown created by the award-winning metalsmith Madelyn Smoak of MadArtjewelry, which is fashioned from found and fabricated objects including vintage chandelier parts, tiny brass bells, and Swarovski crystals.
See also page 241

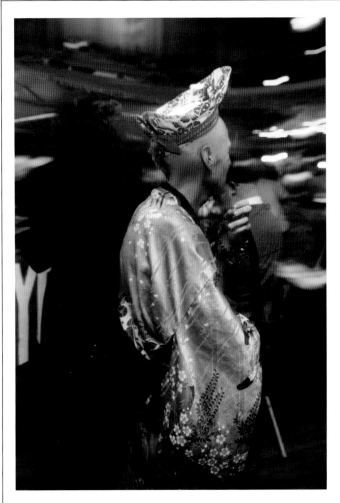

LAO HAT

Lao Hats, which dealt in hand-crafted hats and other wearable artworks by Heather Daveno, is now trading as August Phoenix. Here, she has transformed a thrift store straw pith helmet with brocade and decorated it with Chinese calligraphy. Red and gold brocade edges the brim and forms the hatband, which is framed by a black upholstery trim. The official-looking insignia on the front is fashioned from a jade disc and found brass objects, while the brim is faced with black cowhide, and a gold military button tops the crown.
See also page 241

CHINESE ROBES

Rich brocade robes stand out at an American West Coast event. Having traversed the Pacific, Chinese junks plied up and down the Californian coast in the 19th century—perhaps this silken-attired oriental gentleman jumped ship?

RAJ ENSEMBLES

Indian dress inspired these outfits (left and right), seen at the Asylum event, England.

AUSTRALASIA

From a Victorian Steampunk town quarter in New Zealand to the legacy of Ned Kelly, a magnificent manufactory, and stirring steam train adventures in Australia, there is plenty for Steampunk visitors and locals to explore. Like in much of the former empire of good Queen Victoria, there is an affectionate time-traveling nostalgia for a time when a quarter of the world's map was colored pink.

OAMARU, STEAMPUNK CAPITAL OF NEW ZEALAND

On the edge of a historic precinct that is home to well-preserved Victorian buildings, in the town of Oamaru on the east coast of the South Island, is located the Steampunk HQ. Inside this imposing reclaimed commercial building, curious machines and steam-powered aetheric devices from other worlds, portals to unexplainable mysterious dimensions, greet curious visitors. Outside, a steam train—poised like some leviathan on its way to (or from) Hell, with a skeleton engineer in the driver's cab—is installed at a precarious angle to the sky, puffing steam and firing flame for a $2 coin-in-the-slot donation. The Steampunk HQ Gallery operates alongside other local Steampunk movers and shakers, including Professor Damotimus Tipotus of the Libratory Steampunk Art Gallery, and the League of Victorian Imagineers, Oamaru.

See also page 241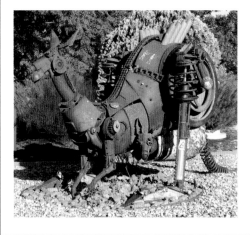

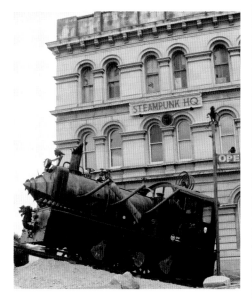

STEAMPUNK HQ, NZ

A sculptural train installation outside the HQ building at Number 1, Itchen Street, Oamaru, signals the headquarter's steamy intent.

KANGAROO

When the earliest European explorers first made their way across the land masses of Australia and New Zealand, they were amazed by the plethora of strange creatures they found there. Likewise, Mr. Darwin made his astounding studies of the flora and fauna of the Galápagos Islands and other outposts of the Pacific. Left, a Steampunk-inspired sculpture of Australia's iconic animal, forged from recycled metal and with what looks like steam pipes atop its haunches.

THE MANUFACTORY

The finest purveyor of vintage housewares, plus reclaimed and refurbished items, giftwares, fresh botanica, and Steampunk ephemera, the Manufactory store is located in Thornbury, Victoria, Australia.
See also page 241 👈

NED KELLY'S ARMOR

Testament to one of Australia's national legends, the home-made tin armor worn by Ned Kelly at his famous last stand at Glenrowan, Victoria, Australia, is inspiration for those of a Steampunk disposition who might require some iron suiting.

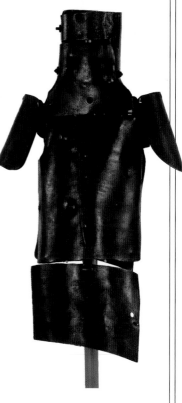

ZIG ZAG TRAIN

The Spirit of Distinction steam train is just one of the vintage trains operating on the Zig Zag Railway, based at Lithgow, New South Wales. The original Zig Zag line, operating from 1869–1910, formed part of the Main West line from Sydney across the Blue Mountains. Charter-hired, the train makes occasional Steampunk evening runs.
See also page 241 👈

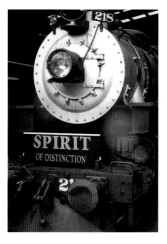

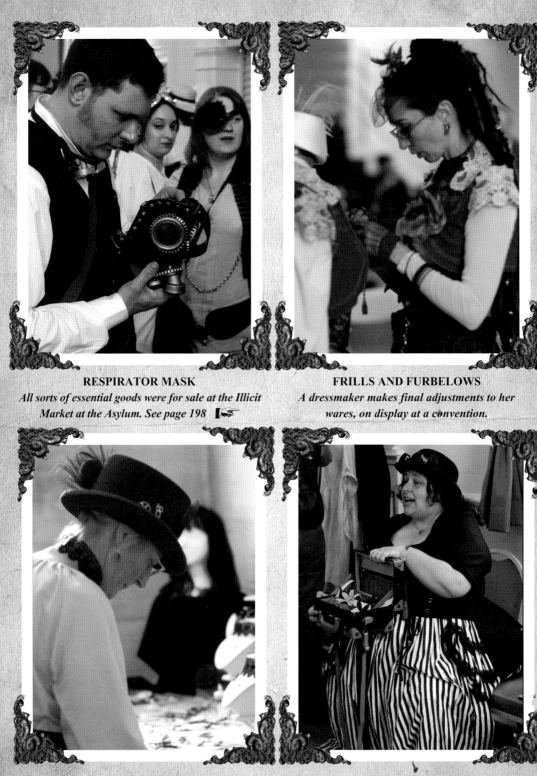

RESPIRATOR MASK
All sorts of essential goods were for sale at the Illicit Market at the Asylum. See page 198

FRILLS AND FURBELOWS
A dressmaker makes final adjustments to her wares, on display at a convention.

MARKET DAY
Conventions provide the perfect opportunity to browse and buy clothing and accessories.

FLOWER SELLER
A hawker with a case full of fabric corsages to tempt convention-goers to loosen their purse strings.

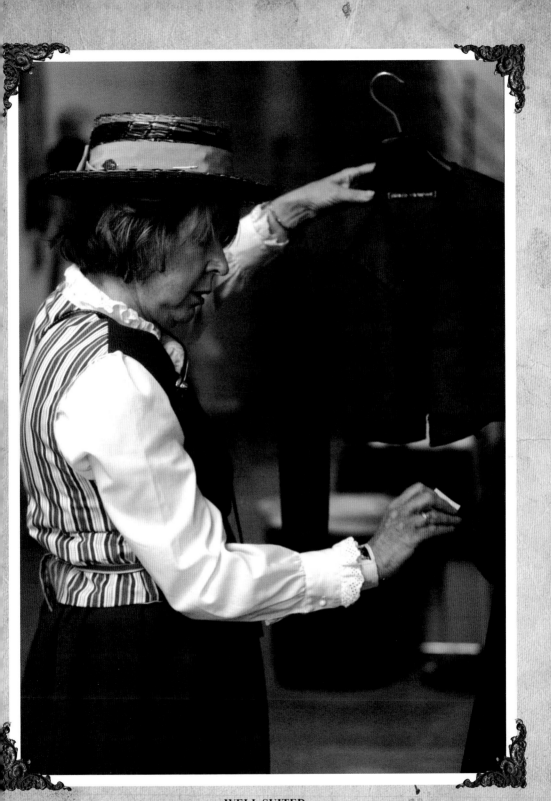

WELL SUITED
*A serendipitous find at a convention market, a little Eton jacket will round off
this visitor's ensemble.*

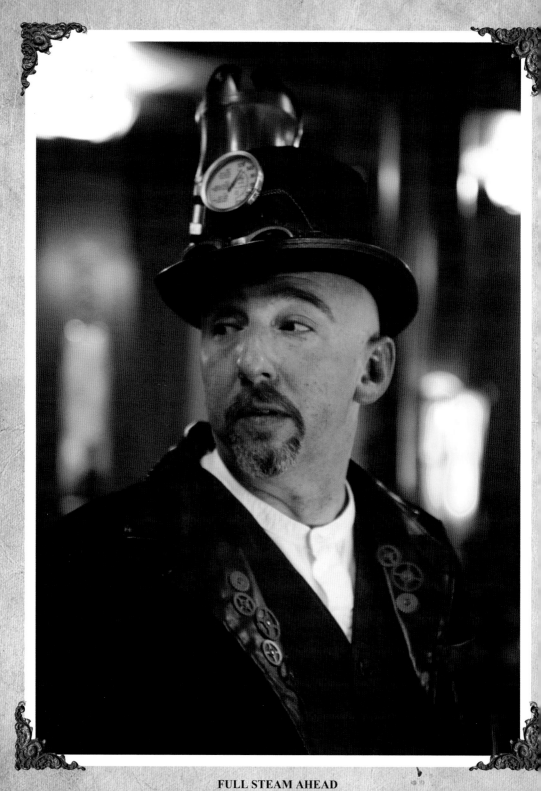

FULL STEAM AHEAD
*Literally over the top, this steam-inspired gentleman's leather top hat boasts its
own brass boiler and gauge.*

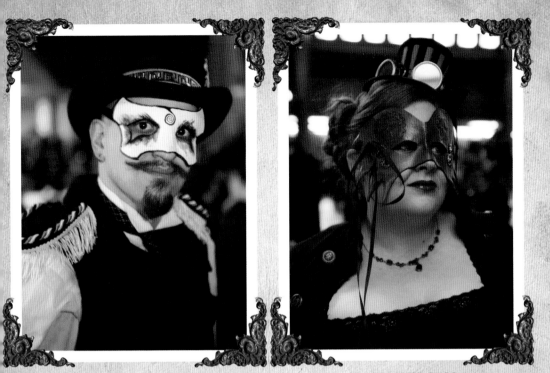

IN BLACK AND WHITE
A painted mask sets off a dapper mustache and goatee, matching the gentleman's epaulettes.

AT A MASKED BALL
Masks are de rigeur for an evening masked ball, often the highlight of a convention or symposium.

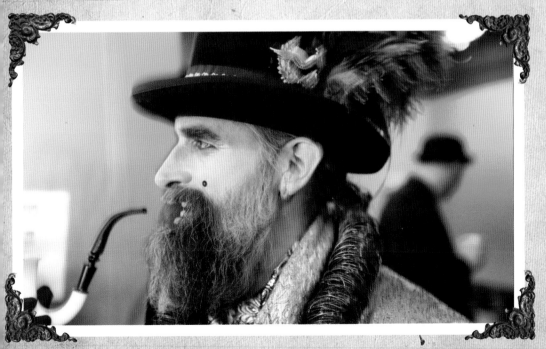

A FEATHER IN HIS CAP
A jaunty hat is complemented by a lavish feather trim, the exuberant ensemble topping a distinguished profile.

MODE

If so much Steampunk fashion looks like the contents of the prop box at a long-shuttered theater, there is good reason. Musicians and performers are at the forefront of the movement, with bands like Abney Park selling curious and wonderful garb alongside downloads on their websites. Inspired by the Cosplay community, Steampunk divas take on personas and tell their story via costume, while tea parties, salons, conventions, and balls offer opportunities for a troupe of newly minted artisans to parade their original ensembles crafted from a treasure trove of haberdashery and hardware—found and reclaimed items laced with ribbons and bonded with sturdy materials like canvas, leather, and brass. The look mixes the Victorian and Edwardian eras (roughly 1801-1910), and their industrial aesthetic, with goth, cyber, fetish, and punk styling. Corsets, gowns, frock coats, and top hats are accessorized with tattoos, goggles, gas masks, wings, and jewelry forged from old watch parts. The sub-culture has influenced high-end designers including Nicolas Ghesquière (Balenciaga), Alexander McQueen, and Ralph Lauren.

GENTLEMEN'S OUTFITTERS

To a 21st-century man, the most striking thing about a Steampunk wardrobe is the sheer number of items that can be worn at any one time. Jackets, vests, gaiters, suspenders, neckwear, gloves, and headgear are variously piled on, embellished with a veritable cornucopia of abandoned antique accessories such as pocket watches, stickpins, and spats. The formal dressing ritual is a key prerequisite for a gentleman wishing to travel back in time from the T-shirts and cutoff jeans of today. Be aware that the modern zipper did not arrive until 1917, so trousers were all button-fronted. The high-waisted cut of formal trousers meant that suspenders were preferred to belts. Other differences include detachable collars, usually in either cotton or linen, but easy-to-clean versions in an early form of plastic known as celluloid were also available. Besides formal dress, a gentleman would have sporting clothes for such outdoor activities as hunting, bicycling, and motoring, and chamber garments such as smoking jackets. If life as a swell sounds too daunting, then Old West–style garments make for a less formal alternative. Victorian gentlemen were often bearded or mustachioed—the clean-shaven look did not arrive until the 1880s. Facial hair can be a great accessory if you are willing to grow and wear it, and many imaginative Steampunks make the most of this style statement, with waxed mustachios, long beards, and the like.

DAPPER DOCTOR
The eminent Herr Döktor, seen here sporting his Sunday best coat and silk stock, accessorized with a pocket watch, top hat, and cane (unseen here).

LADIES' FASHION PLATES

Steampunk women don't accept the restricted world of the 19th century—even as they lace on corsets, they aim to be airship pilots, adventurers, and scientists. Seattle artist and jewelry designer Molly Friedrich approaches Steampunk "from a perspective of 1,000 years into the future, after society has crumbled but people have chosen to live in Victorian fashion, wearing scavenged clothes." Ms. Friedrich has devised an alternate identity composed of petticoats, old military storm coats, goggles, and aviator caps with a dash of Amelia Earhart.

HATS OFF TO THE FUTURE
A milliner wears a stovepipe hat made from the finest American leathers and with corset-style leather lacing at the sides.
See also page 241

"That's the great thing about this—Victorian women were repressed, but Steampunk women are the opposite of that. They're tough adventurers and they've got tools." (ROBERT BROWN, OF STEAMPUNK BAND ABNEY PARK)

STREETWEAR

Steampunk streetwear encompasses outfits that incorporate trends from various other contemporary subcultures. In terms of youth tribes it ranges from the classic Hell's Angels jacket to various elements of punk and goth; in older groupings it might even mean the appropriation of vintage suburban fashions, such as the leisure clothing worn on cruises or the golf course.

ANDROGYNY

The golden rule, where gender-related fashion is concerned, is don't feel bound by the rules—just remix and reimagine gender-specific 19th-century garments, with the result that dandy girls and crinolined men can strut the streets together. Look out for the Genderplayful Marketplace project by Sarah Dopp, which celebrates "diversity in gender presentation." Consider Libby Buloff's theories on gender-bending Steampunk fashion: "Androgyny should be a gender smorgasbord, not an absence of gender." For inspiration, explore Oji or Kodona style, Japanese takes on the Victorian dandy or schoolboy, which can be worn by both genders.

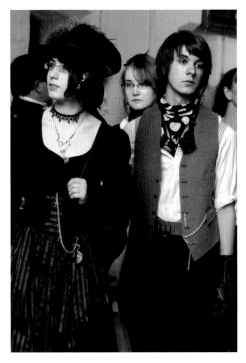

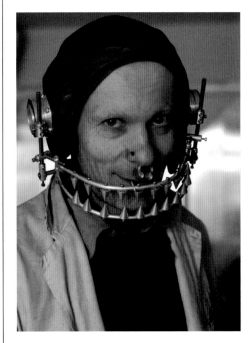

HAVE A NICE DAY
A time-traveling teen has paired a 1980s smiley face acid-house neckerchief with an 1880s-style waistcoat, a classic white shirt, and black trousers of indeterminate date. Plus, black leather gloves, a bandolier belt, and a watch chain add a certain gravitas.

JAWS OF STEEL
Nicolas le Feu of Atomefabrik crafted this jaw-dropping aviator helmet from leather and steel. See also page 241
See also page 241

LAW AND ORDER

Any respectable street or event needs policing. The sheriff here is armed with a straightstick— the oldest form of baton design— wearing riding boots, and displaying her star and shield. Avoid sporting any genuine law enforcement badges that resemble current ones, and refer to the laws of the jurisdiction you are in for regulations.

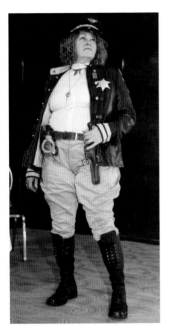

CRUISE WEAR

A stylish gentleman pictured on board the magnificent vessel the Queen Mary, at Long Beach, California, in some fetching plaid leisurewear.

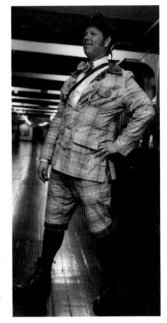

STEAM ANGEL

No winged death's head—what would Hunter S. Thompson think of this San Francisco rider?

HIGH FASHION

Short shorts are teamed with a corset and thigh-high stockings.

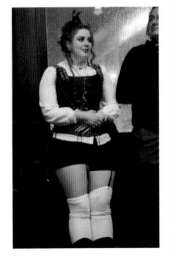

FORMAL WEAR

Balls and conventions—and other gatherings on the Steampunk social calendar, both formal and informal—provide regular opportunities for gentlemen to parade in tailcoats, with cane, gloves, and even a chestful of decorations, while the ladies can put on their finest ball gowns and indulge themselves in a splendid array of sparkling jewelry and scintillating tiaras.

BLACK TIE

Eschewing 21st-century casual wear, Steampunk gentlemen can twist the rules of convention. Become an alternative dandy by donning a black coat, cut away at the front, with satin facings, trousers with a satin side stripe or two, a white stiff-fronted shirt and wing collar, white bow tie, and white waistcoat paired with black socks and shoes. Along with three-piece suits, canes, gloves, neckties, hats, and other accoutrements should be carried or worn. Alternatively, formal robes in the style of the east—the banyan from Turkey or the xuanduan from China, for example—are ideal for ambassadors from far shores.

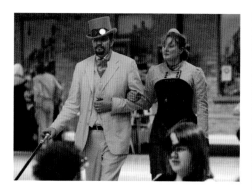

PROMENADERS

Elegant day dress is ideal for a visit to a convention—in this case, Weekend at the Asylum.

ETIQUETTE FOR WEARING ORDERS AND MEDALS

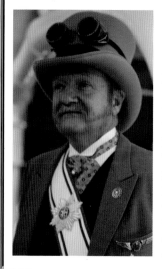

You can buy imaginary awards for airship captains, rocket test pilots, and the like; repurpose old medals or pins dating from previous centuries (but making sure first that they are not valuable antiques); or just be that bit more imaginative and put together your own. With these honorary decorations, you can wear a single award pinned to an official-looking sash, in the manner of an order as illustrated here, or sport a spectacular chestful.

See also page 80 See also page 80

GENUINE MEDALS

Be wary of wearing a current medal, medal ribbon, or sash from the last 100 years unless you are entitled to do so. It's disrespectful and in some countries illegal (in the US it would contravene the Stolen Valor Act). If you are or were a serving member of the military and are entitled to wear a medal, check out the protocol with your regiment, as they may not be happy for you to display it at an event that is primarily for entertainment.

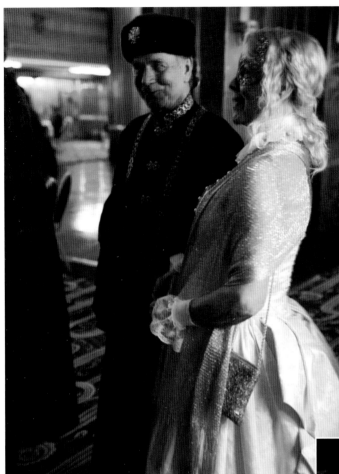

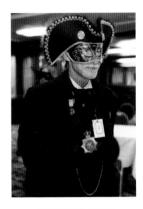

COCKED HAT

Tricorn and bicorn cocked hats are a stylish alternative to a topper, especially at sea—like this gentleman, time traveling on the Queen Mary.

BLACK-AND-WHITE PAIRINGS

A stylish couple watches a performer at the Edwardian ball in San Francisco.

GILDED BALL-GOERS

Glittering trims and other accessories ensure that this couple sparkles at the ball held at Her Royal Majesty's Steampunk Symposium, on the Queen Mary cruise ship.

SUMMER WHITES

In warmer weather, ivory or white tuxedos are worn at formal occasions, with desert fawn as the color of choice in tropical climates.

AVANT-GARDE

Stretching beyond Victorian style, Steampunk fashion design takes in a mixed bag of ideas, including past trends and influences—from medical devices to industrial hardware, and taxidermy to androgyny. Significantly, it has also become an influence on mainstream fashion, and is acknowledged as a genuine style trend on 21st-century catwalks.

ARMOR FOR THE APOCALYPSE

Gas masks and armor, contamination suits, and plague masks are all incorporated into bizarre costumes that reflect darker premonitions of an apocalyptic future.

See pages 62 and 128–129 🖝

BEYOND THE TOP HAT

Toppers and other conventional headwear are all very well in their place, but adventurers at the edge of style like to explore more imaginative options, often incorporating salvaged "found objects" and genuinely scavenged elements, which are then repurposed into catwalk-ready designs. Combining a contemporary preference for recycling of one kind or another at every opportunity with the Steampunk instinct to honor the past through constant reference, these are more a statement of attitude than mere hats.

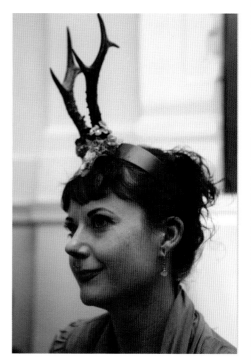

A STAGGERING HEADDRESS
Trophy room chic from Two Weevils of San Francisco. The emporium is the brainchild of Chaos Doll, who admits that she started the store so that her world would be filled with "herds" of stylish young women wearing antlers.
See also page 241 🖝

THE KEY TO FASHIONABLE LOCKS
An alternative fascinator forged from leather and a brass lock reveals the shaved underlayer in this fashionable hairstyle.

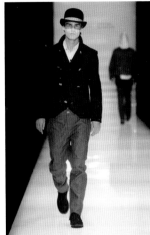

CUTAWAY COAT
The influential Swedish fashion designer Tobias Harboe has reinvented the Victorian coat. See also page 241 ☞

THE AETHER DRESS
Silk velvet dress with ruched bust and green stone brooch pin, by Kato of Steampunk Couture. See also page 241 ☞

PROSTHETIC BREASTPLATE
A scary-looking contraption from the Nekromantik collection by Katarzyna Konieczka, based in Splot, Poland.
See also page 241 ☞

OVERLORDING IT
The Steampunk Overlord is one of a pioneering breed of Steampunk designers who have their outfits specially custom built.
See also page 241 ☞

FASHION INFLUENCES

Design trends include historical dress and uniforms from around the world, alongside a wide variety of influences drawn from film and television genres including the wild west, horror, and—of course—science fiction. Also creating waves are fantasy characters, from mythical monsters to pirates and fairies. Draw from one or all; mix and match. There are no rules—use your imagination.

MILITARY

Military uniforms are perennially popular fashion statements and are covered in another section of this book. Both modish and utilitarian dress from many eras can be incorporated into a modern Steampunk wardrobe.
See also pages 76–77

WILD WEST

Cowboys take inspiration from the TV series and movie *The Wild Wild West*—and elsewhere, including classic westerns of yesteryear. Native Americans are not forgotten.
See also page 179

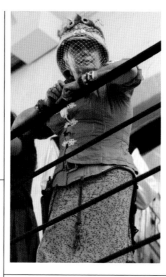

EXPLORERS

Adventurers following in the footsteps of lady explorer Mary Kingsley or gentleman naturalist Charles Darwin should hunt out pith helmets and sturdy belted and pocketed khaki cotton bush jackets. Pair with trousers or skirts suitable for camel or elephant riding, or for a safari meet at a local zoo. Accessorize with parasols, equipment belts, binoculars, and goggles.
See also pages 55, 71, and 76

CLERICS

Men of the cloth—like the good man here, clutching a clockwork bible—have timeless authority, with much of their apparel based on centuries-old styles, harking back to medieval times. And there are no barriers—priests, vicars, rabbis, and all manner of clerics are represented within this broad church of influences. Cassocks and clerical collars, the everyday wear of the clergy, are popular, alongside the familiar habits worn by monks and nuns; the full vestments of religious ceremony are less common.

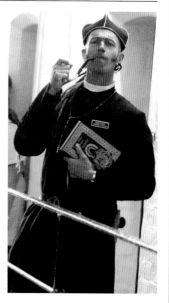

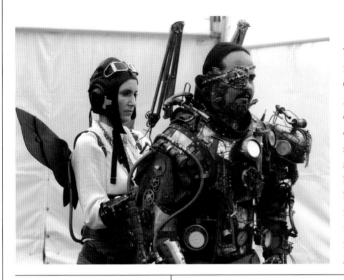

AERONAUTS

Those magnificent men and their flying machines: The Steampunk Overlord (seen here at the Asylum event with his faithful co-pilot Rebecca) designs all his own costumes—like this flying suit with a full mechanical arm and epaulette shoulder cannon—before having them custom built by specialist manufacturers. A major future project is a seven-foot Cyberlord, constructed with moving mechanical parts.

See also pages 112–113

PIRATES

Whether an airship or high seas pirate, or pirate's wench, it's frock coats and ruffled shirts along with tricorn hats. Time travelers could acquire Vivienne Westwood's designs as worn by New Romantic band Adam and the Ants. Accessorize with an eye patch, a rum barrel, or parrot on your shoulder.

See also page 203

VICTORIAN MADAM

Blowzy wild west saloon ladies, peep show models, and bordello madames provide inspiration for some flamboyant outfits that manage to make the most of an ample bosom. Corsets are at the heart of this style, usually in print or plain fabric, ranging from the respectable mourning black spiced with red in a cut velvet or printed taffeta, to saucy satin stripes.

See also pages 48–50

THE SUPERNATURAL

Ghosts, zombies, witches, and warlocks—in fact, all kinds of horror story and other fantasy characters—can be encountered stalking the long corridors of many Steampunk events, often encouraging an imaginative selection of role-playing hunts and chases.

See also page 230

LADIES' DRESS TRENDS

Dress for all the occasions that an alternate formal age might offer. You must consider your fashion accoutrements very carefully, from well-chosen garments to tastefully selected accessories. But never be afraid to indulge yourself, even if it seems at the cost of stylish restraint. There's a school of thought hereabouts that you can never have too many frills and furbelows.

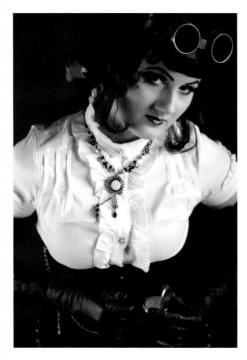

SIMPLY FRILLING
Crisp white shirts softened by piecrust frills and pintucks are sported by everyone from adventuresses to schoolmarms.

REGENCY STRIPES
Bronze and black is a daring variation on the classic black-and-white Regency stripe in this fetching ensemble.

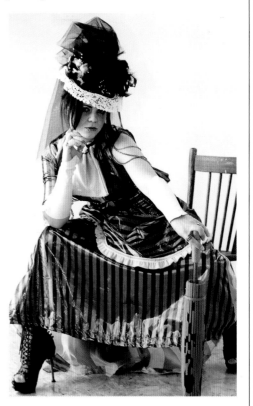

BY THE YARD

Exotic silks from Shanghai or cotton from the southern plantations, plaid and tweed from the Scottish highlands, lace from Spain or Bruges, linen from Ireland or France, or simple broadcloth from the fields of England. There's a world of fine textiles to explore, new and salvaged—and all with tales to tell. Eschew ready-to-wear and sew your own finery. "Make do and mend" may have been a motto for harder times of austerity, but there's much to be said for putting together one's own sartorial confections, given the wealth of fabulous materials on hand.

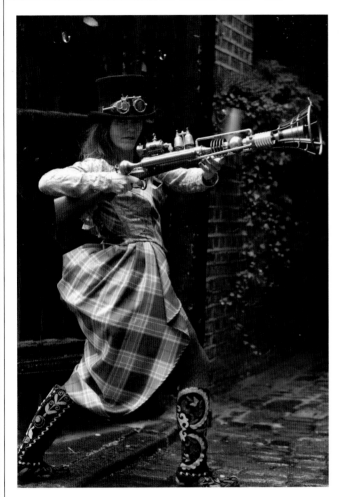

A MYTHICAL CREATURE

A sumptuous taffeta and lace gown is set off here by an innovative hat inspired by the mythical monster Cthulhu.
See also page 180 👈

MINI-BUSTLE

Ruched taffeta layered over lace enhances curves while avoiding inhibition of movement.

PLEASING PLAID

Defend your fashion credentials in a plaid and lace day dress by award-winning costumier Lady Elsie. The full Steampunk look is achieved with a top hat and the ubiquitous goggles, some extravagantly patterned cowgirl boots, and a mean musket.

SHIRR DELIGHT

Shirring transforms a simple skirt and shows off boots without the need for skirt hitchers.

CORSETRY

A corset or bodice could be said to be central to a well-dressed lady's outfit. Professional corsetieres offer a wide range of corsets, in fabrics ranging from cotton drill or leather to the finest silks, fastened with laces, clasps, buckles, or ribbons. And, for ladies with imagination, some will construct custom-made designs to your precise specification, no matter how exotic—or indeed erotic—that may be.

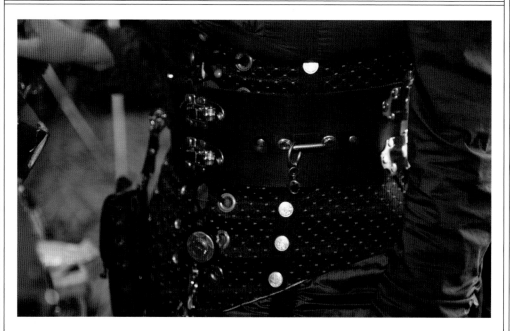

IT'S IN THE BONES

A proper corset is boned in steel (avoid plastic, which can snap). The sprung or spiral steel bones are not rigid; they look like a spring that has been crushed flat. The bones are set between layers in the foundation fabric—which is usually cotton coutil—that supports the more fragile top fabric.

TIGHT LACING

Reducing your waist size by tight lacing is not obligatory, but if you want to try it you should purchase a corset that is 2–4 in (5–10 cm) smaller than your true size. Traditional corsets are laced with waxed cotton cord laces, and there are lacing methods that optimize both closure and comfort.

BOLD AS BRASS WAIST CINCHER

An under-bust corset in a red lattice or diaper pattern, trimmed in brass, harmonizes with the leather belt fitted out in brass and buckled over.

CORSET TAXONOMY

Under- and over-bust corsets do what they say, while a long-line corset covers the hip. Busk refers to the front panel, usually reinforced with a steel (or originally whalebone) piece also known as a busk, and often topped by a buttoned or hooked front opening. Grommets are the metal-reinforced holes at the back of the corset for lacing. Coutil is a sturdy cotton fabric with a herringbone pattern woven from twisted yarn.

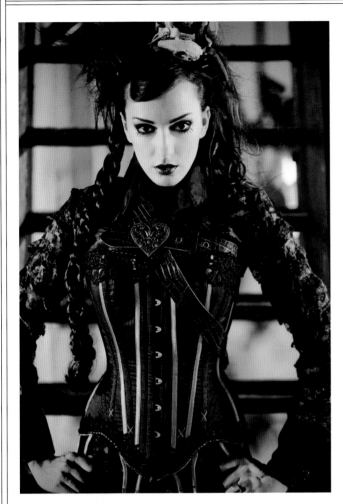

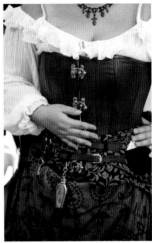

CLASPED

As an alternative to the more usual lacing, the softest leather is fastened with hardware as decorative and intricate as that on the latest purse.

SPACE BODICE

Space Adventuress competing in a Steampunk fashion contest. A skull-decorated leather corset is complemented by gilded skull shoulder caps and a half skull.

STEAMBUCKLES

An hourglass shape in brown brocade, lace trim, and garters with buckles, traditionally made by Bibian Blue of Barcelona. See also page 241 ☞

CLOCKWORK

At the center of the Clockwork Lady's oriental silk corset is a cutaway panel framed in lace that reveals a mechanism. She has a selection of corsets that also reveal her workings.

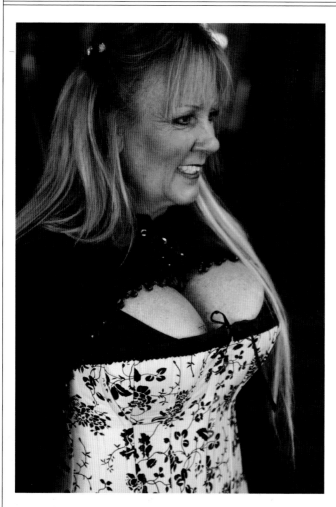

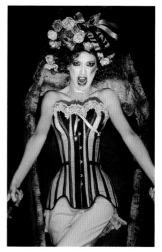

CIRCUS STRIPE
Saucy stripes and lace in a very theatrical number, Viva Maria via western saloon chorus girl.

TARDIS CORSET
Mayfaire Moon created this corset, based on Doctor Who's "Tardis," the time machine that was based on a London police phone box from 1963—when the sci-fi series first aired in the UK. See also page 241 👉

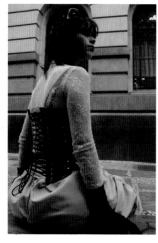

A CUT ABOVE
An over-bust-style corset, topped with a cutaway black shrug, is softened by the use of a floral print.

LEATHER AND LACE
A classic leather corset by Black Cat worn over a simple lace top. Designed as an item of underwear, the corset—based on the Victorian version—has taken on a new aspect as outerwear. See also page 241 👉

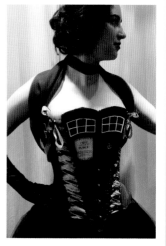

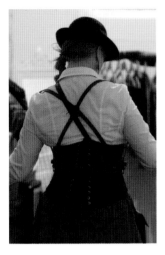

CORRECT LACING

Bi-directional lacing—that is, working back to front, and then front to back—is the traditional and most common method for lacing, as it enables the wearer to better tighten the corset.

COWGIRL IN HIDE

Buckle up for a wild west adventure in a leather corset like the conker brown one shown on the right.

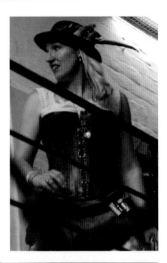

THE SUB-CONTINENTAL EXPLORER

A proper foundation for an intrepid explorer, expertly fashioned in leather, steel, brass, and cotton by Autumn Adamme of the Dark Garden Unique Corsetry and Couture, San Francisco. The navigator's sextant is a handy accessory for any occasion when the wearer is likely to lose her way, be it on an expedition to distant places or merely exploring a Steampunk event.
See also page 241 ☞

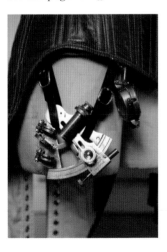

LADIES' ACCESSORIES

Finishing touches can lift an outfit from the ordinary to the extraordinary, but they are rarely purely decorative. Many elaborately designed embellishments were devised for practical purposes—a cane to be leaned on, a parasol to shield a fair complexion from the sun, and gloves to protect hands against bad weather, germs, and dirt. All have a purpose, no matter how frivolous their appearance.

TWIRLING PARASOLS

Celebrated everywhere from fashion plates to the novels of Gail Carriger, parasols are an important part of any fashion-conscious lady's dress. When bonnets gradually became smaller in the mid-19th century, parasols became more significant, both in size and frequency of use. Every self-respecting lady should own at least two—basically, a white and a black. From there the choice is endless, and any woman putting her mind to it can soon build up a fine collection, with a parasol to match any outfit or suitable for any occasion. If you want to restore a vintage parasol—or even customize a new one—then look no further than the many workshops, which you can find at Steampunk conventions and online.

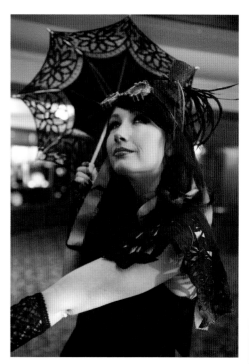

PARASOL DU SOIR

A black cutwork and lace parasol coordinates with a cutwork cape and long lace gloves for a glamorous evening ensemble. The goggles, one assumes, are optional.

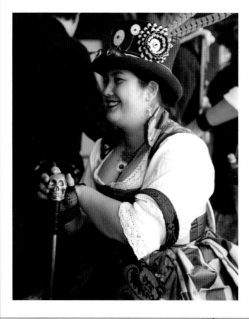

OF MOST EXCELLENT FANCY

A walking cane topped with a skull adds a touch of gothic elegance. On the hat appears a pair of opera glasses, as opposed to the goggles that seem almost de rigueur for many fashion-conscious Steampunk aficionados.

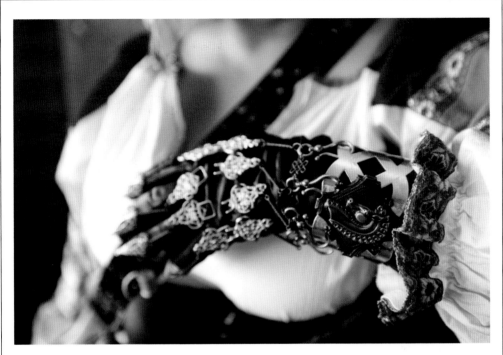

BLOOMING CORSAGE

A feather-edged green silk flower pinned to the neckline complements smaller flowers on the cameo-pinned little hat, the jaunty angle recalling the style of "Belle Epoque" Paris.

SHINY GLOVES OF LEATHER

In the picture above, ornate black leather gloves are over-laid with filigree brass that doubles as jewelry.
See also page 27 👉

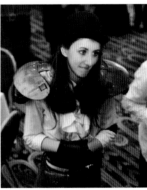

FLYING CAPE

An imposing-looking shoulder capelet manufactured in dark brown leather with artic-ulated distressed copper-tinted panels—ideal for your next air or space adventure.

FINGERLESS GLOVES

Fingerless crochet gloves and a traditional paisley shawl add the latest Victorian style, and almost a "granny" look, to a plain white shirtwaist.

MILLINERY TRENDS

"It is impossible for a hatless woman to be chic," according to etiquette expert Emily Post. A plethora of occasions demand a hat. If you are building a collection, start with a basic top hat, a pith helmet for summer, and a pretty little miniature hat or fascinator of some sort, for eveningwear and celebratory occasions such as weddings. As for etiquette, ladies can wear hats indoors and out.

TOPPERS

Time travelers should note the dimensions of their hat. Early Victorian hats were tall: as high as 9 in (20 cm), but from the late 1830s and for the rest of the century, hats shrunk to 6–6½ in (16–17 cm). From around 1890, the dimensions of the crown grew, making the hat appear more nipped in below it. From around 1920, hat height reduced again, to 4–4½ in (12–13 cm).

TOPPED IN TIN

Toppers were traditionally covered with black silk plush or felted beaver fur, and later wool felt. This Steampunk topper designed by Harvy Santos is covered in silvered sequins and trimmed with clock hands, feathers, and fronds of flies.
See also page 241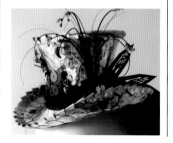

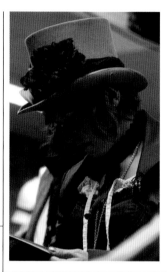

ANY COLOR YOU LIKE

Intrepid style adventurers take the normally conservative topper beyond the usual black and grey, with colors ranging from other neutrals like beige or white to flamboyantly extravagant purple or red. A dash of color is also often daringly introduced via a variety of contrasting bands and trims. In menswear, it is as if the starchy Victorian gentleman had suddenly discovered his other self as a Regency dandy.

MINIATURE MARVEL

Normal rules of dress, mode, and etiquette, are continually being broken in the sometimes surreal salons of Steampunk fashion. Here, such transgression from the norm is achieved by the simple device of shrinking the hat and exaggerating the angle of wear. Given that, conventionally, a standard-size hat was intended to be worn at a 10-degree tilt, this exuberant poise is further enhanced by the miniaturization of the headwear itself. The sum effect is of a stylish irreverence.

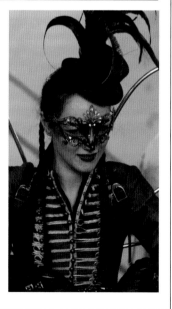

THE BASIC PITH HELMET

Pith is a type of cork extracted from the sola plant, and it is used in making the best helmets. The less expensive types may be fashioned from straw or even plastic. The helmet pictured here is the most common pattern, the early 20th-century Wolseley. The earlier Victorian types were peaked and are most familiar from the pictures of the British military in uniform.

See also page 71 *See also page 71*

AN AMUSING LITTLE FASCINATOR

The hunter has been a ready supplier of materials to milliners from the earliest days of the hat, with feathers and fur from a range of birds and beasts being used. The milliner who designed this unique-looking hat used her domestic hunter—be it cat or trap—as inspiration for a very unusual trim.

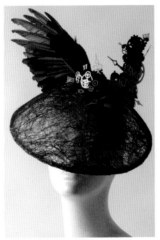

COUNTRY BONNET

The celebrated couture milliner Harvy Santos based this on a farmer's wife's bonnet. It can be tilted over the face like a veil to screen the wearer from the sun, or worn on the back of the head if preferred. The trims reflect a country wife's "make do and mend" approach: sparrow wings scavenged from the fields, lace scraps from the sewing box, and the hands from a clock.

See also page 241

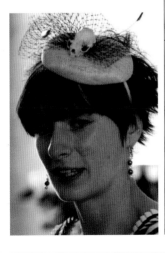

PLAYFUL HAT

The tradition of a gambler always wearing a hat has been subverted in this British John Bull-style hat trimmed with humble dominoes, the game traditionally played in public houses in the UK. The genuine Las Vegas gambler would be seen wearing a soft western-style design.

HARVY SANTOS

COUTURE MILLINER BY ROYAL APPOINTMENT TO QUEEN VICTORIA (PENDING)

A contest in *The Hat Magazine*, a quarterly professional journal for the worldwide millinery trade, introduced Harvy to Steampunk style. It has become safer to take up the once-dangerous trade of hat making since the use of mercury in felt production, which had led to dementia and thus the phrase "mad as a hatter," was discontinued.

How did you come to be a milliner?

I was a professional ballet dancer for seven years in Hong Kong, and when I finished dancing, I started designing costumes and constructing all sorts of bizarre fancy dress outfits. In 2008, I moved to London from Hong Kong (although I'm originally from the Philippines) because my partner was offered a job here. I stumbled on *The Hat Magazine* while shopping for materials for a fancy dress costume. I read every word in that issue so many times, and in the back pages were tuition advertisements. I enrolled in a five-day intensive course with Rose Cory, legendary milliner to the late Queen Mother. After that, I was completely hooked and haven't stopped making hats since! I enrolled in a millinery course at Kensington and Chelsea College, graduated last year, and am now working at the Royal Opera House's Hats and Jewelry Department, occasionally for Stephen Jones and always on my own collections.

Why did you decide on a Steampunk theme for your collection?

The Hat Magazine had a competition called "Hat Designer of the Year," which I entered. The theme that year was "Steampunk," and I made it to the semifinals, where I would have to make up the chosen hats and send them to Paris for judging. I was new to millinery then, and I was competing with professionals. When my designs and hats were sent back after the competition, I decided to enlarge the collection, and also, I had lots of brass cogs left over, so I thought I might as well!

How did you find out about Steampunk?

I've known about Steampunk for quite a while as a theme in animated films and comics. I never lived the Steampunk life, but I've always been fascinated with subcultures of the western world. Karen and John (Major Tinker) opened my eyes

What materials do you use?
I use traditional materials such as felt, straw, feathers, and fabric, and other things like plastics, LEGOs, PVC, bottle tops, paper, and cardboard.

What inspired the traveling crown piece?
I imagined my Steampunk collection to be rooted in the Victorian era, so my first inspiration was Queen Victoria herself. I loved the fact that she had a compact traveling crown, which became iconic to her whole persona. I reimagined it using cogs, and for a quintessentially British hint of punk-style anarchy, I added spikes. Big spikes. I think it's fierce!

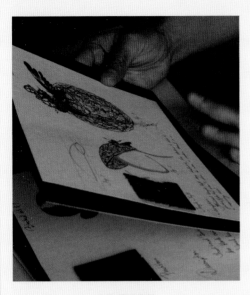

AT WORK
A new design—the preliminary sketches and textile swatches that form the basis of any creation. See also page 241

to the British Steampunk Society and invited me to show at The Asylum two years ago.

What do you think about time travel?
I'd love to do it—where do I sign up? Do I need a visa? It would be really cool to experience life in the French court of Louis XIV—as long as I get to be the one with the biggest wig.

What do you think about technology?
I love technology. It has made our lives easier and more exciting. What I hate about it is the cost!

What are your views on mass production?
I'm not very keen on mass production. Limited editions are great, but not thousands or millions of copies of one design. I believe that everyone is an individual and different—why dress up in the same clothes as everyone else?

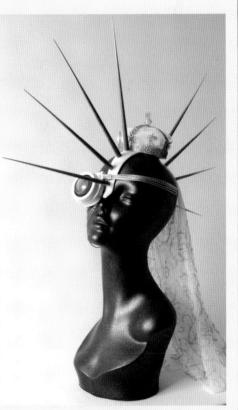

TRAVELING CROWN
This confection is the actual size of Her Majesty Queen Victoria's original traveling crown, and comes with integrated monocle and veil.

OPTICAL AIDS

Goggles to protect against flying sparks and other dangers, or eyeglasses and other aids to visual acuity, are an important part of any ensemble. Leather, brass, and repurposed materials are frequently employed in the construction, and goggles may be custom-designed for particular needs. Additional features range from retractable telescopes to flip-down magnifiers or mesh fly screens.

EYEGLASSES

Corrective visual devices range from the most popularly used nose spectacles to folding lorgnettes, monocles, and quizzing glasses. The lorgnette is a pair of eyeglasses fixed on a handle or suspended on a chain. The handle or chain is often decorative, fashioned by jewelers in a variety of precious materials. Monocles and quizzing glasses are a single version of a lorgnette. Monocles are designed to be worn wedged in the eye socket, and they have a residual handle and rim, if any at all. Quizzing glasses are held in front of the eye and have a larger decorative rim and handle.

EVENING LORGNETTE
A decorative and highly useful optical aid at the opera or a ball.

GOGGLES

Some would say these are essential, an almost ritual must-have for many in Steampunk circles, either worn over the eyes or permanently perched on the head or hat, never actually fulfilling their intended function. Designs range from basic plastic to classic brass to the finest hand-crafted one-of-a-kind art. Or, you can make your own pair of goggles by following instructions available on the aethernet.

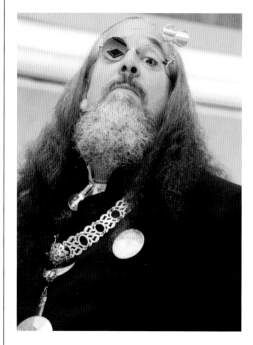

SPECTACULAR SPECTACLES
Wire-framed, with additional magnifying lenses on one side and a mirrored surface on the other.

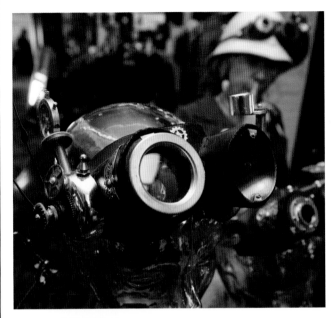

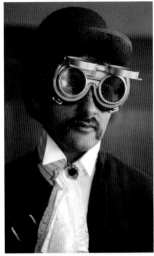

RAILWAY GOGGLES

Double-duty goggles, built with extra lenses that flip up, may well have been inspired by the 19th-century D-spectacles that have two hinged supplementary protective lenses. Known then as railway spectacles, the ingenious eyewear protected the steam locomotive traveler, consigned to ride in open-top carriages, from various irritants including wind, funnel smoke, and sparks from both the engine and the track.

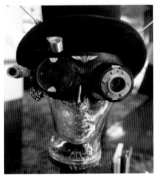

REPURPOSED PARTS

Vendor Daylight Artworks displays one-of-a-kind goggle art. Above, a pair made by Shanti MacEwan from old clock and motor parts, a brass magnifying glass, and hand-stitched cowhide. Left, a brass porthole and magnifying lens, with movable arm taken from vintage typewriter parts. See also page 241

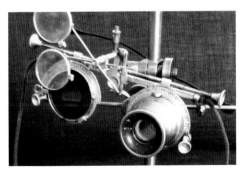

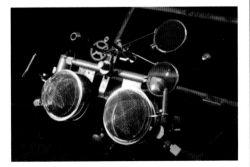

"MAG"-NIFICENT GOGGLES
An intricate-looking goggle design, with built-in additional magnifiers, by Mad Uncle Cliff. See also page 241

THE INSPECTACLES BY MAD UNCLE CLIFF
Inspired by Johnny Depp's role in Sleepy Hollow, *with tea strainers, colored lenses, and a shoelace.*

NICOLAS LE FEU

CELEBRATED MAKER OF A FAVORITE STEAMPUNK FASHION ACCESSORY

Nicolas Le Feu began making goggles, initially purely for his own use, in 2003. He was disappointed at the time with the quality of a purchase he had previously made, and out of that experience came the motivation for him to create a pair of his own. He then began to experiment with various materials and manufacturing techniques, with the intention of starting up a design and engineering business. Finally, he started to design, make, and sell his own goggles in 2005.

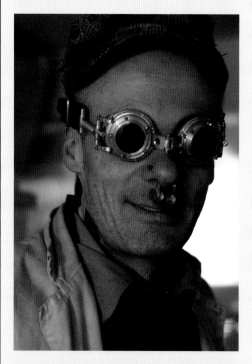

How did you become aware of Steampunk?
I was attracted to Steampunk around 2006/2007 through the LiveJournal communities. I found it inspiring, because it could conjugate the activities (railways model engineering) and readings (Jules Verne) of my childhood with an adult perspective (engineering). Steampunk itself has a subversive element I am attracted to, the DIY spirit mixed with a strong political statement—the globalized world is not working, better to build another one. I think that, through Steampunk or dieselpunk, an alternative world can be made real.

Which science fiction authors do you find particularly inspiring and why?
I am not really keen on SF except Philip K. Dick; he is absolutely spot-on concerning the social control of individuals. Usually SF authors focus on technologies I would find very quickly boring.

What training did you bring to goggle making?
I purchased a lathe and a milling machine after I quit my job as an engineer in 2002. And from then on it was just a matter of work and self learning.

Do you consider yourself to be a Steampunk?
My background is from the "industrial music" scene and subculture. Speaking of aesthetics and utopia, I would say I am fully dieselpunk.

What do you think about time travel?
A few years ago I was interested in the science behind it but, today, because I love the exact times we are in now, I just want to live it to the fullest and would never enter such a machine. My favorite era is now—for all the political, ecological, and cultural challenges it presents. For the aesthetics and inspirations, I am impressed by the futurists and constructivists, and other similar avant-garde movements from the early 20th century.

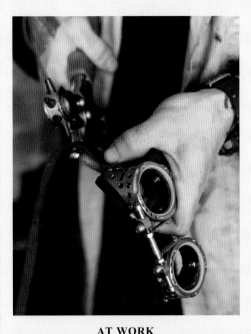

AT WORK

To achieve the quality he wished for in his handmade goggles, Le Feu has had to master various techniques, such as leatherwork and welding.

What do you like and hate about technology?
As a tool, it's a fantastic lever to achieve things. For instance, the knowledge of mathematics and applied sciences is liberating. Through those we have a better understanding of the world. But technology through the passive use of products marketed by corporates is just alienating for the people and destructive for the habitat. I am keen on the "low tech," "no tech," and "open designs" movements. Regarding mass production, I don't see any benefit for the individual. It needs mass consumers, and we now see where a consumption society is leading us.

What materials do you use for your pieces, and where do you find them?
Brass, aluminum alloys, stainless steel; and all the metals are purchased from specialized engineering suppliers based in England. I recycle all the offcuts, and cutting chips are put again in the loop via recycling. The leather is purchased here in London. I am still looking for a very good alternative to animal products, but it's almost impossible to buy small quantities required to make goggles. The lenses are plastic (optical polycarbonate), and I now purchase them from a very old and traditional family business in Jura (France) who are manufacturing lenses for the luxury and high-end market.

What future designs do you have in the works?
Wow, a lot. I want to renew my entire range, to add more details without compromising the functionality, to mix more metals, to change the forms. I have plenty of ideas, and I would have never guessed one can be really creative with just the making of goggles!

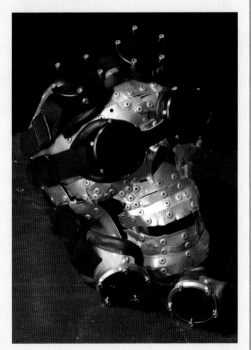

HANDCRAFTED GOGGLES

Three pairs of Atomefabrik eyepieces, which come in a choice of colors.

See also page 241 See also page 241 ☞

MASKS

Whether they cover the eyes, mouth, or both, masks can be used to disguise your identity and proclaim a new one, or simply to protect the face. From rituals to carnivals, masks have played a part in ceremonial and celebratory events since ancient times. In the theater, masks are used as part of a costume to describe a character, and when taking on a Steampunk persona you can do the same.

MASKS AND HELMETS

Certain kinds of masks are found incorporated into helmets and cover the entire head and face. These industrial types of design are usually regarded as work equipment rather than fashion, and are therefore to be found in the Science and Manufacturing chapter of this publication.

See also pages 128–129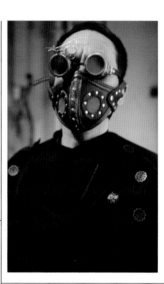

CARNIVAL MASKS

Masks made specifically for carnivals include a range of traditional designs that have traveled through the centuries. Here, a simple but effective molded leather design with a long-nosed protuberance is based on a traditional Commedia dell'Arte mask.

CUTWORK MASK

Spied at a recent Steampunk extravaganza, this exotic mask features a filigree pattern cut into red leather, in the manner of a decorative screen from the Far East. It would make an ideal accompaniment for an Asian Steampunk costume, or indeed Western costumes that employ rich brocades or sari silks. The effect, of course, is essentially cosmetic, inasmuch as the wearer can be easily recognized, thus negating the basic function of a mask, designed to preserve his or her anonymity.

PROTECTIVE RESPIRATORS

Masks that protect their wearers from alien vapors, industrial smog, or infections, cover the face and nose. Some of them resemble industrial protectors, as can be seen here, while others have "plague doctor" snouts, based on 14th-century designs that had a "beak" packed with flowers, herbs, spices, and vinegar to dispel all manner of evil miasmas.

See also pages 128–129

VENETIAN FILIGREE

Famously, metal masks in gilt or black filigree are crafted for masquerades, carnivals, and balls in the intoxicatingly beautiful setting of Venice, Italy. Here, we can see a mask fashioned out of stiffened lace and decorated with crystals. In the Venetian past, the masks were often used at the annual Carnivale as a device for hiding the wearer's identity and social status—and, of course, as a useful cover for clandestine romantic encounters.

A HEADY VISION

Masks incorporating a feathered headdress are found everywhere, from burlesque dance to native cultures. The feathers draw our attention to the wearer, while the mask hides their identity. The version illustrated here has been custom-made to match the wearer's ball gown, featuring ruby red and black dip-dyed feathers attached to a braid-trimmed gilt eyepiece.

PAPIER-MACHE

The traditional art of papier-mâché has been used for carnival and masquerade masks for many centuries. This horned example is a representation of a mythical ram-like creature, which can be seen in various forms in ritual ceremonies around the world. The practice of men and women dressing as animals, whether rooted in myth or reality, goes back to medieval and even pre-Christian times.

LEATHER MASKS

From simple shapes carved out from a plain hide, to fancy dyed and hardware-decorated designs, to molded and shaped versions, leather is a versatile medium for mask manufacture. Black leather can often have dark and sinister connotations, as with the executioner-style mask pictured here.

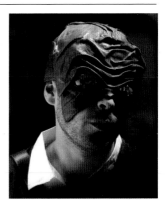

HAIRSTYLES

Vintage hairstyles—ranging from pin curls or ringlets to pompadours, updos, finger waves, braids, rolls, and buns—mixed with punk-inspired day-glo colors, decoratively shaved areas, and extravagant extensions are all opportunities for imaginative individuals to enhance their look. Not for these ladies the formality of a simple bob cut, or for the gents a straight short-back-and-sides.

HAT HAIR

You will need to tailor your hairstyle to your hat. Top hats, for example, have the advantage of allowing enough space for hair that is piled on top of the head. Elaborate hairdos or dreadlocks, on the other hand, will often obviate the need for any millinery adornment at all.

COLOR

Bright, eye-catching colors such as red or pink add a rebellious touch to any hairstyle. The elaborate French hairstyle pictured below incorporates a plethora of elements, including dreadlocks and giant buttons, in a Steampunk-inspired Marie Antoinette-style wig.

COMBS AND OTHER HAIR JEWELRY

Tonsorial updos call out for combs, tiaras, and other forms of hair decoration. Spotted at a Steampunk event, the feather and clockwork comb seen here is a typical example of the sort of head enhancement that can be achieved with some imagination. And, despite men's diverse hairstyles, such adornment essentially seems to remain the almost exclusive preserve of women.

DREADLOCKS

Worn by many societies and ethnic groupings around the world, dreadlocks can function as a religious, political, or fashion statement. In Great Britain they were usually associated with West Indians of the Rastafarian persuasion, but more recently they have been common among a broader constituency of young people. Dreadfalls made from synthetic hair or tubing, or felted yarn, can be woven into real hair for a temporary style, and brass beads and other notions can be added to the locks.

MUTTON CHOPS AND MUSTACHIOS

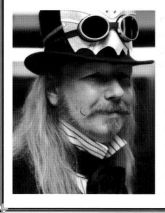

Gentlemen should investigate the many and varied styles of mustache, sideburns, and beard that will complement their Steampunk ensembles. New-fangled aids such as wax are also sometimes employed. Contests for having the most extravagant and splendiferous growths are occasionally held at various conventions and symposiums, popular with the participants regardless of prizes or popular acclaim. Splendid facial hair has been a feature of male fashion for generations, though it has enjoyed various ups and downs in its popularity over the years. The golden age was undoubtedly during the late Victorian and Edwardian period, when nearly every adult male sported a magnificent mustache at the very least.

WONDROUS WIGS

Elaborately styled wigs in all colors of the rainbow are a great help to time travelers. Once upon a time, of course, the wig was an essential item for both the male and female fashionistas of the 17th and 18th centuries. Here, a glamorous weekend ballgoer wears an aristocratic wig that resembles a powdered pompadour style.

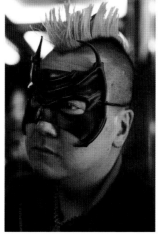

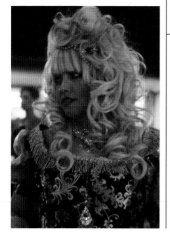

THE MOHAWK

Known as the Mohican haircut in England, this look derived from a Native American style reputedly worn by the Mohawk, Mohican, Iriquois, and other tribes. It became popular with the London punks—in particular those who frequented the King's Road in Chelsea—during the 1970s. The gentleman pictured here is displaying his coiffure, along with a Batman-influenced mask, on Californian shores.

HIGH HAIR AND BEEHIVES

Backcombing and false hairpieces can be used to construct towering hairstyles for both ladies and gentlemen. The "beehive" was a hugely popular female style in the 1960s and served as inspiration for the gentleman's confection shown here, which took four hours to create.

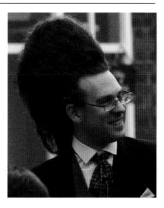

GENTLEMEN'S LATEST

Time waits for no man, and fashion certainly doesn't. Acceptable attire ranges from colorful evening dress to somber business attire, while the ever-changing worlds of field sports and motoring have introduced new designs for daywear. Hats of one kind or another are de rigeur in almost all circumstances, as are vests, known in Great Britain and the Empire as waistcoats.

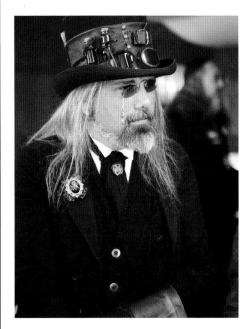

MAN IN BLACK

A somber hue is an elegant choice. Only a white shirt relieves the black mood.

GENTLEMAN'S WORKING JACKET (FORMAL)

Vintage Harris tweed jacket with upcycled leather, mixed metal, and pheasant feather trim. S-hooked jacket sleeves allow for removal or replacement. Bronzed vintage hat with metal trim and antique clock hands. Designed and made by Second Coming, Ms. D's Costuming Empire.

LASTWEAR: TAILORS AT ARMS

Makers of Professor Elemental's fighting trousers, the Seattle-based tailors Lastwear are the original open source clothing company that makes their design, patterns, and process available for free to everyone. As well as Pinkerton vests and cargo steeplejacks (for an example, see the motoring outfit opposite), they are famed for the oriental-influenced Nakoma Hakama trouser. And this forward-looking design atelier, always on the lookout for what is next on the fashion horizon, is currently investigating a new style for fresh inspiration, known as Art Deco.

See also pages 74–75 and 241 ☞

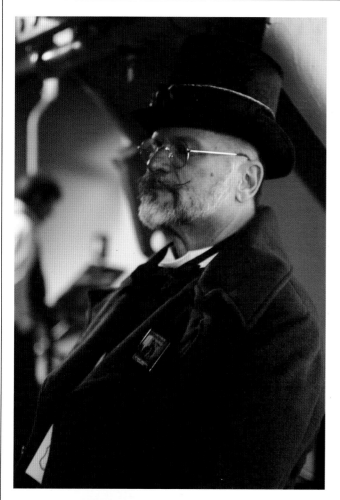

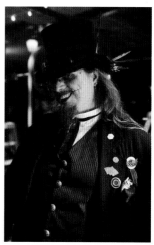

THE LATEST HAT

This dandy wears the new style of waisted topper with his evening dress.

MOTORING OUTFIT

Plus fours, a stopwatch, and protective goggles are essential items for driving—or even just riding as a passenger—in the new-fangled motor vehicles.

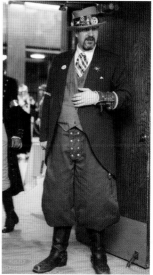

IMPERIAL PURPLE

A colorful, dignified alternative to black for smart formal wear.

SALUTE THESE LAPELS

Intricate embroidery lends an exotic military air to the lapels of an evening jacket, on show at a formal ball during a Steampunk gathering. Many of the grand outfits are homemade by the wearers; others are made to measure by the finest bespoke tailors in the land.

GENTLEMEN'S VESTS

This body warmer evolved from the Elizabethan doublet and has been a gent's sartorial choice ever since. Worn under a jacket and over a shirt, it allows sober-suited men to indulge in fine fabrics, vivid colors, and lavish patterns—as well as providing a surfeit of that gentleman's standby, pockets. The vest, or waistcoat, is also the essential third party in the conventional man's three-piece suit.

ENHANCING THE SILHOUETTE

Whether a gentleman follows Prince Albert's lead and wears a corset or not, the line of the body can be enhanced by a well-fitting vest—some have boned stiffeners or a laced-up back to aid this.

DAY AND NIGHT

Vests can be single- or double-breasted, and may include a pocket for a pocket watch and chain. Day vests have between four and six buttons, while evening styles tend to be lower cut, with only three buttons. Practical at every level, the time traveler can use a vest for carrying everything from a tin of snuff to a credit card.

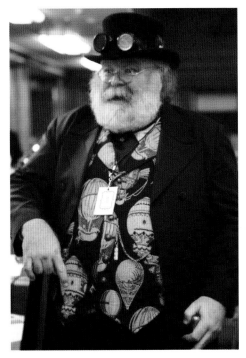

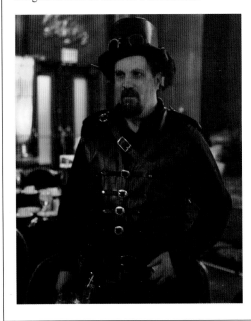

PRINTED VESTS

Prints allow you to wear your allegiance on your vest. As well as the familiar cogs and gears, airships, balloons, Cthulu, difference engines, and time machines could all be subjects for prints. Here, Montgolfier sails across expansive skies.

LEATHER

Stride across convention frontiers while buckled securely into sturdy leather, enhanced with crossover shoulder strap and military style epaulettes. The leather topper is an optional extra.

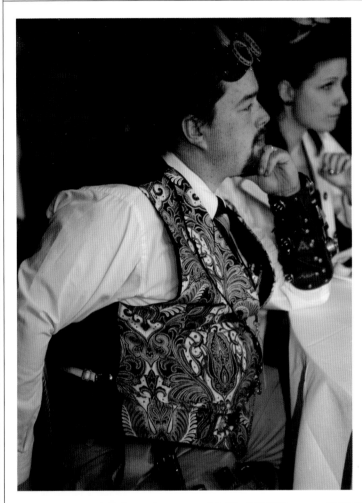

DAYWEAR DOUBLE

A six-buttoned double-breasted waistcoat in fawn, with matching plus-fours.

EVENING DRESS

A grand ball calls for a brocade silk vest. Brocade is usually a silk with an intricate raised figured or floral pattern woven with fine gold or silver threads. Rising to the occasion, an evening of ballroom luxury will bring out the dandy in almost any man.

BACK DETAIL

A series of riveted panels echo the vertebrae of the spine on the back of this vest.

ARMORED VEST

The vest becomes body armor in a leather and brass design, The Emperor's Armor of Empowerment, by Ian Finch-Field of Skinz-N-Hydez. Mr. Finch-Field has also made a robot glove for Justin Bieber.

See also page 241

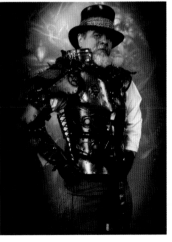

GENTLEMEN'S HEADGEAR

Whether you choose a bowler, topper, derby, homburg, porkpie, boater, fez, deerstalker, or tricorn hat; a pith helmet; or a newsboy or forage cap, an outfit isn't complete unless it's topped with a hat. First devised as protection from the elements, a man's hat has evolved into something far more significant, with class, manners, and military might all having a bearing on design and function.

ON THE IMPORTANCE OF A HAT

No self-respecting gentleman is thought to be dressed without his hat, and grave consideration should be given to the choice of style. As Mr. William Makepiece Thackeray wrote: "If you want to understand the individual, look at him in the daytime; see him walking with his hat on. There is a great deal in the build and wearing of hats—a great deal more than first meets the eye." On these pages we are dealing with dress hats—from top hats and derbys to newsboy caps. Military headgear, on the other hand, is covered on the uniform pages.

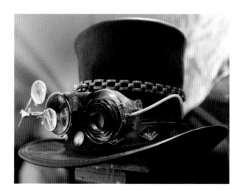

HATBANDS
Goggles perched on a hatband are somewhat of a style convention at Steampunk gatherings.

THE ETIQUETTE OF MALE MILLINERY

INDOORS OR OUT

There are numerous and very confusing rules about wearing hats indoors, depending on both the culture and the actual establishment involved. To remove your hat is almost universally taken as a sign of respect and is strongly recommended in the presence of royalty or a lady, and also at solemn events like funerals or religious services. But some occasions, like parliamentary or legal ceremonies, call for headgear to be worn indoors.

DOFFING

Greet others by raising your hat briefly or by tipping it—touching it or tilting it forward. Doffing comes from the same tradition as the military salute, and it is both a mark of respect—especially toward a lady—and acknowledgment of one's standing in relation to a social superior. A member of the aristocracy would never feel obliged to doff his hat to a commoner, but vice versa the gesture would be almost obligatory.

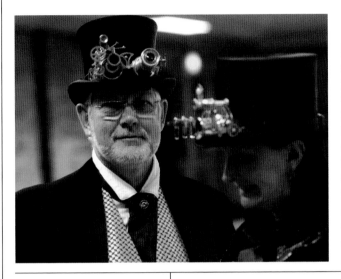

TOPPERS

Early toppers were very tall and straight-sided and were popularly known as "stovepipe" hats—for example, the ones famously worn by Abraham Lincoln. The later designs changed, however, with the height of the hat being reduced and crowns growing, giving the hat a pronounced "waisted" effect. Most toppers today, seen widely at Steampunk events and elsewhere, are of this latter type. *See also page 54* 🖙

BOATERS

Made of stiff straw, with a flat crown and brim and a grosgrain ribbon band, boaters are often paired with a striped blazer or light linen jacket. These days, in Great Britain they are most often associated with boating events. In the United States, Straw Hat Day in May marks the switch from winter hats and heralds the beginning of summer.

PITH HELMET

Also known as a solar topee, this cork-covered tropical protector comes in two main styles: the peaked Victorian type, which is illustrated here, and the more modern Wolseley pattern. First devised in the early 1840s, the pith helmet became popular with British military personnel in the 1870s and was mainly seen in the far-flung outposts of Queen Victoria's vast empire. *See also page 55* 🖙

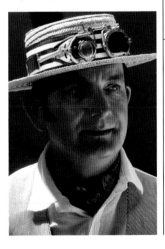

BOWLER OR DERBY

Devised in 1849 for a customer of the London outfitters Lock and Co., this hat has proved a universally popular item of dress, with a wide range of wearers including wild west lawmen and outlaws, railway workers, British bankers, and American working men. In America the hat became known as the Derby.

GENTLEMEN'S ACCESSORIES

Whatever your character, a gentleman isn't properly dressed without a few key accessories. These can range from the very simple—a fabric dress glove, for instance—to elaborate one-of-a-kind constructions like an articulated brass glove that is part of an armored sleeve. Plus, there are all manner of accessories devoted to carrying things, from bags and belt pouches to a handgun holster.

TIE YOUR OWN

Hand-tied neckwear is preferable to—and more authentic than—the inferior elasticated examples. Diverse methods for tying stocks and bow ties can be found on the aethernet, with moving picture demonstrations to aid you.

TIE AN ASCOT

A scarf tied with a flourish and secured with a pin under a traditional wing collar. Ivory silk, sometimes trimmed with lace or a silk fringe, is a classic choice.

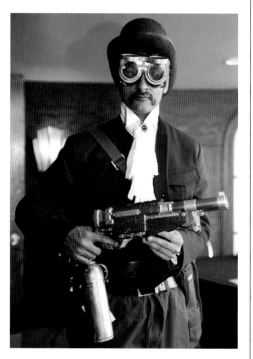

NECKWEAR

Before the regular necktie arrived, neckerchiefs and scarves in the form of cravats, Steinkirks, jabots, solitaires, stocks, and Ascots, and later bow ties, adorned men's necks for everyday and formal wear. In the wild west the shoelace-style bolo tie took precedence.

BELTS AND HARNESSES

Belts do more than hold up a man's trousers, providing tabs, hooks, and rings for carrying all sorts of essentials from an airship captain's compass to a cowboy's flask of moonshine. And, likewise, harnesses are similarly equipped for carrying solutions.

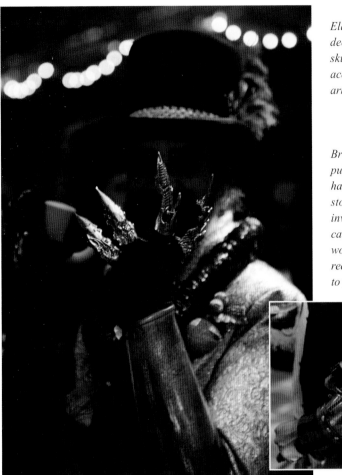

HEADY FINGERTIPS

Elaborate metal finger shields decorated with gargoyle-like skulls sit on a glove that is accessorized by a simple brass arm covering.

ARM FURNITURE

Brass, leather, a gauge, drawer pulls—someone looks like they have raided the local hardware store in order to make these inventive accessories. You too can be a walking do-it-yourself workshop, by restoring and recycling all sorts of bric-a-brac to your own devices.

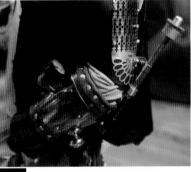

POWDER-CARRYING BELT

A simple tabbed leather belt holds powders and potions to ward off everything from a vampire to the common cold.

DON'T FORGET A HOLSTER

In case of trouble, or maybe just for show, you'll need a leather holster to keep your trusty steam pistol or atomic ray gun at your side at all times.

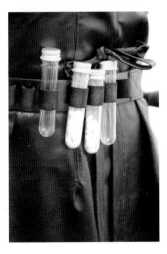

THOM B.

FOUNDER OF THE LASTWEAR CLOTHING COMPANY OF SEATTLE

Designing since 2007, Lastwear had never heard of Steampunk when they started out. Their designs were first posted online on deviantART, and within a few months were being described as Steampunk—so they decided to investigate. It very soon began to influence their style, and although they don't consider themselves exclusively Steampunk, they are happy to be considered part of it.

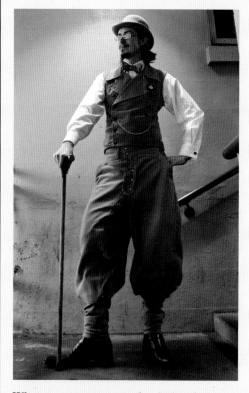

What are your most popular designs?
The Pinkerton Vest is by far our most popular that's available for sale at this time. The other one is probably the steeplejacks. They're both very versatile designs that can be made to work with a variety of different looks or characters. What we try to do with our designs is to make clothes that can fit into everyday life just as well as they can act as the foundation for a full character costume.

Why the name Lastwear?
We believe that your clothes should be able to stand up to some abuse, just in case you find yourself in the middle of a zombie apocalypse. The clothes are built to last, hence the name. Also, after throwing some names back and forth, that's the one we all liked the most.

You have a creative commons offering, which allows people to make use of your patterns for free. Why and how does this work for you?
Well, we've recently been finding that it doesn't work. Sadly, it seems that our idealism got a little too far out in front of reality. Our hope had been that allowing people to download the patterns and have a go at making the clothes themselves would promote conversation and interest in the brand. We had expected that the sales we'd lose to folks making their own would be exceeded by the increased sales to the people who had no interest in sewing. In the end, that hasn't happened. The free downloads, while we can't say how many sales they've lost us, certainly haven't been bringing in any sales either. The other problem was that getting the patterns ready to use was taking a ton of time. The actual business of file conversion was a real pain, and we ended up spending a lot of time offering technical support on a free product. We will keep doing our sewing tutorials, though, and we're looking at other ways to help support maker culture, but at this moment in time, the free patterns are no more.

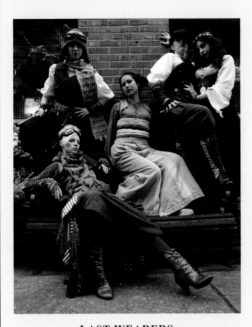

LAST WEARERS

Opposite, gents' Pinkerton vest and Cargo Steeplejack pants. Above, ladies' ensembles. See also page 241 See also page 241

What materials do you use and why?

Currently most of our designs are made from cotton canvas or poly/cotton twills. These fabrics meet the right midpoint of cost, durability, and appearance. We would love to do more with wool and hemp blends and other more rarefied cloth, but for now we can't afford the initial outlay for such things, so that will have to wait until we've grown the company a little.

What do you think about time travel?

I think it's important to make time to allow one to travel. Personally, I love history, and the fiction behind the Lastwear universe concept is full of temporal anomalies where different time periods can bleed into each other. For Lastwear, time travel is mainly seen as a design tool that allows us to play with any period of clothing and fashion that we feel like.

What is your favorite era?

Gosh that's an impossible question. I love Meiji-era Japan for the incredible design work; also the early 20th-century Art Nouveau and Art Deco movements. Really, though, there are no historical periods that aren't fascinating when you really start to dive into them.

What are your views on mass production?

I think mass production is great. Mass production allows the delivery of high-quality goods at reasonable prices to people who otherwise could not afford them. By contrast, I hate corporate colonialism, which is the system of government we have now. That prioritizes profit over life and leads to the mass production of useless crap that poisons the world we live in, demeans minorities and women, disincentivizes learning, and sets the people against their own government. Mass production is just a technology. Lastwear works with a factory here in Washington state, and it's that relationship that allows us to produce a superior quality of product at a fair price while supporting the local economy—so, for us and our customers, I think mass production is a good thing. Viva la industrial revolution!

BAR MAIDS

Lastwear models enjoy a drink at the White Horse Trading Co., Seattle's antique bookstore and bar.

MILITARY UNIFORMS

Steam-driven tailors can travel the world for military inspiration, taking in caps and helmets, battle dress and ceremonial jackets, equipment belts, and other contents of the knapsack. Unfortunately, the "army surplus" stores that stocked all kinds of ex-service clothing in cities and towns across the country—and a great source for those seeking the genuine article—now seem a thing of the past.

ZOAVES

Originating in units of the French army serving in North Africa, the Zoave name and style of dress was adopted in other countries, including Spain, Poland, British regiments in Africa, and some regiments in the American Civil War. The uniform consists of a short open-fronted jacket and baggy trousers, often accessorized with a sash and a fez.

MILITARY HELMETS

Helmets are an essential part of any armor, protecting the head against a blow or from bullets and shrapnel. This tin hat with its spiked finial was adapted by Herr Döktor from a Prussian pickelhaube helmet.

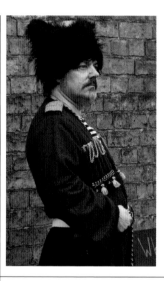

COSSACKS

Slavic semi-military communities (in what is now Ukraine and Russia) are known as Cossack hosts. They dress in loose-fitting tunics with ornamental cartridge loops and wide trousers, and a fleece hat or cap in colors that vary according to their group or host. They are famous for horse riding and Cossack dancing, and in Western eyes they have defined "Russian" style since the days of the Imperial Tsars, who ruled an empire from Moscow to the Pacific.

FATIGUES

Service coats in khaki cotton drill may be sack coat style, with two pockets or the newer, longer length with four pockets. The original fatigues were worn by lowly soldiers undertaking hard labor, but over time the term has been applied to any kind of non-ceremonial uniform, like those worn on duty, work detail, or the field of battle. Illustrated here, it is accessorized by an officer's red sash. Sash color will vary with the era and location you have landed in, of course, and the rank of the wearer.

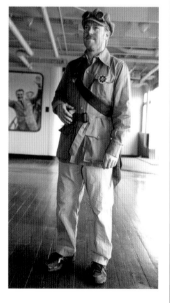

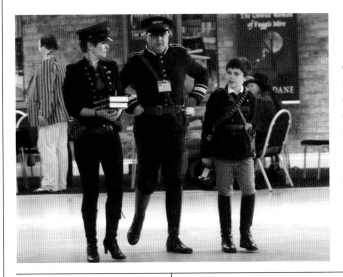

A NUCLEAR REGIMENT

Groups ranging from the nuclear family to a party of friends can express their allegiance by designing and wearing their own uniform. It might seem odd in these days of individuals doing their own thing, but adopting a common mode of dress for Steampunk events adds to the camaraderie of the occasion—and is probably the only time when junior really doesn't mind dressing just like his dad!

STEAMPUNK SAPPER

Military uniforms of all kinds can make a statement, whether for wear or display. This highly specialist bomb disposal outfit by Major Thadeus Tinker is equipped with chainmail face protector, a protective breastplate in the forerunner of Kevlar (waxed cotton), a tool belt, goggles, and a tin hat.

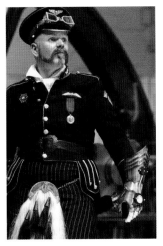

HIGHLANDERS

Scottish regiments have their own tartan, and the Steampunk militia often make their own choice of fabric—here, a city pinstripe cloth is pressed into action. Kilts and sporrans are a fertile ground for potential dress modification, far from the strict regulation of traditional clan attire. And the kilted regiments provide inspiration for similar Steampunk battalions, on both sides of the Atlantic.

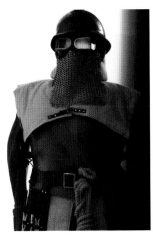

REDCOATS

Often thought of as a symbol of the British Empire, the British Army last fought in redcoats in the Sudan in 1885, and it is now used for ceremonial occasions. Redcoats were also worn by some European armies, including Danish, German, French, and Russian regiments, and US Marine Corps bandsmen.

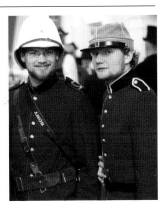

FOOTWEAR

Retro-futurism doesn't stop at the ankle—shoes and boots need to chime with the rest of the outfit for a perfect transformation. Practical almost by definition, footwear nevertheless has become a part of fashion design creativity. Gentlemen and adventuresses can't fail with a pair of buckled motorcycle boots, while ladies should try laced or button ankle boots to accent a bustle or crinoline.

BOOTED AND SUITED

Workaday biker and Western boots can be worn by both sexes, especially with adventurous gear, while laced Victorian ankle boots with a delicate heel are ideal for ladies of refinement. Given that, ideally, footwear should be both functional and stylish, the Steampunk approach works well in so many instances. Items like motorcycle boots, by definition, already have an inbuilt style related to their use—sturdy, secure, and so on. Gaiters and spats also have to serve their purpose, while of course looking as elegant as possible. At the other end of the fashion scale, the precarious-looking high heels or stilettos, favored by many ladies, call out for some heavy-duty decoration.
See also page 25

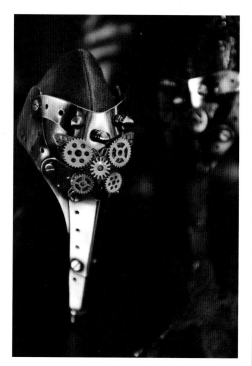

HEEL HARDWARE

Metal cogs, rivets, and panels protect the heel leather on shoes by Hades, from Steamtropolis.
See also page 241

BUCKLE UP

Black leather motorcycle-style boots with coggy buckles, available from Demonia. Not a million miles in style from the familiar Doc Martens, the ubiquitous British boot of Germanic origin; the original Dr. Märten was a medical man serving in the German army during World War II.

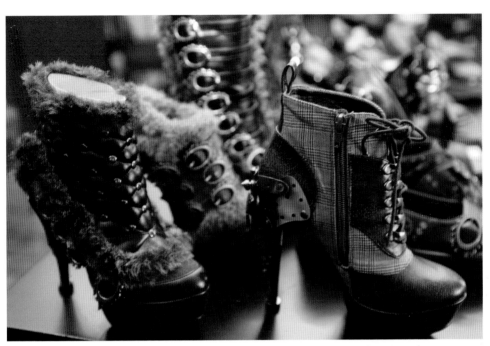

FOR A FINE ANKLE

A display of stiletto ankle boots in leather, tweed, and fur by Spanish brand Hades, and displayed by importer and vendor Steamtropolis at a symposium in California.

SPATTERDASHES AND GAITERS

Spats cover the instep and ankle, while gaiters cover the shoe and lower leg to the knee. The leather gaiters seen here are by Autumn Adamme of Dark Garden Couture.

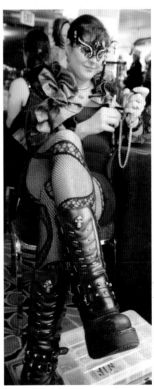

BIKER BOOTS

These spectacular platform-heeled leather boots, designed in chunky cyberpunk biker style, certainly reduce any risk of appearing at all androgynous when topped with some racy lace stockings.

JEWELRY AND WATCHES

A major consideration when planning or creating a wardrobe is jewelry, and the market for jewelry is extensive. You will find items at every price—or, should you choose, instruction for making your own. Whichever route you opt for, in the Steampunk universe the choices can be almost limitless, and they extend far beyond the conventional categories of baubles, bangles, and beads.

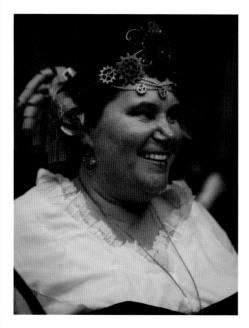

CLOCKWORK TIARA
Copper cogs, many probably salvaged from the workings of a disused timepiece, are forged into a timely headpiece.

A CHESTFUL OF DECORATIONS
Colorful ribbons, a vibrant silk and gilt braid sash, and sparkling medals and pins lend this ball-goer a festive clockwork soldier look. It was no accident that the awards bestowed on military men for valiant action in the field became known as decorations—for an upstanding soldier of the Queen, the nearest equivalent of ladies' jewelry.

JEWELRY WITH A NEW PURPOSE

Repurposing or recycling is very popular among Steampunk jewelers. Discarded clockworks, cogs, and other mechanical parts—plus of course the actual watch and clock faces themselves—are all pressed into service, along with other repurposed items, from doll's eyes to coiled springs and typewriter keys. You will find pieces at all prices, whether forged from found materials or precious metals. And if you prefer to craft your own, there is much practical advice available on the aethernet or in book form, from esteemed instructors such as Jenna Hewitt.

See also page 242 ☞

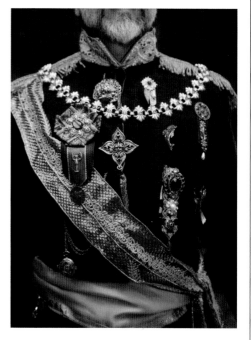

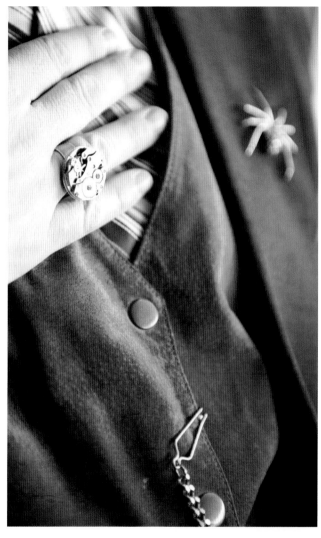

ATOMEFABRIK BANGLES

Brass and steel bangles have been milled into a cog shape, designed by the famous fabricator, Nicolas le Feu.

See also page 241 ☞

NOVELTY PINS

Spied on a vendor's display at a Steampunk extravaganza, a fine collection of zombie cameos and propeller pins.

WATCH PART RING

Clockwork mechanisms are often recycled to produce new jewelry like this man's signet ring.

DANIEL PROULX RINGS

Wire-wrapped jewelry with brass, copper, taxidermy eyes; watch parts; and gemstones by Canadian artist Daniel Proulx.

See also page 242 ☞

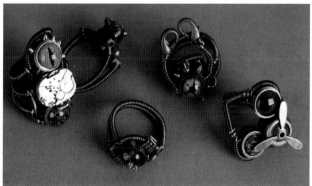

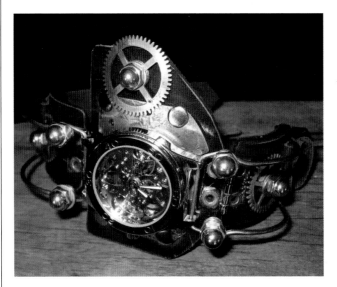

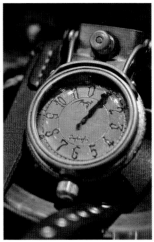

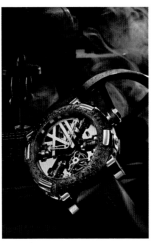

HARUO SUEKICHI WATCHES

OLGA NAROZHNA

Made of leather, oversized rivets, and vintage parts with an asymmetric layout. To quote the artist herself: "Wheels and gears symbolize movement like the wheels of time."

TITANIC DNA

Romain Jerome of the high-end company Tourbillon created this in oxidized steel, like the metal from the Titanic, the dial inspired by the ship's engine room.

Artist Haruo Suekichi from Tokyo, Japan, makes highly stylized one-of-a-kind watches in brass and leather, like the examples shown above and below, that are sought after by persons of distinction from around the world. For over a decade, Suekichi has been developing his handcrafted watches. Inspired by both Jules Verne and manga comics, his watches, which he first tried to sell at a flea market, have been called "vintage futuristic."

WATCHES

An impressive timepiece is a useful—indeed, some would say essential—piece of equipment for time travelers. Consequently, some makers and specialist watch companies have added suitable versions to their ranges; consider those from Retrowerk or Tourbillon. Alternatively, individual artist watchmakers create highly stylized one-of-a-kind pieces for collectors. Pieces by Haruo Suokichi from Japan and the Ukrainian craftswoman Olga Narozhna are particularly sought after.

See also page 242 🖙

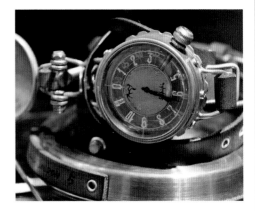

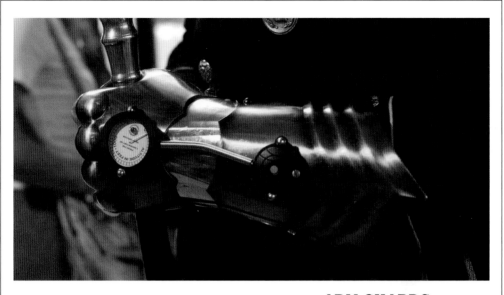

HAND IN GLOVE

A brass and steel glove, conveniently fitted with an altimeter for an airborne Highlander.

⟹◆⟸

BRUTE FORCE WRISTGUARD

Below left, a celestial timepiece controlled by re-purposed typewriter keys and set on a leather cuff.
See also page 241 👉

⟹◆⟸

HANDY AT ANY TIME

Right, with timepiece, key fob, and flashlight.

ARM GUARDS

Bracers or arm guards crafted in leather are often fitted out with watches. Other fitments and small devices such as gauges and typewriter keys may also be used to decorate the arm piece. Bracers that are solar-powered and fitted with a brass sundial will allow explorers to navigate without the risk of mechanical failure, while other bracers may be fitted with three watch faces, each one set to a different time zone and era for the intrepid time traveler. Bracers may also include a compass or scientific gauges to assess temperature or altitude.
See also page 86 👉

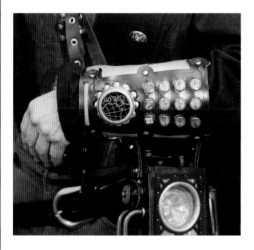

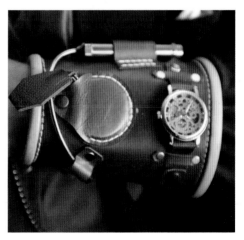

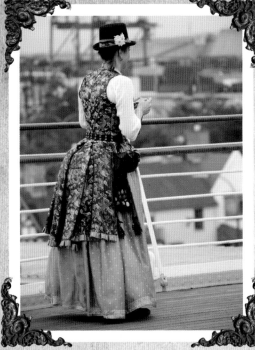

INTERNATIONAL TRAVELER
*Sourced worldwide, a sari silk skirt is topped by
Chinese dragon brocade.*

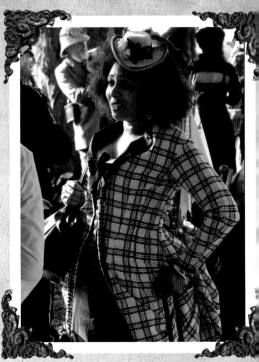

ELEGANT DAYWEAR
*A chic guest in black and ivory plaid, cane in
hand, takes a stroll in the open air.*

BEAUTY SPOT
*A black satin under-bust corset is set over a
white chemise.*

FAIRY HUNTER
*A crisp white shirt and sensible corset accessorize
by a fairy hunting rifle.*

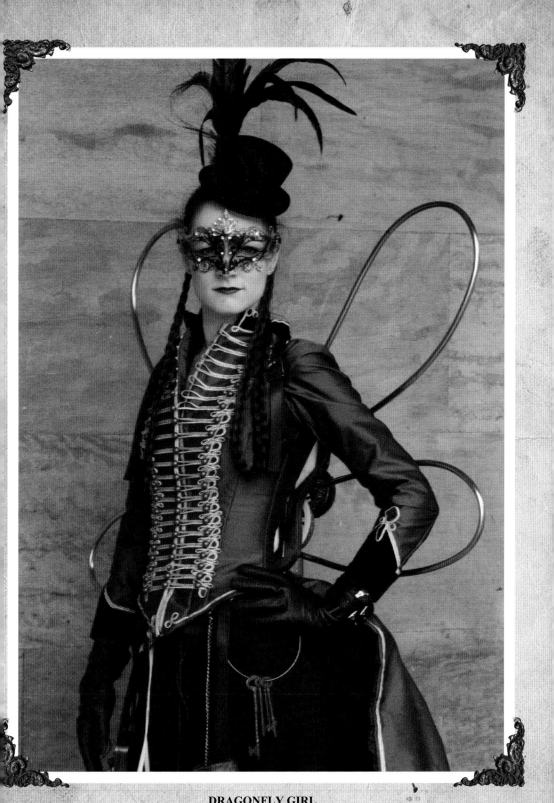

DRAGONFLY GIRL
A kingfisher blue silk gown with military braiding is set off by a winged rocket pack forged from copper piping. See also page 36 ☞

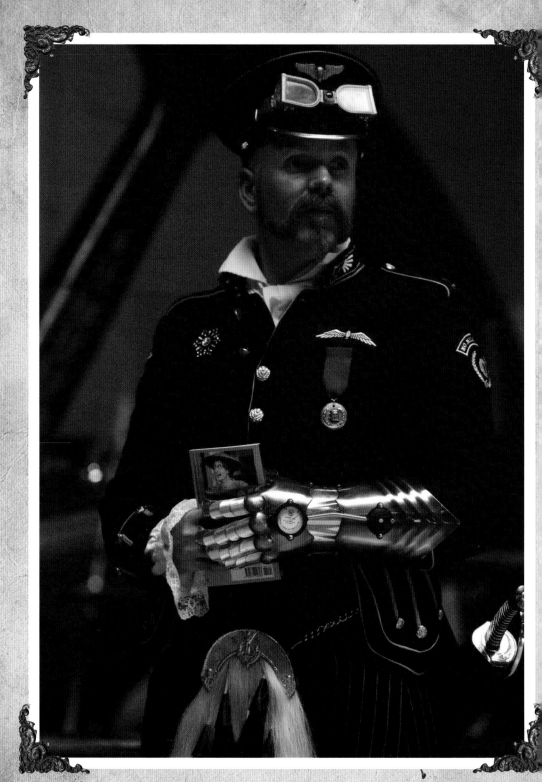

HIGHLANDER
At ease in a military-inspired uniform at Kew Bridge Steam Museum,
London, England.

A PIPING HOT HAT

Steel-rimmed goggles and a miniature steamboat funnel adorn a gentleman's hat.

FATHER MICHAEL

The clerical accessory of a bible, teamed with an earring and a badge offering spiritual correction.

FEATHERED FRIENDS

Two hat wearers at Her Royal Majesty's Steampunk Symposium, California, agree on feathers and rosettes to trim their headgear.

FURNISHING

Where does the weary time traveler hang her goggles and her ray gun? What does the intrepid airship captain use to light his study? How does the Steampunk look translate into the creature comforts and inspired environs of the home and shared spaces? Here we will explore the nuances and the spectacle of Steampunk design and décor from the fictive and fantastical to the semi-historical and delightfully bizarre. We will also show how Steampunk can be both classic and contemporary in its timeless approach to living. Many folks are attracted to the retro-futuristic style partially because it challenges the mind—as the future past that never was—and in addition because it is really cool. Then there are those who live full throttle in the culture, from the moment they make their breakfast in their modernized Victorian kitchen to the time they lay their heads on the dirigible print pillow. Materials, motifs, and reimagined objects lend an air of a style that can vary from the machinist and industrial to opulent Victoriana—or somewhere between the two, akin to the contraptions and curiosities found in some eccentric professor's library.

INSPIRED LIVING

Born from early science fiction, or "speculative literature" as it has often been dubbed, the underlying aesthetic of Steampunk style has found its way onto the sketch pads of interior and industrial designers. The limitless canvas—literally "to infinity and beyond"—of the science fiction genre allows artists and architects alike to reimagine items from the past and upcycle spaces that have fallen into disrepair, finding the elegance in them and the stories they tell. The fantasy element grants a freedom of expression far broader than that enjoyed in more conventional forms, bound as they are by issues of fashion and practicality. The spectrum of texture and tone finds its way to the Steampunk palette—from the ornate mahogany, brass, and rich velvets of Victoriana to the more reserved scientist's salon, and all the way to the machinist's foundry. A closer look reveals a hint of the Arts and Crafts or Art Deco movements, too.

WELL-APPOINTED OFFICE

The Three Rings games studio in San Francisco enjoys an open office design on Steampunk lines, with work spaces for over twenty people, plus games room and lounge. Designed by Because We Can, it was completed in 2006.
See also page 242 🖙

MAKING HOME IN THE RETRO-FUTURE

Architects and artists aren't the only ones having fun. Tinkerers and technophobes, in fact anyone with a love of old-time craftsmanship and a sufficient imagination can Steampunk their homes in a variety of ways, from decorating a table with Victorian-era curiosities, to selecting a stunning lighting piece.

PIPE ORGAN DESK

A salvaged pipe organ has been transformed into a stylish workstation by ModVic.
See also page 242 🖙

Or they might venture to designing an entire series of rooms that help answer the question of what might it have been like if the Victorians had access to modern technologies, or what the era of the enlightened steam-powered Industrial Revolution would look like today. As with Steampunk dress attire, a home environment can become the time machine in which the traveler makes his or her selective journeys into the past. The results are extraordinary, creating spaces that remind us of Nikola Tesla's workshop or Ada Lovelace's atelier.

DESIGN INFLUENCES

Aesthetically, the appeal of Steampunk is that it pulls from multiple genres (science fiction and alternate history), mashes aesthetics (Romantic opulence with post-apocalyptic starkness), and asks us to make sense of the madness. The results are as unique as the folks that tinker and dream them up. However, there are design principles that guide the otherwise open-ended approach.

NEO-VICTORIAN CHIC

Victorian style often comes back into fashion with a contemporary twist. The most recent revival has been feminine, delicate, filigree, and pastel tea cups. Since the original era was so long, it can be interesting to see what aspects of the period designers mine for inspiration. There can be a hint of bizarre, like images of *Through the Looking Glass* or a skull under a bell jar. While the Steampunk home—and lady for that matter—are hardly fragile, great attention is paid to the refinement of the period and ways to embody it through design.

CHINA STORIES

A Black Widow plate from The New English, this piece has it all. It's dramatic and delicate—and it's fragile—yet looks like it has a tale to tell. Bringing together contradictions in a single object like this gets the gears working.
See also page 242 See also page 242 📖

INDUSTRIAL INSPIRATION

Where would we be without the glories of the Industrial Revolution, halcyon days for inventors and manufacturers? The industrial look is a design style in its own right, expressing the essence of the age—and its contradictions. It can be stark and severe or intricate, like the meshing of gears and spiral of wrought iron. Many contemporary pieces borrow from modern simplicity, but forego its smooth seamlessness in favor of a rugged feel, which adds some soul to the cold metallic objects.

BALLOONING WALLS

Machine Volanti and Montgolfier tiles by Piero Fornasetti, from 1955. Airships are popular in Steampunk décor, here in stark black and white.
See also page 242 📖

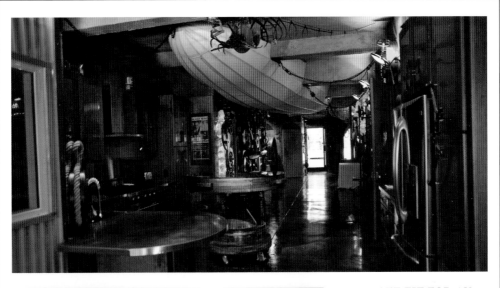

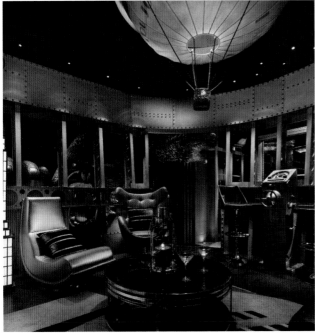

A LOFT FIT FOR AN ENGINEER

Jeremy Nortiz converted a loft with submarine-style front door, colorful zeppelins, and a wall of salvaged gears.

BANK DOOR

This door, from Bruce Rosenbaum's Steampunk House, was salvaged from a bank.
See also pages 94–95 *See also pages 94–95* 👉

ZEPPELIN INSPIRATION

Opened in 2010 in Manila's Peninsula Hotel, the Salon de Ning was named for Madame Ning, a stylish 1930s Shanghai socialite whose mansion in the Philippines was its inspiration.

Among various themed rooms, the Zeppelin marked her long friendship with the German Count Ferdinand von Zeppelin, designer of the airships.
See also page 242 👉

ROGER WOOD

CANADIAN CLOCKWORK MAESTRO EXTRAORDINAIRE

The "Mad Clock Maker" is a proud Ontarian, and the man behind Klockwerks, a company dedicated to creating one-of-a-kind, unconventional time pieces. You will recognize Roger's work by the balance and sculptural influence, the intriguing collection of baubles and found objects included in each piece, and the trademark feather on the second hand. They say time flies when you're having fun, and this maestro of functional sculpture sure is having just that.

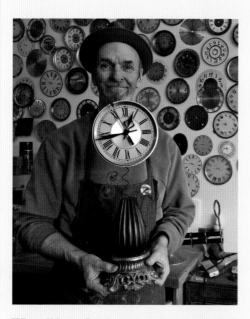

When did you first become a clock maker?
I started off making fine art assemblages and also made a few clocks for friends. The response was so good that I started making more and more.

What led you to it? Was it something you studied? A hobby that became more?
I'm self-taught. The clocks started as a hobby.

When did you become the "Mad Clock Maker?"
I was already mad, so when I became a clock maker I automatically became a mad one. I'm also a mad gardener.

What are some of your inspirations?
Antique scientific and engineering instruments; *20,000 Leagues Under the Sea.*

Favorite pieces (of yours and others)?
I know it sounds corny to say that my current project is my favorite, but it is. That's because I'm really excited by the piece I'm working on and I can't wait to see how it turns out. (Everyone is different so I never know for sure when I start what it'll end up like.)

How did Steampunk come to your work?
I was working with that theme back in the '80s, but called them the "Jules Verne series."

Did it find you, or did you find it?
I've forgotten how I found out about Steampunk (I think various friends sent me links), but I was so delighted to have a handle for what I was doing, and to find out that many others were working with it as well. I like the Steampunk sense of whimsy and inventiveness, and I identify with the punk attitude of irreverence. I think it's a great place for the mildly eccentric.

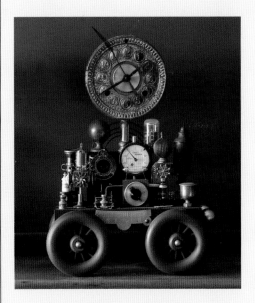

CLOCK ON WHEELS

Labeled simply Clock on Wheels by its maker Roger Wood, this wonderful clock and sculpture measures 15.5 in (39.4 cm) in height.

How do you select the objects that will eventually be included in your pieces?

When I start a new piece I just wander through any number of the boxes and drawers I store things in (there are over a thousand in all), picking out bits that might fit in the new piece. I end up with a messy pile.

Walk me through the process of creating a midsize clock sculpture?

I've got two ways of approaching a new idea. The first way is to work with a major object and add pieces to it or modify it a bit. The second way is to start off with a totally new idea or image, and then gather the necessary parts to finish it. So I sort through the messy pile of artifacts and try adding one bit at a time. If it feels right, then I glue it down quickly so it can't escape. If a new bit doesn't give me that instant good gut feeling, off to the reject pile it goes.

How do you see your work evolving with Steampunk, away from it or parallel to it?

Who knows for sure? I'm an artist first and foremost. But I guess I'll either be working with it, or parallel to it.

What kind of materials and styles are greasing your gears at the moment?

That depends on what I can find at antique flea markets and such. A lot of my inspiration comes from the artifacts that I find. Up here where I live there are just two seasons: winter and flea market. I always go for old brass; it has such a wonderful color.

Have you any closing thoughts on Steampunk design and decor to impart to us?

Let's hope that more people get into it, but I fear there's a danger it could be debased if it were to become too mainstream.

See also page 242 👉

WOOD'S WORKSHOP

Roger Wood's highly organized-looking workshop viewed from the west loft of his home, with all kinds of clock faces on display.

STEAMPUNK KITCHEN

The kitchen should be the heart of any home, but that wasn't so in Victorian times. They were usually small, hot, and unpleasant. What would a late-Victorian kitchen look like with modern conveniences but with period style? This is what Bruce Rosenbaum and his wife asked when remodeling the kitchen in their 1901 home in Sharon, Massachusetts. With a little bit of reimagination, and a lot of help from skilled artisans, they created the Steampunk House. Here's their story of the kitchen.

We didn't start out thinking that we were building a Steampunk kitchen—we just loved the idea of creating a space that was modern and romantic Victorian at the same time—and to make it practical and functional! It wasn't until we built it that friends were telling us we were "Steampunking." Steam what?! Now, the Steampunk community has told us that our retro-future kitchen is a showroom right out of a reimagined Steampunk 1876 Centennial Exposition. Included are Steampunked architectural salvage pieces, some period antiques, knife sharpener, toaster, optical devices, phone, printer's desk, and more. An antique wood cook stove is magically transformed into a modern electric appliance. A modern refrigerator and microwave are given a period look to blend into the overall aesthetic. People who view our kitchen always ask me: "Why aren't more people doing this?" I ask the same question.

A LIFESTYLE ENVIRONMENT

Unlike the Victorian kitchen, which was the exclusive territory of the women of the house or, in grander circumstances, the cooking staff, the modern kitchen is not solely used for cooking. It's a place for all to cook, eat, or socialize, reflecting their collective lifestyle, be it a Steampunk family or otherwise.

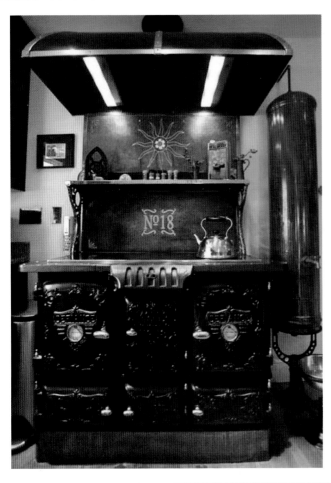

LIGHT UP A STOVE

A late 1800s Buck heating stove is restored with stained glass sidelights and a backlit window box to make it appear that light is coming in from the outside.

IMPRESSIVE ISLAND

An early 1900s printer's desk becomes a multipurpose kitchen island, its long drawers making perfect spaces for silverware and kitchen utensils.

HOME ON THE RANGE

J.L. Mott's Defiance #18 cast iron wood cooking stove from the 1890s has been modernized with an electric Miele glass cooktop and two new stainless steel ovens, complete with new heating elements and controls. Plus, a reproduction range hood has been fabricated to mirror the design of the original. Also, a copper hot water tank has been transformed into a water filtration system for the benefit of family members and the family dog, Zasha.

FURNITURE AND FITTINGS

Architecture can make a place feel cohesive, but it's the accessories we surround ourselves with that make where we live feel like a home. With Steampunk, you can choose from a variety of historic periods, or make your space an alternate reality by mashing genres or making your own pieces. Putting together disparate pieces not only works, but can be creative, elegant, and avant-garde.

FROM MAIN STREET

In the late 2000s the Steampunk "look" finally stepped out of the workshop and on to showrooms at places like Restoration Hardware, Pottery Barn, and Anthropologie. This was a major move away from modern glamor or even the disposable nature of shabby chic. While it may not have been sold as Steampunk, the influence was undeniable.

ONE OF A KIND: THE RISE OF ARTISAN, INC.

When the retro-futuristic aesthetic began to hit the runways, showrooms, and living rooms, it was the artists already working in the idiom that benefited. There is everything from large-scale items like appliances or desks made from salvaged parts, to gadgets and knick-knacks with an old-time feel. Via the aethernet, fairs, or conventions, people could buy custom-made pieces to add charm to their homes.

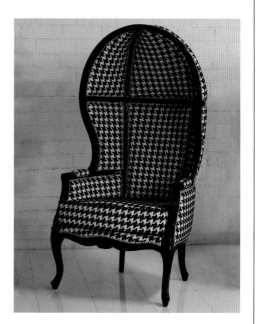

A CLASSIC REVISITED

A traditional take on a modern classic, this is a mid-20th-century balloon chair design combined with Queen Anne styling and a houndstooth fabric print, by RoomService of Los Angeles. See also page 242 👉

INDUSTRIAL ROMANCE

Restoration Hardware was known for 1920s-inspired furniture and accessories but changed its business model from classic retro to retro-futuristic in the mid-2000s, blending industrial with romantic and hitting on a niche that was emerging and ready to be received by the everyday person. See also page 242 👉

MECHANICAL TABLE

Andrew Chase is a furniture maker and mechanical sculptor who uses recycled auto and plumbing parts.
See also page 242 👉

COG WORK DESK

Three Rings is a games studio in San Francisco; the desk below is of their own design.
See also page 242 👉

SALVAGED DOOR PULL

A doorknob that was salvaged from the board of education in Chicago; verdigris gives a touch of age.

PLATE TABLE

Bob "Stig" Campbell uses redundant elements to address the global need to reuse existing materials.
See also page 242 👉

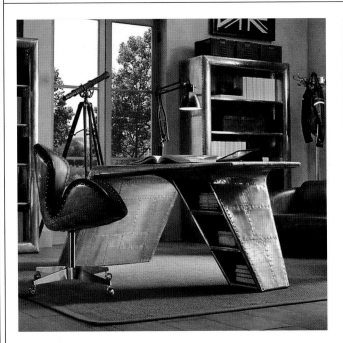

TATTOO CHAIR

This hand-tattooed leather upholstered skull chair made by Scott Campbell of Mama Tried Studios, New York, is a danse macabre with inked skin and dark scrolling cabriole.
See also page 242

AVIATOR DESK

The aviator desk above, which is available from Restoration Hardware, melds industrial chic with the beauty of aviation. The patchwork aluminum attracts people looking for durability, while the simple design appeals to those with an appreciation for the modern look.
See also page 242

KINETIC TABLE

Dale Mathis is inspired by Dali as much as H.G. Wells. This piece of glass and gears is kinetic as well as beautiful.
See also page 242

THE STEAMED GLASS STUDIO'S BOTANICAL TERRARIUM

Tim Witteveen, who works from his Steamed Glass Studio in Kalamazoo, Michigan, describes his intricate piece as a "well-designed terrarium to stir your imagination, and could transport you into a daydream. Look very closely, and you may see yourself as a child exploring the landscape within."
See also page 242

A TOUCH OF HISTORY

With design, the importance lies in tone, texture, and color. With Steampunk décor the difference seems to be in the touch. For example, the touch of time like a patina on metal or a chip on china. All of this plays into the whimsical aspect of Steampunk, and how the owner of a new piece will build on the history of an object into the story of their home. There is a sense that the history of the object (even a history that never was) is important—maybe even more so than the story the piece will tell in an interior design tableaux.

WALL TENTACLE

ArtAkimbo's tentacle with portal is as stunning as it is startling. Each is custom-made and comes in various sizes and colors.
See also page 242 👉

MARINE MINE

Estonian sculptor Mati Karmin gives these old Soviet mines a new life as chairs, wardrobes, tables, and chandeliers.
See also page 242 👉

ENGINEERED FAUCET

By Watermark Designs, their Brooklyn series gives a minimal industrial look to a Steampunk bathroom fixture.
See also page 242 👉

SOFT FURNISHINGS

Once you've chosen your blend of influences and selected your fittings and other accoutrements, it's time to think about what plush comforts will complement the polished mahogany and oxidized brass. But how do you tinker with a sofa or curtain? In a way, it is as much about the intent as the result. See how artists and designers have interpreted alternative historic home décor.

CREATURE COMFORTS

Where hardware gives the rugged element to the room, fabrics call on a civilized sophistication or tattered elegance, mixing the best of both and creating a balance in the room. Repurposing or upcycling period cloth into new items is one way to make a piece follow a theme. Mainstream design has given a nod to Steampunk through textiles, most notably prints of insects, sea creatures, or historic scientific, and nautical motifs. These types of patterns, done with contemporary colors or more modern effects, blend the past and the present seamlessly. Artists fuse old-time elegance with a bit of quirky wonder by integrating used materials or period images in clever ways.

DESIGNS ON A DIRIGIBLE

Pillowpillow from Chicago offers a variety of vintage-inspired print pillows. This one with cream and russet and dirigible pattern fits well in the sensibility of captains, scientists, and modern romantics, while the black-and-white print brings to mind etchings of the period.
See also page 242

APOTHECARY PILLOWS

Upcycled from period textiles and suggesting a Victorian physician's medicines, these hand-embroidered pillows are made by Allegra Hawksmoor in Wales. While magic and candle-light are a natural pairing, fire and vintage fabric are far from a bright idea. Please keep these and all soft furnishings away from open flames.
See also page 242

VELVET DRAPES

Victorian drapery brings to mind the heavy and ornate. This example from Anthropologie is in velvet with a ruched edging. See also page 242

CONVERSATION PIECE

This House of Hackney chair with a colorful sea creature print is an example of boutique and design houses reimagining Victorian furnishings with a modern color palette, whereby a piece goes from being retro-futuristic to fashionably forward. See also page 242

OCTOPUS SHOWER CURTAIN

Squids and octopi are a major theme in Steampunk décor. A lovely example of the engraving style in Victorian text books, by Thomas Paul. See also page 242

SOFT ETCHINGS

Utilitarian Franchise's collage of a Doctor Walrus hand silk-screened on canvas. Inspired by Victorian natural history etchings and handmade. See also page 242

PERIOD PILLOW

This pillow has been made from scanned period photos, layering with software and printing on fabric.

LIGHTING

Besides the gear and cog, there's hardly a more iconic symbol of the Steampunk aesthetic and its ideals than the lightbulb. The long-fought intellectual battle over whether Tesla or Edison was the greater contributor to its development may rage forevermore, but this ubiquitous emblem of innovation is as rich an inspiration for artists and designers as it ever was.

MODERN MAGIC

Lighting as fun and functional sculpture has been a thriving art form for the past few years. Those looking to decorate their home with unique, hand-made, repurposed art pieces with a purpose have a staggering amount of choices as well as much inspiration for their own projects. Recycled, refurbished, restored and reimagined, with gears and gauges, rust and lacquer, both artists and the amateur create lamps of all kinds to illuminate us in a dazzling variety of ways. How we light our spaces truly influences how we see each other, and the warm, amber light of so many of these pieces—in contrast to the mass-manufactured, harsh fluorescent in the outside world—introduce a cozy, welcoming, yet essentially eccentric energy to our homes and important spaces. With their glass bulbs, wires, and filaments, they look like a true product of modern magic.

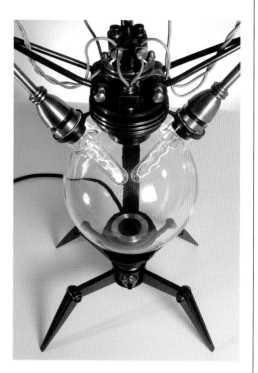

INCANDESCENT ART

Frank Buchwald leads a Berlin-based design firm that combines contemporary and traditional techniques to make custom lighting. Incandescent and refined, these pieces feel inspired by Friz Lang's Metropolis *and Tesla's workshop.*
See also page 242 🖘

NUCLEAR INSPIRATION

Bill Gould's "Nuke" lamp reflects the 20th-century world of atomic reactors and nuclear fission.
See also page 244 🖘

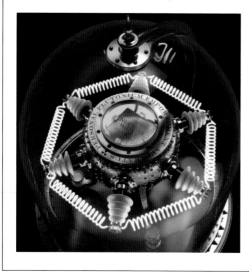

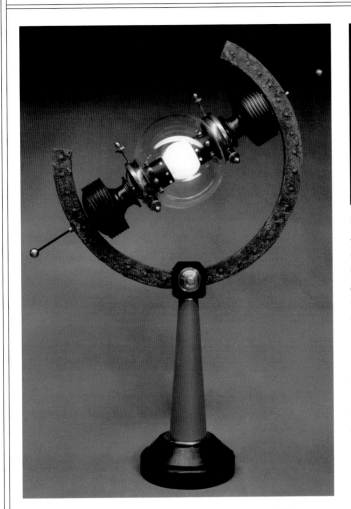

SPARKLING CHANDELIER

Adam Wallacavage's chandeliers are imaginative, sumptuous, and infused with the glamor and wonder of the ocean's depths.
See also page 243

BRILLIANT GEAR

Known for his Diabolical Boxes, Chris Osborne meshes verdigris luminosity with gears and discarded parts to make wondrous light pieces appealing to both industrial and more romantic tastes.
See also page 243

ARK LIGHT

One of Art Donovan's signature pieces made of glass, maple, and mahogany, with a distressed rust effect reminiscent of an astronomer's astrolabe.
See also page 243

HANDY SCONCE

Le Main consists of an aged wood hand with French rubbed steel hardware, created by McLain Wiesand.
See also page 243

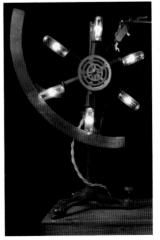

WALLCOVERINGS, MIRRORS, AND PRINTS

It's hard to imagine a Victorian parlor without the ornately patterned walls filled with tea roses, filigree, and fleur-de-lis; however period or historically accurate wall coverings might not be the right choice. When working with this style the focus is less on recreating what was traditional in the era and more working with what was unusual, quirky, or otherwise forward-thinking.

WHAT IF?

Beyond the Steampunk conceit of living in the Victorian future, it's interesting to think about what design, décor, and style would be like if other art movements had taken hold—or how they would mesh with modern technology, or how beauty and design would exist in a post-societal world. What would industrialist Art Deco look like or a Pre-Raphaelite Bauhaus? Mixing eras, movements, and materials in a thoughtful and intentional way will spark the imagination as well and appeal to the senses. In the words of the mid-20th-century communications guru Marshall McLuhan, the medium is the message. Decorating our spaces with maps, educational charts, or the tools of great innovators reminds us of where we've been and where we could go—and the wealth of possibilities that open up to us when we care to ask "what if?"

MARITIME PRINT
This vintage ichthyological chart reminds us of the bizarre wonders of the briny depths.

REFLECT ON YOUR GEAR
This porthole-style mirror is decorated with gears and burnished brass, designed and made by Matchsticks and flames.
See also page 243 🖝

A CASE FOR PAPER

At home with the baggage of the past—wallpaper resembling a stack of vintage leather suitcases, by Andrew Martin.
See also page 243

FLIGHTS OF FANCY

Part of their line in "traditional British homewares for a new generation," House of Hackney produces this bird-adorned retro wallpaper.
See also page 243

OUT OF THE ALBUM

Designed by Vanessa Barneby and Alice Gates, "This Other Eden" wallpaper features vintage sepia photos with a gold finish.
See also page 243

RIVET WALLPAPER

Among natural wall coverings including Japanese Paper, Gold Leaf, Hemps, Silks and Linens, Phillip Jeffries' Rivet line is both eco-friendly and elegant.
See also page 243

DISPLAYS AND CABINETS OF CURIOSITIES

Cabinets of curiosities (or Wunderkammers) were 17th-century collections of relics and antiques that were the precursor to the modern museum. Tabletop displays certainly evolved from these "art cabinets" as well from the collections of treasured items that would be found on a lady's dressing table. Most notable about the cabinets was the gathering of specimens, anomalies, and other items.

TABLETOP AND MANTEL DISPLAYS

Often built by physicians and scientists, these collections laid the groundwork for disciplines such as natural history, geology, and zoology. As the original German name (Wunderkammer) suggests, the cabinets were intended to inspire wonder of the natural world, curiosity to learn more about the mysteries around us. They also served to blend the beautiful and the bizarre, the natural and the unnatural, in a way that will engage the eye as well as the intellect. Traditionally a Victorian lady may have letters and a lock of hair at her table. But since it's a Steampunk-inspired tabletop, this scene will have a twist. Think of a lady adventurer and what she might have had: tinctures, seashells, insects, and field notes. Things that are strange and unusual are featured, since telling the story is key to the appeal of the arrangement of objects.

SHOWTIME
A collection of curious objects that would stir and intrigue any gentleman, seen here on display at the Edwardian Ball, a yearly event inspired by the writer Edward Gorey and held in San Francisco.

PHRENOLOGY HEADS
The heads were part of the Victorian "science" of linking a person's character to the shape of their skull. These are in the collection at Viktor Wynd's Little Shop of Horrors in London, pictured here with some 20th-century robots.

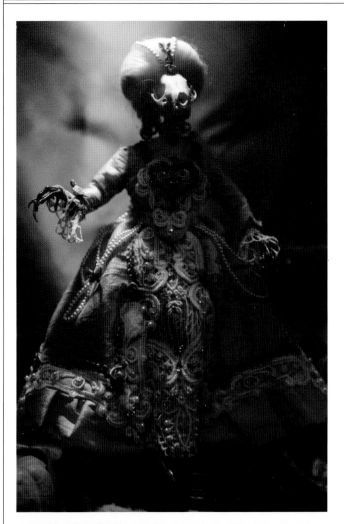

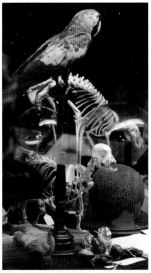

BELL JARS AND PERCHES

Cloche or bell jars and wooden stands are used to show natural history relics: here we see animal skeletons and a stuffed parrot.

―――――◆―――――

DANSE MACABRE

A bizarre display, a variation on the traditional "dance of death." A tableau of figures dressed for the ball, which are, on a closer inspection, animal skeletons.

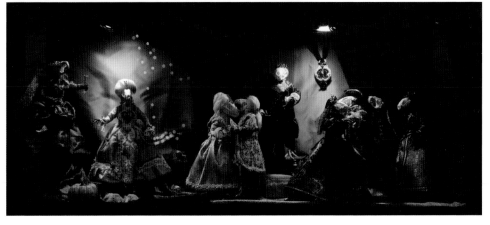

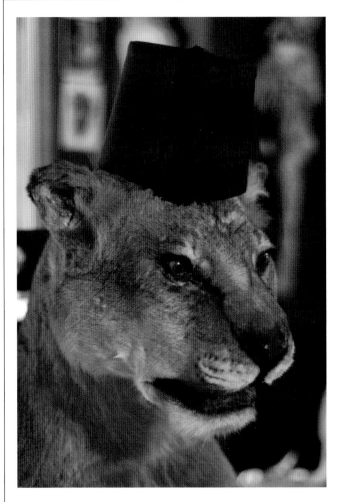

FAIRY RELICS

A desiccated fairy sample which is drawing inspiration from the Cottingley Fairies, of which two young cousins in Yorkshire, England, claimed they had taken genuine photographs in 1917, attracting the attention of Sir Arthur Conan Doyle.

OUT OF AFRICA

An intrepid explorer's souvenirs, from souk to safari, with an Egyptian fez perched on the head of a stuffed lion.

DEATH MASKS

In Victorian times, casts were often made of the head of the deceased to preserve their likeness for the future. This death mask of Napoleon is in London's Little Shop of Horrors.
See also page 243 ☞

TWO-HEADED TEDDY

A macabre twist on a classic cuddly toy from Viktor Wynd's Little Shop of Horrors.
See also page 243 ☞

SHRUNKEN HEAD

This unfortunate Steampunk had obviously fallen afoul of a head-hunting witch doctor, who not only shrunk his head but also his topper and goggles.

⸺◆⸺

GEKKO

A preserved lizard is fitted with an ingenious mechanism which mimics real life, and the sound trumpet allows the audience to hear as well as see.

COLLECTOR'S CORNER

The death mask is a pre-photographic technology used to identify the unknown deceased and by physiognomists and phrenologists with little success in either field. Strange and wonderful, serene but stirring, these pieces bring to mind the mortality of the flesh, the permanence of some objects, and the perpetuity of beauty and spirit. Now very much out of fashion, in their time they fulfilled a similar role to that of celebrity photography today. Another period curiosity is taxidermy. A popular décor element for the Victorians, as we moved into in the modern age people began to get squeamish about displaying mounted stuffed animals around the house. But if it is eclectic and authentic enough, someone will revive it. Many are drawn to these pieces as a stark reminder of nature's beauty. *See also pages 146–149* 👉

GEAR

So, you've done your homework, you've read the classic works of fiction, both the old (Jules Verne, H.G. Wells, George Griffith) and the new (Phil Foglio, William Gibson, Neal Stephenson). You've seen this world and created your own. Now you want to live in it, if only for a little while. They say that the clothing makes the gentleman (or lady), but gear, gadgets, and gizmos are what separate Steampunk from Victorian-inspired fancy dress. Whether you're wearing it, riding it, living in it, or taking a bath in it, the gear should have a story and the story should fit the character that you've created. In your Steampunk world, how do people get around? How do they communicate and how do they send messages? If your particular alternate reality is a post-apocalyptic world, then how do people therein protect themselves from the elements (and from each other)? If you and your gear don't have a story, then you're just another person in fancy dress. Along with the clever creations you'll find in the "Science and Manufacturing" chapter of this book, we ask you to consider the following … Read on and marvel at these amazing wonders of science!

TRANSPORTATION

Since it is very doubtful that any adventures are going to appear in your hometown, at some point you're going to have to get out and about in the Steampunk world. You could take a bus or perhaps a standard train, but where's the adventure in that? A lady or gentleman does not just want to get from here to there. One has to travel (and, hopefully, arrive still relatively intact) in style and, if it's at all possible, with decent tea service. The latest big advances in the transportation sciences promise to get you there much more quickly, in greater luxury, and with only a small chance of any failure. Imagine the look on your old college chums' faces when they arrive bedraggled from the arduous journey by bus across the moors, and having had no tea whatsoever, and you float down gracefully in your luxury airship or hot-air balloon, nibbling a cookie and wiping the very last tantalizing drops of Earl Grey from your lips.

EXHIBITION BANNER

A poster featuring the "Steam Man," Neverwas Haul, and several fictional pieces exhibited at "Steampunk: History Beyond Imagination" in Anaheim, CA. This style of banner was popular for theaters, circuses, parades, and traveling sideshows.

TECHNOLOGICAL MARVELS

The time of progress is on hand! This is an age of technological advances, possibly rivaling those of the late 20th to the early 21st century. The innovation of the telegraph has reduced personal communication time across the Atlantic from several weeks to near instantaneous. Her Majesty's Orbital Heliograph Stations now ensure that we can communicate with anyone on the planet in a matter of minutes. The might of the railroad made traveling across the continental United States take from several months to just a matter of days. Now, with our new rocket packs, the length of the journey has gone to a mere fourteen hours. This is truly an age of wonders. Modern airships, ornithoptic backpacks, submersible carriages, and portable clockwork calculating engines are the way forward!

WHIRLYGIG EMOTO

Detail of Tom Sepe's Steampunk bicycle, Whirlygig Emoto, made from "found objects," junkyard parts, and homemade motorcycle parts.
See also page 243 👉

IN FLIGHT

Traversing the surface of the planet is rarely a civilized way for one to get around. You know what's on roads? Horses. You know what horses do? Exactly. Hardly a pleasantry. Show that you are truly above it all and cover those vast, unpleasant, and usually smelly distances in one of the latest of aerial conveyances that modern science has to offer.

AIRSHIP WONDERS

Some well-meaning but deluded folks look upon airships with fear and trepidation, but these misapprehensions are completely unfounded. Look at the advances that our friends the Prussians have recently made in airship development! Prussia's aeronavy has promised that these peaceful flying behemoths will make this world a smaller but friendlier place, and I see no reason to doubt them.

IN THE TAILWIND OF MONTGOLFIER

Hot-air balloons are wonderful as long as you have no interest in where you're going to end up. For those leading a life of leisure, going literally wherever the wind blows you, these devices are the perfect way to travel. An excellent place to propose to that reluctant young lady or gentleman, who could say no at 2,500 feet above ground?
See also page 24 *See also page 24*

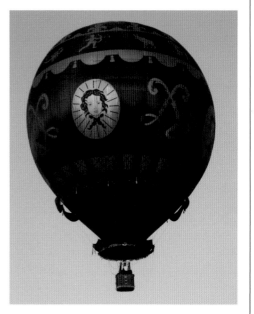

MONTGOLFIER'S COLORS

Decorated in the style of the Montgolfier brothers' balloon, this hot-air wonder features a blue background covered in gold figures of the zodiac, fleurs-de-lis, and the face of The Sun King, Louis XIV, along with the royal monogram.

LES FOUS VOLANTS

The French performance troupe was created in 2007 by the Compagnie Remue Ménage, a group of juggling stilt walkers. These flying madmen and women, equipped with their weird and wonderful machines, brave all dangers on their dedicated quest to discover the end of the world.
See also page 243

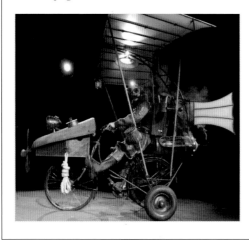

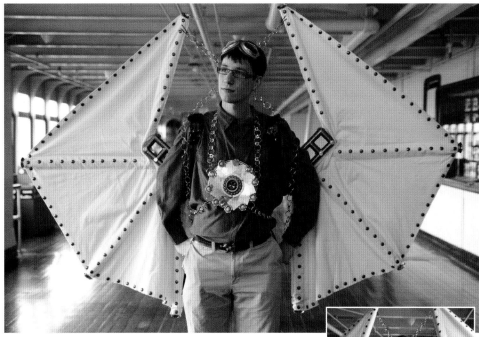

HOMAGE TO AMELIA

Although Amelia Earhart did not take to the skies until 1921, many Steampunk enthusiasts find inspiration in Earhart, the first woman to fly solo across the Atlantic Ocean.

ORNITHOPTIC WINGS

An attendee of Her Royal Majesty's Steampunk Symposium on board the Queen Mary steamship shows off his folding ornithopter wings, reminiscent of Leonardo Da Vinci's design. The opening of the set of wings always draws an approving crowd.

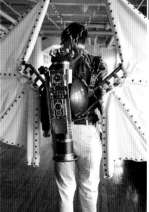

HER MAJESTY'S AIRSHIP LORD VLADEK

A LEGO antagonist figure from the Knight's Kingdom II series lends his name to this Steampunk airship made out of LEGO pieces. Interested parties can find further information on Steampunk LEGO constructions by sourcing "The Empire of Steam" blogspot.

See also page 243

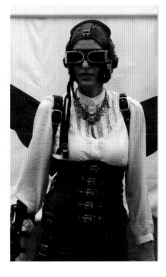

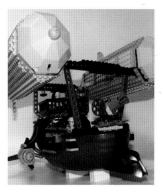

WHEELED TRANSPORTATION

Occasionally you cannot find an airship headed to your desired location, or perhaps the winds are not blowing in the right direction. At these times, one is occasionally forced to travel by land. However, ground transportation needn't be completely boring and mundane. Just take a look at these fine examples of modern terrestrial transport.

STEAM TRAINS

I'm sure that at one time when you've been in a bar, trying to enjoy your drink in peace, some sad old character will have gone on about how, back in 1804, Richard Trevithick managed to make the first full-scale, fully operational steam locomotive travel the tramway from Penydarren iron works to Merthyr Tydfil and tried to convince you that those were "the good old days" even when fit only for moving rock and ore. After a few fits and starts, with trains crawling around hither and yon, we've managed to achieve almost civilised land travel. Some of the more advanced of these lumbering iron chariots have managed to reach blistering speeds, and without anyone yet having the air literally sucked out of their lungs (as was once thought to occur at the speeds over 35 mph/56 kph).

TIME FOR A LOCOMOTIVE

In the movie Back to the Future, Part III, *Marty McFly travels back to the year 1885, where he and Dr. Emmet Brown use a steam locomotive and the technology of the time to send their DeLorean back to the future.*

THE NEW MOTORIST

If a locomotive is not smelly and dangerous enough for you, perhaps you should give road motoring a go. One of the few advantages of owning a motorcar is that you don't have to wait in line every time you want to go somewhere. So if your lust for adventure outweighs your desire for continued survival, I highly recommend these contraptions. I hear that seven out of every eight actually manage to make it to their destination without exploding! Will wonders never cease?!

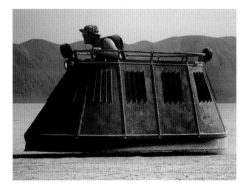

JL421 BADONKADONK LAND CRUISER

Made for the 2002 Burning Man by NAO Design, the "Donk" is an imitation four-seater hovercraft that looks both malevolent and battle-ready.
See also page 243 👉

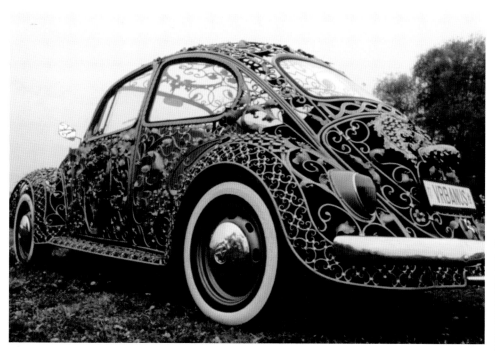

HANDSOME BUG

Zeljko Vrbanus celebrated 25 years of forging experience by building this Volkswagen Beetle in 2500 hours. With a wrought iron body and high baroque filigree, gilt with 24 karat gold, it was designed to be recognized as a Croatian product. Steampunk? I'm not sure, but it is really cool.
See also page 243

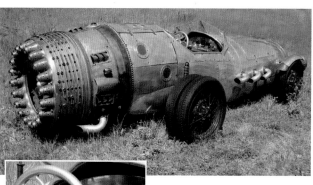

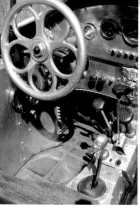

BARON MARGO'S
ROCKET CAR

Disillusioned by the futuristic, largely unobtainable concept cars of the Detroit auto shows, Los Angeles–based metalworker Baron Margo decided to create his own range of rockets, trains, creatures, and automobiles that appear to have come from a parallel universe.
See also page 243

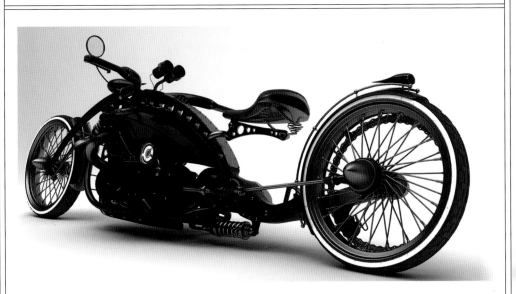

A SERIOUSLY CLUED-UP MOTORCYCLE

The Black Widow is a street-legal motorcycle based on the character Steampunk Holmes by Richard Monson-Haefel, and designed by Mikky Solifague in collaboration with the Putsch Racing restoration company.
See also page 243 👉

VERTICAL VELOCIPEDE

A Steampunk-style segway, made of found materials and featured on instructables.com.
See also page 243 👉

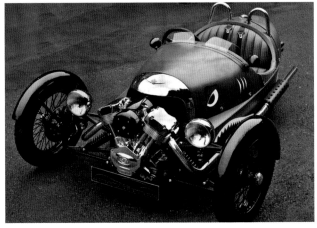

MORGAN THREE-WHEELER

A Morgan three-wheeler, based on the original late-Edwardian 1910 design by Harry Morgan— one of the most successful cars in the early days of motoring.
See also page 243 👉

ON TWO OR THREE WHEELS

The riders of these vehicles have thrown caution to the wind, along with a wheel or two. They claim that what they lack in protection, they make up for in maneuverability. Back in the 1860s, attempts were made at steam-powered velocipedes. Recent breakthroughs have allowed these under-engineered monstrosities to achieve some hitherto unknown, yet absolutely skull-crushing speeds, guaranteed to satisfy even the most foolhardy of adventurers.

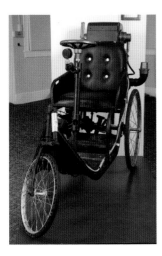

THE MANUCYCLE

This piece by John Harrington is made of an antique invalid chair, steel, and wood. The manucycle actually works if the rider pumps and steers it.
See also page 243

See also page 243

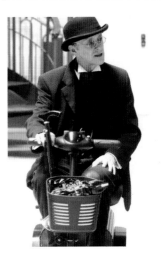

AN INDIVIDUAL WHEELED CHARIOT

A customized mobility vehicle with a pannier—the perfect place to stow a ray gun!

PENNY-FARTHING

Major Tinker on a cycle of his own design. The name comes from the British penny and farthing coins, one much larger than the other, so the side view resembles a penny leading a farthing. The penny-farthings were the first velocipedes to be dubbed "bicycles." It became a popular successor to the bone-shaker, until the invention of the safety bicycle.

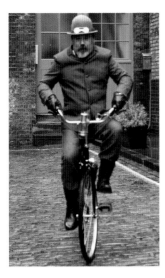

TOM SEPE

TINKERER AND MASTER OF MANY ARTS, FROM CIRCUS TO DIGITAL

Tom majored in science and performing arts and works as a multidisciplinary artist in California. He was part of the artist collective Five Ton Crane, who built the Steampunk Treehouse for the Burning Man festival in 2007. His skills range from stilt-walking to sculpture, filmmaking to working as a chef. He would like to time travel to the early 1800s, the Age of Wonder, when modern science was born, Herschel invented the telescope, and hot-air balloons first took to the sky.

addition, re-purposing old things revives a culture of not being wasteful. It highlights that these objects are still with us, just waiting for people to breathe life and love back into them. But let's not be too nostalgic! Computers, electricity, and other inventions are just too handy to discard outright.

How did you come to be aware of the Steampunk movement and when?
The Steampunk Treehouse was probably my first formal introduction. Previously I had been working in a stilt-walking and fire performance troupe, APSARA, and we were already exploring the nouveau circus aesthetic, blending Victorian-era styling with modern technology and neo-tribal flair. I even built a small rotating platform with gears, and one of us had an Automaton-inspired costume, but at the time I had no idea that Steampunk was about to rise out of literary obscurity and flirt with mainstream culture.

Do you consider yourself to be a Steampunk?
My interests are too broad to fit into one category. What I love about Steampunk is the warmth, function, and whimsy, and also the "Do It Yourself" aspect. I see it as part of a larger DIY movement sweeping the globe, aided by social networking and as a response to manufacturing outsourced overseas. We're fed up with cheap plastic stuff and want to be surrounded by beauty. It's vital to be able to shape our world, and Steampunk offers a sexy, fun way for people to do it. In

Which science fiction authors do you find particularly inspiring and why?
I've been particularly impressed with the Isaac Asimov *Foundation Series*. The premise, that the Galactic Empire is heading for collapse, and these psychohistorians, using social mathematics, have figured out that the 30,000 years of chaos after the collapse can be shortened by taking a certain plan of action, seems to resonate with our current plight on planet Earth.

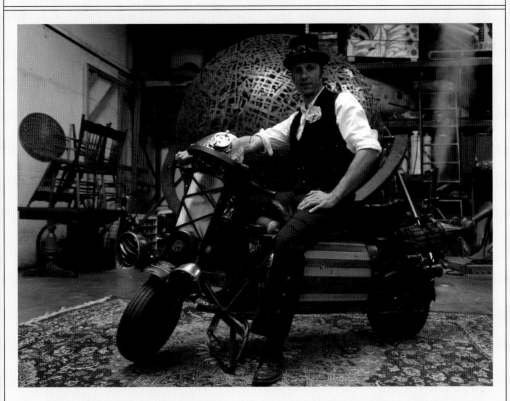

THE "WHIRLYGIG EMOTO"

A steam-electric hybrid motorcycle built in August 2007. The sphere behind it is a kinetic sculpture by Tom's studiomate Michael Christian, which Tom helped build in 2010. Tom's outfit was designed by Steam Trunk Couture.

What is the bike made from?

It began as a gasoline-powered 1960s off-road mini-bike called a Tote-Goat. In 2006 I stretched the frame 13 inches (to hold a passenger!), tore out the engine and gas tank, and added an electric propulsion system. It took a month of tinkering: digging at salvage yards, modifying motorcycle parts, upgrading the electrics, and integrating the steam system. There's a bundt pan and a Jell-O mold, lots of wood, steel, copper, and brass. The tail-pipe/flue is off a metal vase I found at an arts and crafts store. Although it's made of cheap metal, it was the perfect size and shape, and I was running out of time to finish the bike.

How does the steam feature work?

I never intended for the bike to have a real steam boiler; however, after consulting with some friends at Kinetic Steam Works in Oakland, CA, I came to realize that I could actually build one myself. I started with a metal fire-extinguisher tank, a very good pressure vessel. I cut a hole in the bottom and then welded a tube straight through it in order to carry the flame. I also welded some additional fittings, for a safety pressure relief valve, and an outlet for the steam. The fire is generated by a propane torch bought in a regular store. The boiler can produce 100psi before the safety valve opens, and I've pressure-tested the tank to 200psi. I've tried out different steam whistles … I still haven't gotten the exact right one, so I will probably end up building one myself. The only thing missing now is that I want to add an actual "whirlygig" (which looks like a spinning pinwheel) on the dashboard. It was part of my original concept drawing … I guess there will probably always be something left undone!

A REPORT FROM OUR SUBMARINERS

Some large percentage (a number that I've completely forgotten) of our planet is covered with water. Personally, I don't think there's anything evenly remotely interesting down there, but some supposedly clever chaps insist on finding out for themselves. We must keep the Navy busy doing something, if nothing else but keeping the waterways clear and the tea flowing.

NAUTILUS

The book *20,000 Leagues Under the Sea* (or Seas, by the literal French translation) is technically classified as "Victorian science fiction," not Steampunk, as it was the contemporary fiction of its era (in this case, 1870). The titular "20,000 leagues" refer not to the depth of their descent below the surface of the waves, but rather to the distance of their journey, the Nautilus never diving any deeper than four leagues under the surface. The "Seas" refer to the seven seas through which the Nautilus travels. The Nautilus from the Disney adaptation is one of the most iconic pieces of 20th-century science fiction imagery, and a key influence of the Steampunk aesthetic. It was so influential that the first nuclear submarine was named after it. Disney's Nautilus was designed by Harper Goff, also the art director of *Willy Wonka and the Chocolate Factory* (1971) and one of the primary designers of Disneyland.

See also page 181 👈

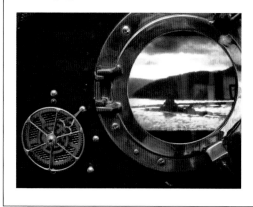

THE NAUTILUS ONE-MAN BAND
Arthur van Poppel's arsenal of wheels, handles, chains, gears, and complicated transmissions operates without an external power supply,

❖

NAUTILUS VIEWER
This Nautilus-themed case by Will Rockwell houses a brass porthole and digital picture frame, which plays a video tribute to the Nautilus.
See also page 243 👈

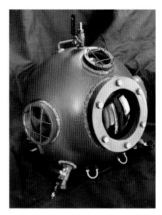

DIVING HELMET

The diving helmet invented by Augustus Siebe in 1837 is still used as a prototype for modern hard-hat helmets. This replica of a traditional helmet was made lighter in weight, for a costume at The Asylum 2010.

CAPTAIN NEMO

A costume competition entrant in a Nemo-inspired outfit. Nemo features prominently in the best-selling graphic novel (and the 2003 film) The League of Extraordinary Gentlemen.

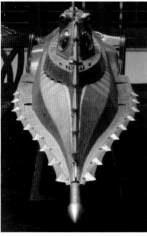

NAVIGATING THE DEPTHS

Bob Martin's 1/32 scale radio-controlled replica Nautilus from Disney's epic 20,000 Leagues Under the Sea.
See also page 243 ☞

CAPTAIN NEMO #3

Nemo Gould's piece made from a clock cabinet, vacuum tubes, and other objects, pays homage to Nemo's foe, the Giant Squid. See also page 243 ☞

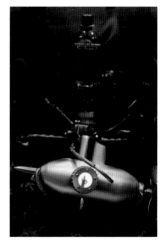

VISIONARY TINKERERS

Discover how ingenious computer-modifiers solder contemporary technology with Victorian craftsmanship to create exquisite Steampunk computers and associated equipment, each one a work of retro-futurist art. Engineer your vision back to an age when Ada Lovelace, Babbage's "Enchantress of Numbers," devised what is now recognized as the first computer program, and amateur tinkerers could arrive at world-changing inventions such as the telephone or the television.

COMPUTATIONAL ENGINES

Indirect descendants of Charles Babbage's Differential Engine are reunited with the aesthetic of his era. Monitors, keyboards, and mice are all transformed here into neo-Victorian creations that are still fully functional in the 21st century. For brave tinkerers information and advice on adapting engines can be easily found on the aethernet— but it's at your own risk!

THE NEW SECRETARIAL TABLET

Taking inspiration from early aviation, gothic cathedrals, and our industrial past, Datamancer crafts custom-made working keyboards that incorporate an emporium of elements, from vintage Scrabble tiles to old aluminum gears.
See also page 243 🖝

MUSIC BOX ENGINE
Designed by Datamancer to look like a Victorian music box, this finely crafted case harbors an HP ZT100 on the inside. To start up the machine, merely turn the key.
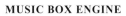

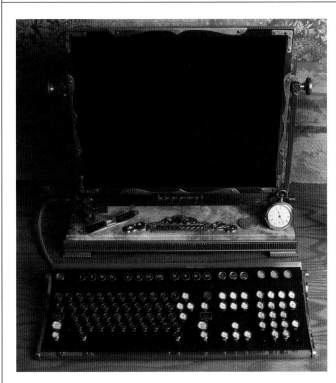

A TYPICAL KEYBOARD
Jake von Slatt modified an IBM Model M "Clicky" keyboard into a retro design.
See also page 244

STEAM MOUSE
Jake Hildenbrandt's Bug; the solid brass, glowing LEDs, and leaf switch buttons provide an old-fashioned, mechanical feel.
See also page 243

THE ALL-IN-ONE VICTORIAN PC

Jake von Slatt, proprietor of The Steampunk Workshop, bought a 24 in (61 cm) flat-panel monitor from an office supply store and made an ebony-lacquered and brass shell around it to contain the motherboard, disk drives, and other components of a regular PC. The screen is theatrically framed with a salvaged knick-knack rack, decorated with rivets, angle iron pieces, and some floral scrollwork. Keys from a 1955 Royal Portable typewriter are employed in the fully functional keyboard.

ALL-IN-ONE MONITOR
Jake von Slatt modified a 24 in (61 cm) monitor and framed it with an accurate scale model of a Victorian theater stage.
See also page 244

TREASURED LAPTOP
A beaten copper and steel casing resembles a jewelry box or medieval book binding.

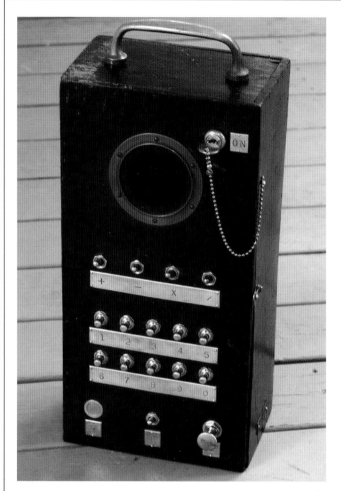

A MOST MODERN ADDING MACHINE

Dating from 2009, the Aaron Adding Machine no.10 features push buttons for the numbers and toggle switches for other functions. Cased in wood, with brass framing the LED display, it is a key addition to your desk. See also page 244 *page 244* 👈

AT THE TURN OF A KEY

The Aaron Adding Machine no. 3, shown left, is key-operated for additional security. The handle makes for portability.

A POCKET CALCULATOR

A convenient little calculator, the Aaron Adding Machine no.4 is cased in oak and fitted out in brass and base metal.

THE LATEST ADVANCES IN ABACI

Captains of industry, satanic mill owners, and social media high rollers can avail themselves of the latest technology to count their dollars faster—at a price. Andy Aaron turns out only a few of his magnificent Aaron Adding Machines a year.

TELEPHONIC DEVICES

It used to be that if someone wanted to pay you a call, they would come to your house and you could ignore them when they knocked on the door. Nowadays, you have to answer the telephone just to stop that confounded ringing. These newfangled portable ones are even worse (I didn't know they made wires that long)! As you're careening down the road in a rickety steam carriage, you may now be able to call for help after flying clean through the main street saloon and into a ditch.

ROTARY SMARTPHONE

A blend of mechanical and digital technology, this Rotary Mechanical Smartphone by Richard Clarkson features two interchangeable brass dials (button and rotary), reminiscent of interchangeable camera lenses.

See also page 244

PUNCH CARD RPG CELL PHONE

Designed by Arthur Schmitt, Marek Bereza, and Andy Broomfield, this phone has no keyboard or screen—only a rotary dial. Contacts are stored in binary code on business card-sized punch cards, inserted into the phone to make calls. The concept reflects users' frustration with bloated interfaces and a desire to be more in touch with the hardware.

See also page 244

THE REDMER WERK-STATT HANDY

A working modified Sagem X-5m cell phone with handmade wooden case and antique brass buttons by J. Redmer.

See also page 244

EDISON CALLING

The Edi-mobile Patented Portable Talking Box is a cell phone in the style of Thomas Edison, by Gould Studios.

See also page 244

A VISIONARY DEVICE

This antique camera houses a functional webcam, set up as part of a unique computer station designed by Bruce Rosenbaum. The entire workstation can be seen in the "Furnishings" chapter in more detail.

See also page 89

ELECTRO ICONOGRAPH

Herr Döktor designed a cover for his digital camera in order to disguise even the least evidence of modern electronics on his person.

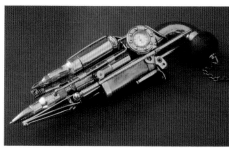

THE MULTIFUNCTIONAL METAPEN

Ivan Mavroviz's Metapen is flatware, lighter, USB stick, watch, lamp, screwdriver, pipe, tooth-brush, shaving blade, nail clipper, etc., all in one.
See also page 244

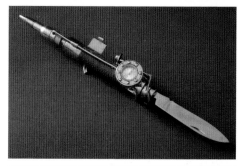

THE AETHERIC ACCUMULATOR

This "portable information cabinet" by John Bannister is actually a memory stick.

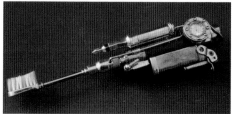

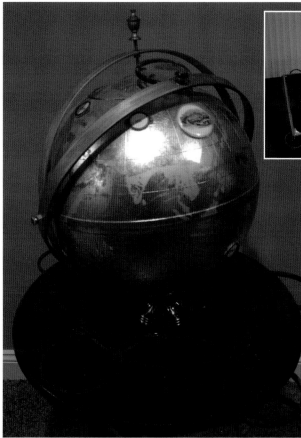

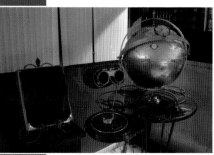

A WORLD-BEATING ELECTRONIC ATLAS

A splendid globe covered in hand-applied brass leaf is combined with modified found objects, utilizing passive radio-frequency identification (RFID) tags and reader in order to remote control Google Earth on a modified tablet computer, designed by John Knight.
See also page 244

PHOTOGRAPHIC IMPLEMENTS

Remember those people that you were hoping to forget? Or perhaps that expression on your face upon hearing of your friend's hideous exploits into the agricultural sciences that you were hoping no one would ever see? Well, give up all hope of doing that because there's always somebody with one of these noisy little contraptions.

TAILOR MADE

Becky Stern salvaged this fine Kenmore brand vintage sewing machine from a charity shop and transformed it with some pieces of brass. The propellers are connected to spin with the movement of the drive wheel.
See also page 244

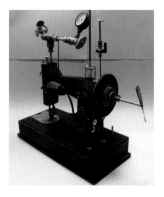

FABRICATORS & FACILITATORS

It seems that there's no end to the perverse tinkerings of modern science. Any item can be given more functions than you'll ever care to use. I'm not sure what I'm going to do with a pen that's cleverer than I am, but some of these devices might be quite useful. However, until they invent scones that butter themselves, I'm not going to be very impressed. If you are inspired by the ingenious products here and want to fabricate something yourself, the secrets of some of these devils can be found in *Make* magazine, *Craftster*, *Instructables*, and other aethernet sites.

PROTECTIVE HELMETS

Lack of protective headgear should be seen as an intelligence test: people who don't wear it often get exactly what they deserve. Toxic fumes, eye-irritants, large things bouncing off the old cranium are all unpleasant yet preventable nuisances that can be avoided with the proper equipment. Filters and breathing tubes protect time travelers against plague or viruses, noxious fumes, and alien atmospheres.

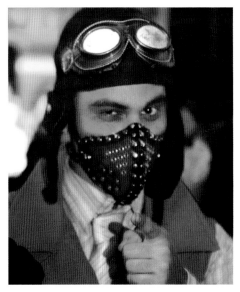

LEATHER ALTITUDE MASK

Inspired by the ideas of early flight, protective leather masks, like this one made by Thomas Willeford of Brute Force Studios, are staples of Steampunk costuming.
See also page 244

TAKE CARE TO GOGGLE

Affording protection to the eye area is a given. Helmets usefully have built-in eye cover, but those wearing a protective mask such as the one shown above will need additional equipment. Whether you are a dashing airship pirate (or "privateer," if you wish to feign an air of legitimacy), skyway-man (not to be confused with the more mundane "highwayman"), or simply the maddest of scientists, nothing screams "STEAMPUNK" quite as loudly as a good pair of genuine brass goggles. Why goggles? They imply adventure. If you're a mad scientist, you need them for your experiments. If you're a daring airship pirate or captain, you need them so you can see everything, as you fall all the way down. Certainly, you could buy some cheap plastic goggles and paint them up, but then you would actually have to be seen wearing them. *See also pages 58–59*

RHINO MASK

Some masks can be more ornate, like this RHINO (Respiratory Hindrance of the Inhalation of Noxious Odors) Steampunk Gas Mask by Tom Banwell.
See also page 244

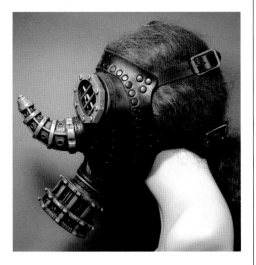

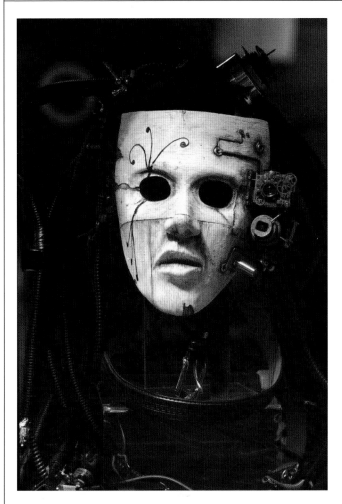

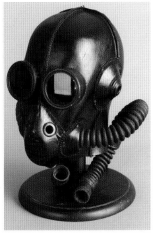

CAOUTCHOUC HELMET

This rubber gas mask by Bob Basset blurs the line between Steampunk and fetish. Rubber also acts as insulation from the discharge of static electricity. See also page 244 👈

HEADGEAR FOR THE UNDERWORLD

This leather, brass, and copper construction by Bob Basset hints at the design of diving helmets. See also page 244 👈

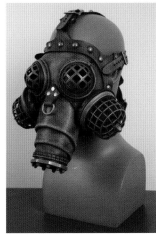

CYBER SCULPTURE

Major Thadeus Tinker's work is reminiscent of a Greek theater mask. It was exhibited at the Kew Steam Museum.

TAURUSCAT DREAM HELMET

The mask shown left is by Tom Banwell, creator of the RHINO mask opposite, and was on show at Muzeo, Anaheim, CA. It is made out of leather and resin. See also page 244 👈

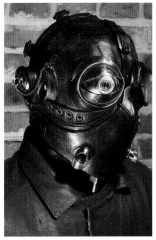

ROCKET PACKS

Why walk when you can fly? Jet packs, rocket packs, and other such devices are ideal for performing mid-flight airship boarding actions and for those days when perambulation does not quite cut it. Reaction-based flying machines usually contain an expansion chamber where a gas is thrust out one end, propeling the wearer forward at an unfortunate velocity.

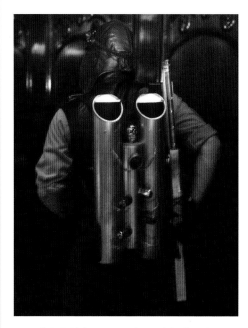

LINE-STREAMING IN THE BALLROOM

An unknown attendee at the Edwardian Ball is wearing a very streamlined jet pack, taking into account the modern idea of aerodynamics. William Gibson and Bruce Sterling coined the term "line-streaming" to describe this effect in their novel The Difference Engine.

ROCKET IN A BOX

A rocket pack is constructed from an adapted cycle storage box and decorated with various metal plumbing parts, plus a doorknob.

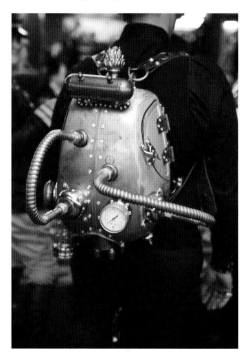

SAFETY PRECAUTIONS

Naturally, the controls on these devices must be as simple as possible. So as not to confuse our marines with a great many numbers, which they would not understand anyway, pressure gauge indicators should have only three values: Falling (pressure too low, please adjust); Flying (pressure just right), and Dead (pressure too high but no need for further adjustment). I recommend the pressure is kept at "Flying" whenever possible. This should prevent you from ever becoming an unintentional part of any firework display. Operate your pack with one hand while the other is free to protect yourself with a ray gun or other powerful weapon of your choice.

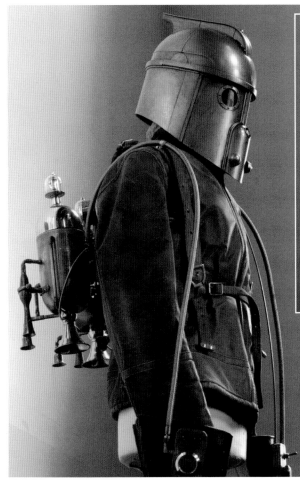

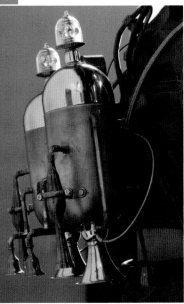

FLIGHTY SET

Herr Döktor's rocket pack in brass and steel is accessorized by a streamlined protective helmet, with a classic leather flying jacket. It was put together especially for The Greatest Steampunk Exhibition at the Kew Bridge Steam Museum.
See also page 244 👉

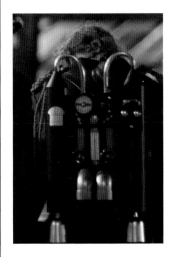

ROCKET PROPULSION

Seen at the Asylum 2011, the pack on the left is equipped with a dial and thermometer, wheels, pipes, and canisters. They combine to make it look genuinely capable of propelling its fearless wearer high into the earth's atmosphere.

POWER PACK

The clear and brass canisters on this pack hint at some form of fuel exchange mechanism.

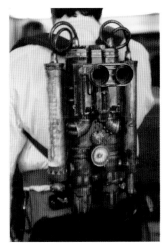

CHAPTER 6
SCIENCE
AND MANUFACTURING

Equipment for weaponry and space travel, and various imaginary scientific instruments are covered throughout this chapter, with telephony, computational engines and other communicative devices, flying machines and wheeled transport, rocket packs and protective helmets, and submarine matters, all having been covered in the preceding "Gear" chapter on pages 110-131. In addition to diverse articles, this chapter also includes an interview with Herr Döktor, a well-known Steampunk inventor and manufacturer. The steam age is blessed with magnificent manufacturers whose ingenious creations are designed to improve, inform, and delight. Never before in history has such a wealth of technical know-how been at the service of creative minds, with the industrial dynamic of the steam era amalgamating with visionary artists and forward-looking thinkers to produce scientific marvels beyond the wildest fantasies of previous generations. Exhibitions of the items included here have been held at galleries, museums, and various Steampunk conventions around the world, where a variety of awards are bestowed on producers of the best inventions.

EQUIP YOURSELF TO TRAVEL IN SPACE AND TIME

Fabulous sci-fi creations abound, including wonderful spaceships, mechanical men—sometimes now known as robots—and time machines, though in some cases you might have to miniaturize yourself to get inside the various craft available. You can also don space suits and helmets, and carry ray guns to vaporize any unfriendly aliens. And, you can explore the galaxies and travel through the ages in marvelous machines—or just by using your imagination, inspired by the breathtaking novels of H.G. Wells and Jules Verne, kinema movies such as *Star Wars*, and televisual programs including *Doctor Who* and *Star Trek*. There's a whole universe out there, waiting for any intrepid Steampunk to discover, and aided by some wondrous inventions from the likes of Dr. Augustus LeRoy, Mr. James Richardson-Brown, and the redoubtable mind of Herr Döktor. *See also page 244* *See also page 244*

DARTH VAPOUR

The Dark Lord of The Steam, Thaddeus Tinker's Darth Vapour sculpture strives to seduce the powerful to the steamy side. This piece also represents imperial aspirations of European powers in the 19th century, presaging the horrors of the Great War to come.

DISCOVER THE WORLD OF INVENTION

ANALYTICAL ENGINE

An ingenious bi-polar-morphing device developed by the great Dr. Augustus LeRoy, and displayed here on loan from the Bill Gould Studios.

Whether they are building machines to travel in time, cure maladies, or defend themselves against aliens or vampires, ingenious scientists have created wondrous alternate inventions and retro-fit their machines with stories that explain and justify their presence in the world.

BILL GOULD AND DOCTOR LEROY

According to artist Bill Gould, the engine shown on the left was invented by one Dr. Augustus LeRoy, one of the world's leading practitioners of bi-polar-morphing, based on his principle of "balancing electrical vapors" by utilizing a perfect exemplar cerebral matrix as the balancing source. Dr. LeRoy had previously worked as an assistant to the great Nikola Tesla before obtaining his Doctorate of Neurononsense at Crackinhead College of Medicine. This most elegantly constructed piece of equipment is intended to call attention to how serious illnesses were, and still are, misdiagnosed and improperly treated—both by "quack" doctors and bona fide medical professionals.

IMAGINARY SCIENTIFIC INSTRUMENTS

Explore a world of weird science, strange medicine, and mind-boggling alternate inventions. Marvel at the often eccentric geniuses responsible for these bizarre breakthroughs, and ponder some of the wonders that might have been and still could be. And, most importantly, perhaps be inspired to invent your own contribution to the world of scientific advances.

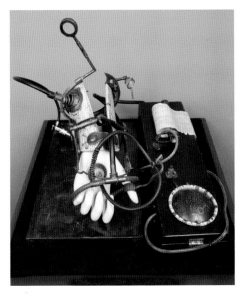

TREBORIAN MONITOR

The Treborian Monitor designed by Robert Dancik for Madame Duchamp, photographed on display at a Steampunk exhibition.

ADA LOVELACE: AN ANALYST AND METAPHYSICIAN

Dubbed "The Enchantress of Numbers," Ada was the daughter of Anne Milbanke, a mathematician known as "The Princess of Parallelograms," and the poet Lord Byron. She collaborated with Professor Babbage on his Difference Engine and anticipated the development of computer-generated music, artificial intelligence, and computer software.

THE FALSITIES AND ANOMALIES DETECTOR

Created by Nick Baumann of the League of Steam, the machine registers certain fluctuations of the subject's responses to questions to determine their natural intent. The League anticipates that this device will be much in demand at all the best parlor nights, in addition to séances and more scientific investigations of the paranormal. Not to mention, of course, its very obvious value to the forces of the law, in their interviews with those suspected of wrongdoing.

See also page 244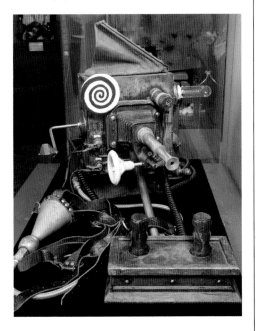

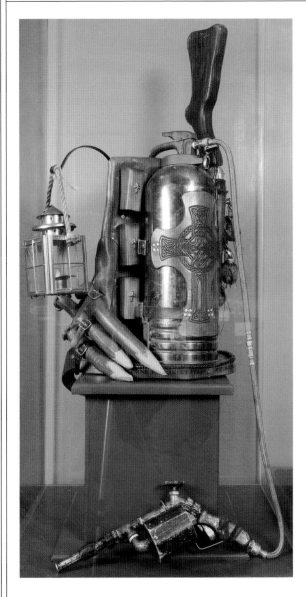

MEDICAL MARVELS

Innovative equipment that will save lives is being developed in Steampunk laboratories all around the globe.

MONITORING ALIENS

Constant watch requires the right tools. Steampunk scientists are continually striving to protect the earth from evil with the very latest devices.

VAMPIRE HUNTING COMPENDIUM

A Bible and crucifix, along with a silver stake and various potions set in an attractive red-lined traveling case, created by Patrick Reilly.

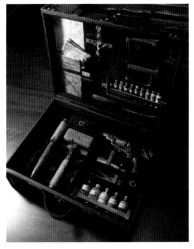

THE LEAGUE OF STEAM VAMPIRE HUNTING WARPACK

The vampire hunting kit, dating from 2009, was created by Conrad Wright Junior of the League of Steam, an exceptional invention that scientifically equips any stalker of the undead.

BATTLING THE SUPERNATURAL

Vampires, zombies, and the undead can be defeated, as long as their gallant challengers have the right equipment. An authentic Victorian vampire hunting kit might well be furnished with a copy of the Holy Bible, a mallet and stakes, a Derringer revolver and silver bullets, garlic powder, a silver dagger and crucifix, coffin nails, a hank of rope, garlic cloves, a bottle of holy water, a rosary, and a glass vial of vampire serum in case of bites. For its security and protection when traveling, the collection is housed in a sturdy hardwood box.

SPACE AND TIME TRAVELERS

The science fiction stories of writers like the Frenchman Jules Verne, England's H.G. Wells, and a host of American writers going back to the 19th-century novelist Edgar Allan Poe are now regarded as true classics. These pioneering tales of planetary exploration and journeys through time have become both inspiration and signposts for today's armchair travelers.

TIME TRAVEL

Long a fantasy of oracles, dreamers, and science fiction aficionados, traveling through time is upon us—at least in alternate, virtual reality. Romantic thinkers and other visionaries have come up with a variety of vehicles for time transportation, from H.G. Wells's 1895 *Time Machine* to elaborate devices for teleportation. Present-day applications include a Steampunk-style subway station in Paris, Arts et Métiers, where the walls are lined with window-like portals into other worlds. The design was inspired by the work of Belgian comic book artist François Schuiten, whose graphic novel *Les Cités Obscures* (Cities of the Fantastic) explores the idea of a counter-earth.
See also pages 25, 175, and 189

K-9 REINVENTED
Doctor Who's K-9 was reinvented as K-1909 by James Richardson-Brown, for the Waltz on the Wye—Wales's first Steampunk festival—where it was voted favorite by attendees.
See also page 244

CELESTIAL SPACE
Working from "His Laboratory, His Castle Dungeon, United Kingdom," Herr Döktor creates all kinds of marvels, like this ingenious machine for exploring new worlds.
See also page 244

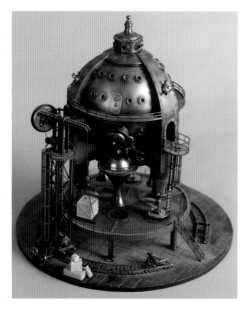

MARTIAN RED WEED

Collected by explorer Herr Döktor, the Martian Red weed would rapidly take over the Earth if not housed in a containment vessel.

❖

MARS HELMET

The good Döktor also designed the Mars helmet below, before setting off on his first expedition to the Red Planet.

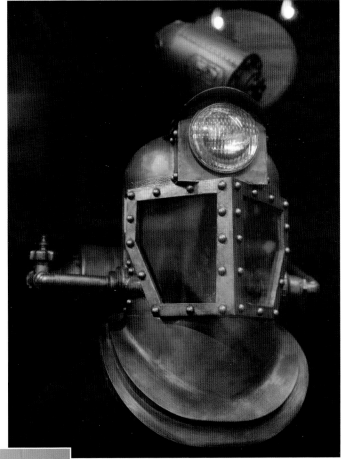

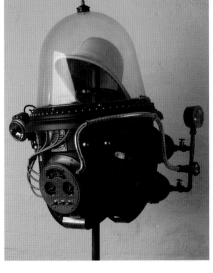

MOON HELMET

An American-manufactured, copper-colored helmet designed for visiting our nearest heavenly neighbor.

❖

PLANETARY EXPLORERS

Inspired by the bravery and derring-do of past explorers, cosmic heroes set forth into the unknown, in search of new worlds in our solar system and beyond. Space travel requires purpose-built attire and extraterrestrial transport, while the threat of alien life forms gives birth to all manner of ray guns and other wonderful weaponry. Once the province of comic books and pulp fiction, pioneers like Herr Döktor have brought their own sense of sci-fi style to interstellar exploration.

See also page 244 *See also page 244*

HERR DÖKTOR

GENTLEMAN SCIENTIST AND EXCEPTIONALLY INGENIOUS GUNSMITH

Ian Crichton, who is also known as Herr Döktor, makes his living as a prop and model maker for the film and television industry. In his spare time he creates a variety of imaginative Steampunk works, including ray guns and pistols, elaborate cases for equipment like cameras and MP3 players, and various mysterious-looking models. His work has been featured in exhibitions at galleries and museums around the world. Ian is a Fellow of the Victorian Steampunk Society.

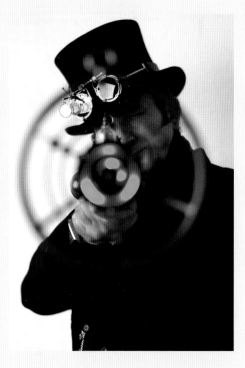

and James P. Blaylock, and there are comic book artists and writers, such as Bryan Talbot (*Grandville*) and Alan Moore and Kevin O'Neill (*The League of Extraordinary Gentlemen*). Also D'Israeli and Ian Edgington, whose work includes *Scarlet Traces*, a sequel to *War of the Worlds*, and *Stickleback*, set in the Victorian underworld with fantastic villains and some clueless heroes.

Why the name Herr Döktor?
It's no secret that I'm an admirer of the BBC TV program *Doctor Who*, so when I first signed up to "Brass Goggles," I attempted to register as "The DOCTOR"—but it was taken! So, I made it a bit more Germanic, registering as Herr Döktor—even if the umlaut is in the wrong place!

You have made action figures of/things for *Doctor Who*. What have you made?
I made a range of action figures, including Davros, the creator of the Daleks; K-9, the fourth Doctor's robot companion; and many variations of the Daleks over the years.

How did you come to be a Steampunk?
I always loved the Victorian and Edwardian style; the clothes, the attention to detail, the colors! Then the "Brass Goggles" blog and forum brought me into contact with like-minded individuals.

What is your favorite era?
As I spend half my time thinking of the future, and the other immersed in history, I'm living in just the right era! I like "now," as it gives me the past to play with, while studying the future.

Which science fiction authors inspire you?
Well, the greats—Wells and Verne; also some of the first "modern" Steampunk authors, K.W. Jeter

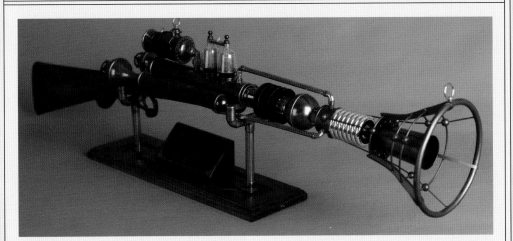

What do you like and hate about technology?

A few years ago, a person could make an educated guess as to how devices around them worked. Take the back off an old telephone—there are wires coming in and out, connecting a handset with a microphone and speaker, a pulsed dial—you could see how it worked! Now, you have a phone that plays music, films, and surfs the net, with a computer inside with more processing power than NASA had to put a man on the moon!

What are your views on mass production?

The Victorians tempered the Industrial Revolution to produce a great deal of objects and technology quickly, cheaply, and reliably. And a number of the mill owners and industrial tycoons started model towns and villages for their workers, and schools for their children; so it could also be a force for social change.

What materials do you use for your pieces, and where do you find them?

Whatever comes to hand. I use a lot of "found" objects. I trained in plastics, so there's quite a lot in the mix: hardwood offcuts, leather from old leatherwear—absolutely anything! For instance, the tanks on my rocket pack are two steel kitchen containers; the exhausts are made from brass candlesticks and vases linked together with brass

THE THUNDERBUSS: A GENTLEMAN'S SONIC HUNTING RIFLE

When you are out and about in the wild west or elsewhere, this will keep you in good stead. Made by Herr Döktor, the piece has setting gauges that are labeled "Wound, Hurt, Kill, Liquiefy" and "Quiet, Loud, Louder, Pardon?"

pipe and copper plumbing fittings, joined to control boxes made from candy tins with braided car brake cable and mounted on a pair of motorcycle gauntlets. The tanks are on a steel frame attached to a repurposed army backpack frame with loops from a leather belt, topped with headgear based on a modified *Star Wars* Clone Trooper helmet. I think that sums up a lot of the materials I use.

What future designs are in the works?

There's a scale model of an aerial battleship, a dirigible version of a Dreadnought, with forty guns and a giant "cloudbuster" gun on the prow to clear the way ahead. In real life, this would be over 400 yards in length, completely impractical—but that hasn't stopped anyone before. Also, a miniature of a three-legged armored walking machine—the idea being that, after the *War of the Worlds*, British scientists back-engineered Martian technology to build weapons for the army, and maybe take the war back to Mars.

WEAPONRY

Guns can be seen as both wearable art and a necessary protection for an adventuring time traveler, should the emergency arise. Basic types are adapted from plastic toy Nerf guns, firing foam balls, and the like, while the more elaborate handmade guns replicate real weapons in wood and brass, with finely crafted details, but fire imaginary rays or steam-powered projectiles. Although traditionally considered a gentleman's prerogative, faux weapons also appear as ladies' accessories.

SWORDS INTO PLOWSHARES

Or, to put it another way, deactivated ammunition into works of art. Explore the work of Steampunk artists like Tom Hardwidge, who turns bullets into sculptures of insects, and jewelers like Two Altered Visions, who insert old chandelier prisms into shell casings to make pendants. A major inspiration were the Swords Into Plowshares programs being run in war-torn regions like Mozambique, in which artists have turned disabled guns into sculptures, like the Crocodile by Humbert Delgado, that was acquired by the Imperial War Museum in London, England.

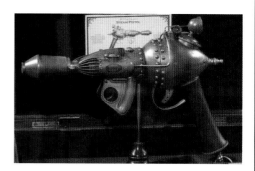

STEAM PISTOL

Herr Döktor's brass, steel, and wood pistol has two chambers—with spherical projectiles for earthly foes, and cubed ones for those of other worlds.

DUELING FOR BEGINNERS

Take up the challenge to a duel: meet at dawn or dusk, bring your weapon of choice, stand back-to-back, take the requisite number of paces, and on the instruction from the official dueling master, fire—as long as it's paint, foam, or ping-pong balls. Detailed rules and regulations will vary depending on the jurisdiction and should be overseen by the official dueling master. The role of the "second" is to prepare the weapon and make sure that no unseemly cheating occurs, and to hold their party's coat if necessary. If guns are not your weapon of choice, then investigate the alternative sport of tea dueling.

See also pages 228–229

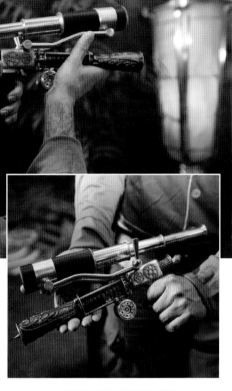

RAY GUNS

First brought to the public's attention in the form of the now-iconic Heat Ray in H.G. Wells's ground-breaking science fiction novel *The War of the Worlds*, ray guns are directed energy weapons, emitting potentially lethal rays that will either kill or evaporate humans, or destroy objects. Other names used for them are laser or phaser guns, plasma rifles, or blasters. The famed Austrian-American inventor and engineer Nicola Tesla attempted to develop this type of weaponry, and on more than one occasion such weapons featuring in sci-fi movies have been named after him. The actual ray can be a laser, a particle beam, plasma, or indeed some new technology with which we are not yet familiar in current scientific know-how. The nature of the powerful beams or waves emitted by the weapon is usually high-intensity light but can alternatively be enormous heat, or even extreme cold. Some such guns, like Herr Döktor's Thunderbuss, are carefully designed with devices like shields at the end of the barrel, to protect the user from any back flash from the death-dealing beam. Others, like the infallible aether oscillators of Dr. Grordbort, function with an array of mysterious moving parts.

TELESCOPIC LENS

Thoughtfully designed with the convenience (and safety) of the traveler in mind, and beautifully crafted in wood and brass, this elegant little gun features a built-in telescope for better viewing of the target when taking aim.

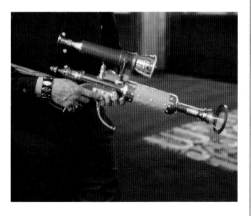

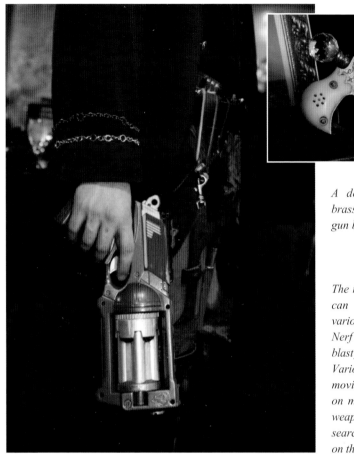

HANDGUN

A delightful little aluminum, brass, plastic, and electronic ray gun by Shannon O'Hare.

GET YOUR GUN

The majority of small arms that can be found on display at various conventions are modified Nerf guns like this one, which blast foam balls, darts, or arrows. Various esteemed designers offer moving or still-image tutorials on modifying these useful little weapons; to access them, simply search "nerf gun modifications" on the aethernet.

VULCAN'S HAMMER

Named for a Philip K. Dick novel, an electric pistol by Gordon Smuder of the The Gentlemen's Gadgeteer Society for cryptozoology, aetheric exploration, and other scientific studies.
See also page 244 See also page 244 ☞

STEAM SABER

Less clumsy and random in its effect than a blaster, any Steampunk Jedi knight would be proud to carry the elegant saber shown above, made by the talented armorer Gordon Smuder. Similar to the Vulcan's Hammer model illustrated left, also created by Mr. Smuder, it combines a lethal precision with intricate design details.
See also page 244 ☞

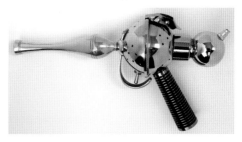

DR. GRORDBORTS
INFALLIBLE AETHER OSCILLATORS

LORD COCKSWAIN'S RAY-BLUNDERBUSS
"THE UNNATURAL SELECTOR"

THE UNNATURAL SELECTOR BLUNDERBUSS

From Dr. Grordbort's Laboratories (a.k.a. the Academy Award-winning Weta Workshop in New Zealand) comes this limited edition metal, glass, and rare Venusian worm oak gun.
See also page 244 *See also page 244*

GUN ETIQUETTE

Different countries and states have varying legislation regarding the use and display of imitation weapons; check your local regulations. In addition, some conventions and symposiums set rules for attendees.

RAY GUN ENSEMBLE

From Nick Robatto of Rubbertoe Rayguns, makers of the sonic screwdriver, the Clockwork Vaporizer will blast an opponent from fifty space paces (around 60 miles). Made in the finest oak and brass with LED light, and a hand-cast muzzle, with a wood display stand and matching ammunition belt, goggles, and wrist device.
See also page 244

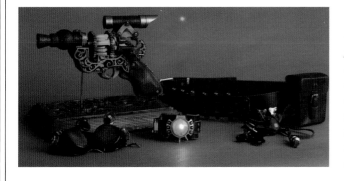

HELP THE AGED PISTOL

Created by Herr Döktor from found metal components, in the futuristic-style firearm (pictured above) a coiled array emits a pulsed electromagnetic burst to floor any assailants, without harming their surroundings.
See also page 244

NATURE

From global issues such as energy, to domestic priorities surrounding the family pet, there's a Steampunk take on the natural world. Starting at home, man's best friend is introduced to Steampunk mode, with collars, coats, and other accoutrements, and even pet urns for a final resting place. Staying with the cycle of life, the Victorian love of taxidermy is seeing a revival, and an interview with a Steampunk taxidermist discusses its 19th-century roots and how it is being explored today. Steampunk takes inspiration from the technology of the Industrial Revolution. The factories of the age of steam began emissions of carbons and chemicals, causing long-lasting problems, so Steampunk's green qualities are not exactly intellectually sound. However, some technologies loved by Steampunk are now being reinvented to help the environment. At the same time as the great coal mines in Germany's Ruhr valley that fueled many a steam engine are being gradually closed, theorists are exploring alternate ideas for power, with the possibility of new airship technologies reducing carbon emissions from travel or even creating hydrogen gas farms in the sky.

STEAMPUNK AND GAIA

Steampunk creators' respect for materials is evident, repurposing and reusing and in a manner that coincides with ecological values, although steam technology itself is less earth-friendly. Theorists are debating the green qualities of Steampunk, or attempting to start a new punk movement where green technology merges with retro-futurism or science fiction writing. Meanwhile, green initiatives are raising the possibilities of airships in our skies once more—look out for the Lockheed SkyTug cargo freighter or architect Christophe Callebout's Hydrogenase, a fleet of algae-producing airborne craft that will generate hydrogen gas without taking up land space. Steampunk fashion is often eco-friendly, and is an ideal entry-point for those wishing to make their Steampunk experience more earth-conscious. Old garments or jewelry can be revived and repurposed, thus saving them from landfills, and many designers who create new ensembles often use eco-cotton and natural dyes in their fabrication. Decoration often incorporates reworked hardware—clockworks, gauges, gears, and much more—and other detritus that would otherwise be thrown away.

PIPED CANE

Plumbing supplies are recycled to create a curious cane that comments on our profligate use of water resources from the Industrial Revolution onward.
See also page 244 👈

FANTASY ANIMALS

Imagine a world of two-headed beasts and fairy mermaids—not a sci-fi movie from tomorrow's world, but the stuff of the past, seen in Victorian freakshows and taxidermy shops. Taxidermy is reappearing as an art form once more, with contemporary and Steampunk artists exploring its biomechanical possibilities. And artists are turning scrap metal into imaginary men and beasts, from Kreatworks' giants to Daniel Proulx's miniature arachnids. Animal and human oddities were fully accepted Victorian entertainment, most famously those of P.T. Barnum, with his Grand Traveling Museum, Menagerie, Caravan and Hippodrome, a traveling circus, menagerie, and museum of human freaks.

JEWELED NATURE

Many Steampunk jewelers incorporate animal relics into their work—in the example shown here, an insect is frozen in Lucite by the jeweler, rather than the amber that nature would employ.

See also pages 146–147 👈

TAXIDERMY

Fairground showmen, hunters, and collectors fueled the 19th century's widespread fascination with taxidermy. Oddities such as flying cats and dogs, monkey mermaids, and furry fish were to be found on display at carnivals and traveling fairs, while fine, rare specimens from the jungle, forests, and plains worldwide adorned the walls of adventurous big-game hunters.

FANTASY CREATURES AND SIDESHOW EXHIBITS

Artists like Sarina Brewer have reinvented the showman's hoaxes to produce strange creatures such as a goth griffin created from a wildcat, turkey, and rooster, with antler spikes, or twin-headed squirrels or chicks. Some of her pieces are used in operating carnival freakshows.

BIOMECHANICALS

The fairground hoaxes of the 19th century have traveled through time and are reinvented in bio-mechanical mash-ups by artists like Lisa Black, who retro-fits animals with mechanical parts, often vintage clockworks or hardware. Some creators introduce Steampunk themes, such as the clock-work rats and stoats from Amanda's Autopsies.

TOPPING MOUSE
An anthropomorphic piece by Amanda Sutton.
See also page 245 👈

DISPLAYING TAXIDERMY
Striking vintage pieces can be used to furnish a Steampunk interior.
See also page 243 👈

WALTER POTTER

Founder of Mr. Potter's Museum of Curiosities, this Victorian taxidermist made anthropomorphic dioramas that were inspired by the German Hermann Plouquet, who exhibited at the Great Exhibition. A Potter disciple, Amanda Sutton of Amanda's Autopsies explains, "He created large pieces where there were schoolrooms of rabbits or kittens attending a wedding, and they all sat in their own amazingly ornate cases… I decided that I'd make my own pieces, making clear Potter was my influence. If the public couldn't see Potter, at least they could own a piece influenced by him."

HERE WOLF, THERE WOLF

A fantasy creature, captured by Mr. Peter Harrow in the darkest hours of the night.

MUMMIFIED MERMAID

A carnival oddity, the FeeJee Mermaid consists of the lower body of a fish and the torso of a primate sewn together.

TIME-TROUBLED WHITE RABBIT

Straight out of Alice in Wonderland, *created by Amanda Sutton of Amanda's Autopsies.*
See also page 245 ☛

HORROR HOUSE BAT

A bat with glowing eyes perched on a skull, a typically ghoulish exhibit to be found on display at Vicktor Wynd's Little Shop of Horrors in London.
See also page 243 ☛

AMANDA SUTTON

AN ETHICAL ANTHROPOMORPHIC TAXIDERMIST

London-based Amanda Sutton, of Amanda's Autopsies, gives live displays of taxidermy art online and in the real world and makes one-off pieces from roadkill or animals that have died naturally, to commission or sell in wunderkammer—also known as cabinet of curiosities—stores. She is particularly inspired by the work of the celebrated Victorian taxidermist Walter Potter.

How did you come to be a taxidermist?
When I was a kid, I visited the Walter Potter museum, and I just remember falling in love with the little stuffed animals dressed up in costumes.

Taxidermy: art form, or a technical craft?
I love Potter, who mainly used taxidermy as an art form, but I appreciate it more as a learning piece. Natural history museums were important in educating the Victorian public, with animals that most people would never have seen. Darwin contributed with specimens to help express his evolution theories, which might have been ignored without that evidence. I appreciate taxidermy as an art form, too—nature is an art in itself, and as long as the piece isn't grotesque,

expresses the beauty of the animal in some form or another, and doesn't use animals killed just for the piece, then I think it's wonderful that taxidermy can contribute to the art world.

How did Steampunk come into your art?
I always loved Steampunk even before I even knew what it was. It was refreshing to finally be able to put a name to that particular style; it's always been around for me. My house has all sorts of Edwardian and Victorian gadgets and gizmos. That era was the industrial age; they also had a taxidermy shop on every street corner, as it was all the rage to have an animal mounted in your home, so I just mixed those two elements together.

How do your customers display your work?
I get all sorts of commissions—for example, a chap wanted a squashed mouse made. The idea was that the bell ringer had fallen out of a hanging bell and fell straight onto the mouse. He wanted it in quite a cartoonish position, legs splayed out and a very flat belly. Another guy wanted a mouse holding open its stomach, which was empty, just a black hole; he planned to make a bronze cast of it. I also made a couple of floppy hares for a woman that wanted to use them in a performance piece. In her show she has a fake belly, she unzips it, and pulls out the two hares to indicate that she's giving birth to them. I'm happy to help people with projects; it can be very interesting!

SPLENDID SQUIRREL
Clad in tweed jacket, shirt and tie, with a pipe and a fashionable waxed mustache, this squirrel looks like an excellent chap.

What artists and writers are particularly inspiring and why?
Walter Potter is an obvious one; Darwin has been a huge influence artistically and historically; but I'm mainly influenced by museum collections if anything. In London, I love the Wellcome Trust and the Natural History Museum. The Grant Museum is wonderful, too, for wet specimens.

What do you cover in your master classes?
They are more of a show and tell; it gives people an opportunity to ask me questions. I'll work on an animal in front of an audience while answering questions and telling of my experiences, talking through the process as I go along. Most people are quite shocked how tidy and clean it all is. I think they expect me to be tearing out the guts with blood all over the place, but it really isn't like that. I appreciate my animals and want to express this in my talks. I want to demonstrate that death isn't horrible; it can be beautiful and educational.

How do you find your material?
I either pick up fresh roadkill, or buy frozen reptile feed, mainly rats, mice, and chicks. Some butchers and farmers keep the skin on for me. This means I can skin it myself and eat the meat, that way nothing is wasted.

What do you think about time travel?
First place I'd visit would be the Great Exhibition. Important inventors would be there selling their ideas, plus scientists and taxidermists that I would very much like to meet.

What is your favorite era?
Victorian—so much history was created in that time that contributes to a lot of what we know and understand now. It's amazing how much of their knowledge we still use today.

NEWS-WORTHY RAT
Is this clever creature reading our esteemed Gazette, *or some other rodent-sized periodical?*

ANIMAL COMPANIONS

Pets can be incorporated into a family's Steampunk lifestyle, from cradle (or bed or kennel) to grave—or pet urn. Many people, Steampunk folk included, draw a line at garbing their fur and feathered friends in human attire; but if you are intent on dressing your pet, then dogs are the easiest to dress as many Steampunk leatherworkers make canine collars and even jackets.

STEAMY PET NAMES

Inspiration for pet names can be found in writers' names or characters from their stories—Verne, or Passepartout (from *Around the World in 80 Days*), for example. Inventors and engineers are also a rich seam: Tesla, Brunel, or Montgolfier might suit. Or consider real pet names from the past—Jules Verne named his dogs Follet and Satellite, Abraham Lincoln chose the rather unadventurous nomenclature Fido, while Queen Victoria—also the proud owner of a spaniel and a parrot—called her Pomeranian Turi. Edgar Allan Poe admitted that his poem "The Raven" was inspired by the real-life pet of writer Charles Dickens, whose raven was called Grip.

GEAR UP

A made-to-order collar for a small dog, decorated with metal cogs, created by Kerin Wolfe. See also page 244 🖝

PARLOR AQUARIUMS

Philip Henry Gosse published *The Aquarium* in 1854, initiating a craze for parlor tanks. A fine example is on display at the Horniman Museum, London, England, and can be viewed online. Such experiments are ripe for Steampunk re-evaluation. Nautilus themes are ideal for fish tanks. If you intend to purchase one, then George Maridakis has designed a Nautilus peepbox aquarium—an illuminated cylindrical tank made of perspex and copper-colored aluminum. Alternatively, build a Victorian-inspired cabinet from hardwood, glass, and brass and fill it with follies, submarines, and such (and a few fish). *See also page 245* 🖝

IN MEMORIAM

Pet urn by artist Mark Bensette au Bois. Based on a steam-powered ash vault, for pets up to 25 lb (11 kg) in weight, the urn is from Direct Pet Urns. See also page 245 🖝

KRAKEN COLLAR

Decorated with a kraken, a dog collar, and matching goggle set by Kraken Leather.
See also page 245 👉

COGGY TAG

A cog design is a clue to the Steampunk style of Remington's owner. A custom-made dog tag by MODPawed of California.
See also page 245 👉

STEAM'S BEST FRIEND

Over the ages, man's best friends have often been adorned in the style of their owners. Clothed in leather, adorned with brass hardware, and sporting some cool canine gadgetry, Jack looks at home at any Steampunk gathering.

CULTURE

Authors, film directors, musicians, and artists produced Steam- punk art well before K.W. Jeter put a name to it in the 1980s. Victorians and Edwardians could take a seat in H.G. Wells's time-traveling chair, journey around the world with Jules Verne, or take off to the moon with pioneer film director Georges Méliès. Punk was in our vocabulary before the Sex Pistols took to the stage, embodying rebelliousness long before the 1970s. Fast-forward to today, and a mash-up of imagery and eras collide with time travel and alternate technologies in an amusing, inventive soup of ideas that connect mysteriously to long-held aesthetics, emotions, and cultural memes. Cur- rent recycling means a new mix of reused materials, styles, and concepts. Artists take industrial detritus to create work that comments on the politics of manufacture, while writers and film- makers explore cultural remashes, taking heroes and heroines from past classics to alternate worlds. Exploring today's evolving Steampunk art world will enlighten, entertain, give insights into past masters you might not have known about, and introduce intriguing new stars.

WRITERS AND ARTISTS

Novelists H.G. Wells and Jules Verne lead the canon of Steampunk, a term that was coined by K.W. Jeter, author of *Morlock Night*, itself a sequel to H.G. Wells's *The Time Machine*. Jeter applied it to science fiction, and novels before and after his 1987 *Locus* magazine article take on the term's mantle. The term has since expanded to cover an entire sub-culture, with artists in all medias producing inspiring works in the genre. Some of these creators positively identify themselves as Steampunk, while others have the Steampunk label thrust upon them. Authors who would not identify themselves as Steampunk but are described as such, whether writing for adults or children, include Thomas Pynchon and Philip Pullman. The authors who identify themselves with the genre include Americans Neal Stephenson (whose work has also been categorized as cyberpunk) and Paul Di Filippo (author of 1995's *The Steampunk Trilogy*), and the British writer China Miéville.

HARRY SHOTTON

Imagery of skulls, internal clockwork mechanisms, knights in armor, zombie lovers, and punks in space all feature in the work of UK illustrator, animator, and puppet maker Harry Shotton. After studying interactive art in Manchester, he moved to New Zealand, where he now resides.

See also page 245 ☞

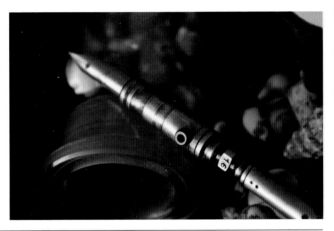

SCHOLARS AND CRITICS

The serious study of Steampunk as a contemporary phenomenon is growing in literature, arts, and humanities departments in the academic world, and you will find discussions of issues like multiculturalism, gender, and post-modernism in relation to Steampunk, as well as detailed monographs on various key individual artist's work. These in-depth studies are not confined to any one continent: respected academic journals like the *Neo-Victorian Studies* e-journal boast board members and contributors from around Europe (the United Kingdom, Germany, Poland, France, Spain, the Netherlands, Belgium), North America, India, and Australasia.

THE STEAMPUNK SCHOLAR

A portrait of blogger the Steampunk Scholar, also known as Mike Perschon, professor of English at the Grant MacEwan University, Edmonton, Canada. Perschon's widely admired blog provides some of the very best reviews of science fiction and fantasy literature and film.

ART FOR THE WALL

Gathering their inspiration from a multitude of different eras and cultures, visual artists often hang items for sale in the aethernet galleries of Etsy or deviantART. Many are influenced by the fantasy graphics prevalent in comic book art and digitalized gaming; others by the 20th-century surrealists. Some work in traditional media, while others manipulate imagery in their computational engines.

USING NEW MEDIA

While some Steampunk-influenced artists reach back to early technologies, like the photographers on the previous pages, others use the latest computer software that allows artists to manipulate imagery and easily create alternate realities—a wonderful tool for retro-futurist material. Files can be uploaded to sites like deviantART and prints can be sold via a download, enabling an artist in Hong Kong to sell his artwork in Seattle or Sheffield, Munich, or Moscow at the click of a mouse. Artists can mix Victorian artwork with their own, blend imagery from different sources, and use the latest software to achieve their vision.

MICHAEL PUKAC

Unicorn Travel Headgear, 2010—acrylic on canvas. Pukac is influenced by a barrage of cultural elements, including myths, romantic and "painterly" eras—from Baroque to Art Nouveau— and the novels of Twain and Hemingway.
See also page 245 See also page 245

AURELIEN POLICE

The Teethwriter. French illustrator Aurelien Police uses numeric creation to create his highly original artworks from a melting pot of scanned paintings, photographs, and drawings.
See also page 245

JAMES NG

The Imperial Inventor, from Ng's Imperial Steamworks series, with his faithful robotic servant and pet parrot at his side. See also page 245

DAN HILLIER

Luna. Winner of the Club Monaco Emerging Artists Award, Hiller works in collaged elements of Victoriana. See also page 245

WAYNE HAAG

The Buddha Returns. Science fiction-themed oil by Australian artist Haag combines an alternate world with the spiritual. Haag's vision of fantasy landscapes recalls the classic cover art of pulp science fiction from the 1950s. He has worked in the art department on a number of major films, including The Fifth Element *and* Lord of the Rings. *See also page 245*

THE ART OF PHOTOGRAPHY

This wonderful new medium is set to eclipse the work of silhouette artists and traditional artists in oils or watercolors. Various chemical processes and materials are being experimented with, and all around the world the astounding equipment and technology are capturing an immeasurable quantity of moments for posterity—images for future generations to contemplate as if traveling back in time.

CYANOTYPES

Discovered by scientist Sir John Herschel in 1842, the cyanotype process was originally utilized to produce the blueprints employed for plans and diagrams by engineers and architects. The cyan-blue prints came to the wider public's attention through the work of Anna Atkins, who used it to produce photogram images of her meticulous collection of ferns and seaweed.

DAGUERROTYPES

Louis-Jacques-Mandé Daguerre introduced a new photographic process to the world in 1839, using a light-sensitive silver plate and chemical processes that led the painter Paul Delaroche to exclaim, "From today painting is dead!" The plates require an exposure of several minutes, so portrait subjects are required to stand very still, and some studios use head clamps and other devices to assist in this. It is, however, quicker than the lengthy sessions required by an oil portraitist!

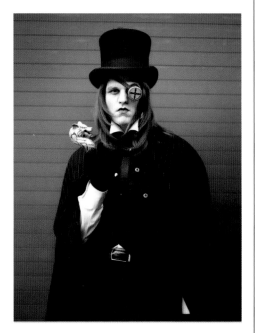

PETER NAPPI'S HANDMADE PHOTOGRAPHY

Pictorial alchemist Peter Nappi works in cyanotype, tintype, and albumen, mixing his own chemicals, coating paper by hand, dipping metal plates in silver baths, and—with the artistry of a magician—turning blank sheets of paper and quantities of chemicals into images of the world around him. See also page 245 See also page 245

DAGUERRE OVERLOOKED

A Google map view of the Eiffel Tower has been given a Daguerrotype treatment by photographer John Danforth.

PINHOLE PHOTOGRAPHY

A light-tight box without any kind of lens, having just a small hole or aperture to let in light as required, will expose any photographic material held at the back of the box. The images are soft compared to those created with a lens, yet they are characterized by an almost infinite depth of field. You can purchase the ready-made devices for this popular form of photography—in London alone, no less than 4000 of these pinhole cameras (Photomnibuses) were sold in 1892—or you could make your own. Indeed, the construction of these primitive yet effective box cameras has recently been introduced to school children, as part of their education in the basic principles of photography.

PHOTOGRAPHY'S BLUE PERIOD

A cyanotype on paper by Alessandro Rota. Cyanotypes fade if exposed to light for too long but regenerate in darkness!
See also page 245 See also page 245

DRAGONFLY PINHOLE CAMERA

Wayne Martin Belger of Boy of Blue Industries made this 4 x 5 inch camera as a memento mori to a 9-year-old girl long passed away, painstakingly created from aluminum, steel chain, acrylic, insects, and other relics.
See also page 245

PORTRAIT OF TARA

Taken with the Dragonfly camera, this is a toned gelatin silver print. The subject has been painted with prickly pear black tea. Despite the soft focus image produced, the overall, almost ethereal, quality lends a delicate atmosphere to the picture.

INSTALLATIONS AND SCULPTURE

Whether conceived as large- or small-scale, the works of art shown on these pages explore creative ways to reuse scrap material or introduce kinetic elements, as pioneered by artists like Cesar Baldacinni and Jean Tinguely. The works comment on man's relationship with both the natural world and aspects of our man-made environment, in the context of the Steampunk aesthetic.

CALIFORNIAN INSTALLATION ARTISTS

Various talented West Coast teams work together to produce large-scale pieces like the treehouse shown here—this group was led by Sean Orlando of Engineered Artworks and included Tom Sepe and members of Kinetic Steam Works. The works are often made for the Burning Man Festival and then displayed at events and exhibitions around the state and elsewhere. Neverwas Haul was made by the Academy of Unnatural Sciences, based in Berkeley, California. This loose group of tinkers, gear heads, and steam bohemians create steam-powered art pieces out of repurposed industrial detritus, taking inspiration from the works of Jules Verne and H.G. Wells.
See also pages 118 and 245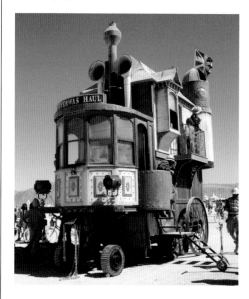

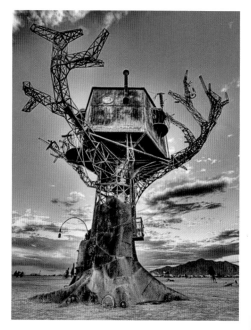

THE STEAM TREEHOUSE

Thirty feet (9 meters) tall, with steel plates and beams supporting steel pipe branches, a wooden treehouse is accessed through the trunk. Pipes in the branches emit steam, while others allow people to converse from different parts of the tree.
See also page 245

NEVERWAS HAUL

A self-propelled Victorian house, made from 75% recycled materials on a travel trailer base, by members of the Academy of Unnatural Sciences. The turret contains the Camera Obscura project.
See also page 245

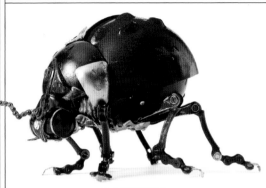

LADYBIRD

Without using solder, Edouard Martinet transforms discarded objects into animal and insect sculptures. See also page 245 📖

METAL GURUS

The earth's valuable resources are never wasted in the constant quest to create Steampunk art. From the arthrobots of Tom Hardwidge, almost entirely made from deactivated ammunition, to the sculptures of James Corbett fashioned from discarded automobile parts, or the cartoon-like characters of Stéphane Halleux, all kinds of repurposed metal is continually being put to use for our delight and entertainment—proof that the earth's resources are not limited to those endowed by nature, but enhanced by the increasing volume of detritus from man's industrial history. *See also page 245* 📖

MINIATURE SPIDER

Illustrated right, a brass and copper wire miniature sculpture by the Montreal jeweler and artist Daniel Proulx, who has created organic shapes from wire, gemstones, vintage clock parts, and other unconventional components. The delicate and intricate designs thus created combine the organic sensibilities of nature with a mechanical and industrial feel. See also page 245 📖

DIANE LE BUSTE

A bronze bust of Diana by the sculptor Pierre Matter, who cites the artist H.R. Giger, filmmaker Alejandro Jodorowsky, and writer Jules Verne as his primary influences. See also page 245 📖

WAR PUPPET

Jules Verne–influenced elephant sculpture in gilded bronze by Peter Overstreet.

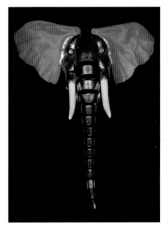

POPULAR ART

The world of popular art embraces collectable models, body art, and more, cross-referencing works elsewhere in the *Gazette*. Prop makers create collector's figures as well as ray guns; novels and films spawn character models; and games promote models and cards. And Steampunk iconography crosses over with tattoo's roots in the sailing world, with airships, tentacles, and pirates.

COLLECTOR'S TOYS, DOLLS, AND FIGURES

A retro-futurist vision is a rich seam for designers of collectables. Some pieces, like the figures of Doktor A shown opposite, are custom designed, while others are cult collectables that have been modified or dressed for the steam age. Dolls like Blythe can be dressed in custom-made outfits for a fraction of the price that would be spent dressing their owners.

BODY ART

Whether permanent tattoos or temporary body painting, the Steampunk aesthetic is beginning to make its mark in body art. New Zealand artist Yolanda Bartram of Body FX won the special effects category in the World Body Painting Festival in Austria in 2010 for a Steampunk-influenced design. And in the work of the best tattoo artists, skulls, clockwork hearts, and biomechanisms abound.

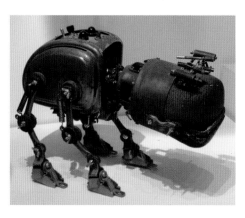

COLLECTOR'S DOLL

Oversized heads and eyes are a feature of dolls like Blythe and Pullip and give a twist to Steampunk clothing, while one-of-a-kind custom dolls hint at the unsettling silent stares or even the zombie characters found in dark Victorian novels.

ROBOT PET

Character or sculpture? The Belgian sculptor Stéphane Halleux started work in an animation studio and is fascinated by the art of the comic strip and the work of Jean Tinguely.
See also page 245 🖘

AIRSHIP TATTOO

An airship in full sail, from the Red Sea Tattoo studio of Dan Morris. See also page 245 🖒

MONTGOLFIER TATTOO

A tattoo evocation of the 18th-century Montgolfier brothers' balloon, by Katie Davis of the Salvation Tattoo Gallery, Virginia. See also page 245 🖒

CHARACTERS BY DOKTOR A

Amnesia Primm, pictured right, and Montague Grimshaw (Elder), below, are collector's models created by Doktor A. The Doktor uses vinyl, metals, and a variety of found objects that included a vintage toy bath chair that now houses Grimshaw, one of the oldest of the Mechtorians. Amnesia Primm has no short-term memory and a lot of keys—and more of their story can be found via the link on page 245 of this publication.

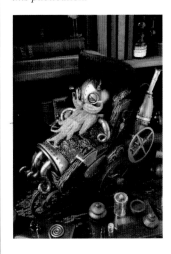

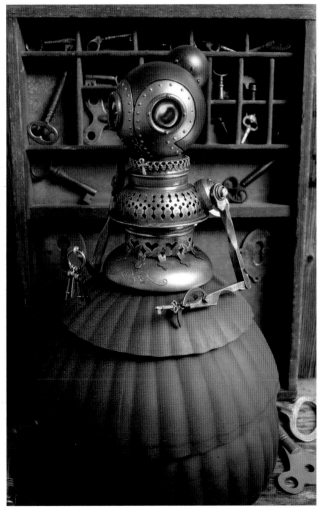

POPULAR MUSIC

Steampunk popular music encompasses a wide range of influences from different eras: punk (naturally), Victorian music hall, European fin de siècle cabaret, jazz, blues, goth, swing, heavy metal, world music, Balkan beats, electronica, industrial dance, synth-pop, and rap. Essential to any such musical enterprise is an open mind, unencumbered by the restrictions of one particular genre.

STEAM FUSION

Unusually for a sub-culture, music followed art and literature, and the music of Steampunk is more eclectic and multifaceted than most genres as a result. For example, up-and-coming band Tankus the Henge draws their influences from carnival and circus, Gogol Bordello, the Beatles, Tom Waits, and Radiohead. Their single "Smiling Makes the Day Go Quicker" has been featured in an Ikea advertisement in Russia.

SUNDAY DRIVER
Singer Chandrika Nath and her talented band's debut album, In the City of Dreadful Night, *takes its inspiration from both Victorian London and the old Calcutta of the days of the British Raj. See also page 245*

SATIRICAL SONGSTERS

Acts like Professor Elemental and The Men That Will Not Be Blamed For Nothing follow in the footsteps of 1960s art school bands such as the Bonzo Dog Doo-Dah Band, bringing satire and surreal humor into their songs. Others strike a more serious note, in the tradition of protest music: the London poet and comedian Anna Chen's *Steampunk Opium Wars* debuted at the National Maritime Museum, with poetry and songs such as "Commissioner Len Zexu's Opium Protest Song."

THOMAS TRUAX
American songwriter, performer, and inventor of extraordinary musical instruments Thomas Truax, here playing his Hornicator at the Asylum 2011. See also pages 169 and 246

THE MEN THAT WILL NOT BE BLAMED FOR NOTHING

London-based band The Men That Will Not Be Blamed For Nothing take their name from a graffiti discovered near a Jack the Ripper murder scene in the city's Victorian East End. Punk, cockney sing-songs, grindcore, and Victorian music hall are all cited by the band as influences on their work. Their quirky self-penned songs include "Victoria's Secret," about a zombie who happens to be called Albert. See also page 246

ABNEY PARK

Seattle-based Abney Park have raised the profile of the Steampunk music scene, with a sound that combines world music with industrial dance, and lyrics that encompass Steampunk themes.

See also page 246

STILLS

Electronica at Asylum 2011: vocalist Andree, with Felix on keyboard and guitar.

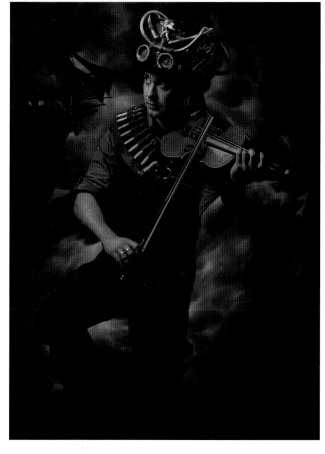

STEAMY PLAYLIST

The *Gazette's* steam-powered jukebox has randomly selected a dozen or so tracks for time travelers to sample at their leisure:

Abney Park: Herr Drosselmeyer's Doll

The Men That Will Not Be Blamed For Nothing: Stephenson

Professor Elemental: Cup of Brown Joy

Thomas Truax: Lost on the Moon in June

Sunday Driver: The Squirrel Song

Vernian Process: Something Wicked (That Way Went)

The Clockwork Quartet: The Doctor's Wife

Ghostfire: The Last Steampunk Waltz

Clockwork Dolls: The Ballad of Black Jack Jezebel

Dr. Steel: Dr. Steel

Unextraordinary Gentlemen: Dirty Old Silver

Emilie Autumn: 4 O'Clock

The Cog Is Dead: The Death of the Cog

Steam Powered Giraffe: Honeybee

Rasputina: Bad Moon Rising

Johnny Hollow: Alibi

Mr. B The Gentleman Rhymer: Hail the Chap

Humanwine: Pique

Veronique Chevalier: The Beer Hall in Hell

LEGENDS AND STORIES

Beyond the clichéd posters and T-shirts of the average rock band, Steampunk stars create and disseminate works of fiction and games that expand their world. Abney Park's fictional backstory of a time-traveling band in an airship crash informs their music and lyrics and are extended in the pages of a novel by founder Captain Robert Brown and through the Airship Pirate RPG games that are marketed on the band's website. The Unextraordinary Gentlemen also have a backstory, set in an alternate time that's a mixture of Victorian England and the American Old West. And with Clockwork Cabaret, the Davenport sisters' fictional travails amuse their fans at their shows, on their site, and in their weekly podcasts.

UNWOMAN

Solo artist Erika Mulkey takes her name from a character in Margaret Atwood's The Handmaid's Tale. *Seen here performing at Her Royal Majesty's Steampunk Symposium, her sound mixes cello with more contemporary electronic influences.*
See also page 246

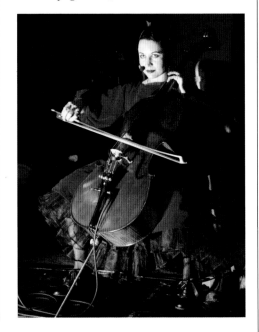

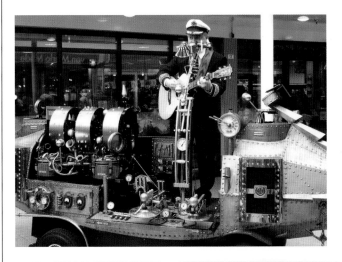

ARTHUR AND THE NAUTILUS

In the grand tradition of street performers from other eras, the one-man band seems a natural opportunity for some Steampunk customization. Dutch musician Arthur van Poppel has created for himself the ultimate one-man band vehicle, from which he plays an eclectic mix of party hits, rock and roll, country music, and even a selection of old-time Dutch waltzes.
See also page 246

JON THE MAGNIFICENT

Cited as Steampunk's foremost rock artist, seen here appearing at Her Royal Majesty's Steampunk Symposium in 2011.
See also page 246

POCKETWATCH

Consisting of a trio of banjo, cello, and folk guitar, Pocket-watch's work includes "The Watchmaker's Apprentice" and "Boiler Heart."
See also page 246

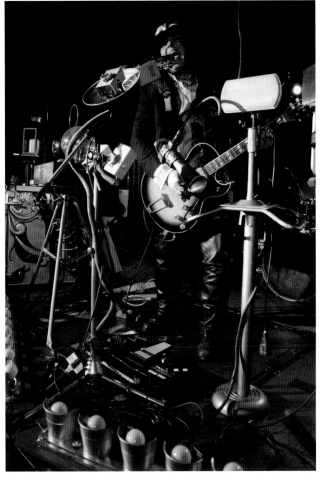

CAPTAIN ROBERT BROWN

FOUNDER AND FRONTMAN WITH PREMIER STEAMPUNK BAND ABNEY PARK

Captain Brown sings and writes the songs and plays a variety of instruments. The other main vocalist, with an amazingly versatile voice, is Jody Ellen. Kristina Erickson plays the keyboard and piano, and, according to the Captain, "keeps everyone in line." Maestro Josh Goering does things on the guitar that seem impossible; Dan Cederman provides the bass foundation; while Romanian violin player Titus Munteanu "can make the strings sing and the ladies cry at the same time."

What science fiction inspires you, and why?
His Dark Materials by Philip Pullman. His style is so clean, and his world just breathes—set in the present time, but in alternate universes. Also, *The Diamond Age* by Neal Stephenson. He's saying that the Victorian aesthetic is so luxurious that, in the far future, the very rich will be drawn to it. S.M. Stirling's *The Peshawar Lancers*—set in a future where society collapses, and rebuilds itself. I love future-Steampunk because it's possible. We know what happened in our past, but the future might yet become this world we dream about.

What other musicians are influences?
I mostly listen to vintage music—Boswell Sisters, Gene Autry, the Ink Spots, Django Reinhardt, Cab Calloway. I listen on a hand-crank victrola.

How did you come to be a Steampunk band?
We have had Steampunk themes in our lyrics for decades, and since no one was writing Steampunk songs at the time, it seemed an opportunity to free ourselves from any predefined musical styles.

What do you think about time travel?
It's a good way to make a living, if you've got the tools for it.

Why do you think music is not so prominent in Steampunk as it is in some other sub-cultures?
From my perspective, it is as prominent! There are hundreds of Steampunk bands all over the world, making hundreds of albums every year.

What is your favorite era?
My favorite era is the one that never existed, where all the eras merged in just the right way. There are things about every era that are horrible, but the beautiful thing about the fictional Steampunk world is that you can keep the wonderful parts of all times, and toss out the horrible parts.

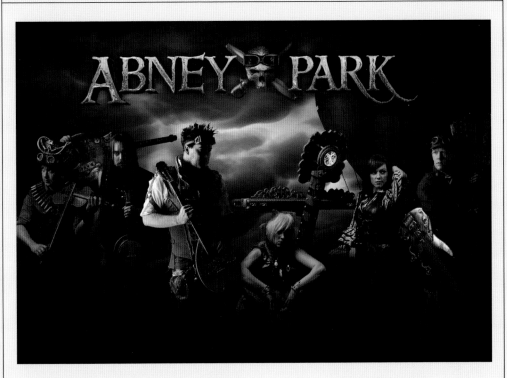

What do you like and hate about technology?

I don't hate technology; I hate the mindless way it's applied, and how its application has turned off so many peoples' minds.

ABNEY LINE-UP

Abney Park (left to right): Titus Munteanu, Josh Goering, Robert Brown, Kristina Erickson, Jody Ellen, and Dan Cederman.

What are your views on mass production?

Mass production isn't the problem. Designing products to appeal to the masses creates horribly ugly products. If you avoid specific tastes, what you make ends up being tasteless.

How did *The Wrath of Fate* come about?

The songs were based on my life. I started writing songs set in a faux-Victorian world, and code the things in my life by turning them into sci-fi. My life became the backstory for this Steampunk adventure, but the fans only knew the adventure. Eventually, it was suggested I write a novel of the story in front of the story, if you follow me.

How did you devise the Airship Pirates game?

The game was written by Cakebread and Walton, a role-playing game writing team from the UK. They wanted to make a game based on Abney Park songs. The game has been winning awards left and right, thanks to its writers and artists who contributed. When they approached me I was already writing a novel—*The Wrath of Fate*—set in this world. So, in a way, the RPG was based on the game, based on the novel, which was based on the songs.

What is in the pipeline?

Well, we've got another album due out probably before this interview gets published. We might finish the Christmas album that we've been working on for years. I'm also working on a sequel to the novel; and we've started filming cinematic videos for all of our more iconic songs.

MUSICAL INSTRUMENTS

Just as tinkerers bring an alternate reality to computers, guns, and the like, those of a musical bent bring a Steampunk aesthetic to their instruments. Some are for personal use, for sale, or purely display. Music called Steampunk by the players usually involves instruments appropriate to the genre—like trumpets and saxes for a brass band, or electric guitars and drums for a rock group.

STEAM-POWERED SOUNDS

The many genres covered in Steampunk music include world music, rock, folk, electronic, and even classical. The composer David Bruce was commissioned by Carnegie Hall to write a piece (originally for the Beethoven septet, but he added an oboe to this), and he chose to create a work entitled "Steampunk." Opening with a fanfare of French horns, a dark, brooding passacaglia follows, then a third movement inspired by the armilliary sphere, a fourth that hints at ticking clocks, and a final fifth that starts with a desolate stillness and builds relentlessly—as if it was being powered by steam—to what can only be described as a breakneck denouement.

TOOT THAT HORN

Various wind instruments have become a steam-powered sculpture in this piece, which is shown here when it was on display at the Edwardian Ball held in San Francisco in 2011.

MICROPHONE STAND

When singer/guitarist Jon the Magnificent was only five years old, he made his own microphone stand, carefully assembled from Tinker Toys. So later in life, the opportunity to have his own customized Steampunk stand was too good a chance to ignore, as far as the award-winning rock artist was concerned.

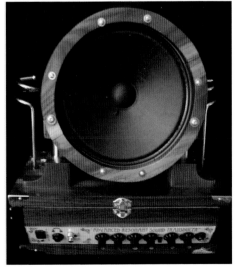

BANJO ART

Exhibited at a "History Beyond Imagination" exhibition staged at Muzeo, Anaheim, California, an old-time instrument with a decidedly Steampunk twist.

THE ADVANCED RESONANT SOUND TRANSDUCER

Ingenious cabinetry from luthier and prop maker Kyle Miller of Thin Gypsy Thief Studios.
See also pages 170 and 246 ☞

THE HORNICATOR

A unique trumpet-like instrument, the Hornicator is based on an old Victrola gramophone horn with certain customized additions that squeak and twang. Handheld, noise generation is voice-powered.

THOMAS TRUAX

Singer-songwriter Truax has created instruments from recycled microphones and mixers, and upcycled components like hubcaps and bicycle wheels, to create original sounds. Inventions include the Mary Poppins, combining spoons, aerodynamics, centrifugal force, a motorcycle headlamp, and a playing card; the Cadillac Beat-spinner Wheel, a mechanical sound sculpture; and a portable rhythm machine, the Backbeater.

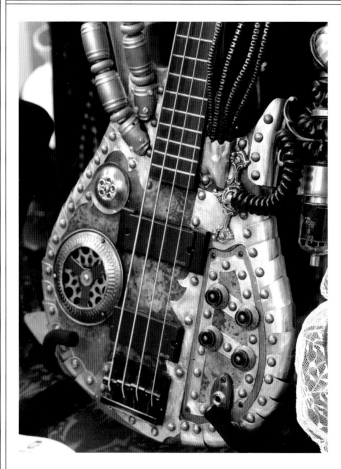

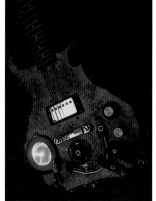

ELECTRIFIED GUITAR
Based on a vintage model, this guitar by Kyle Miller of the Thin Gypsy Thief Studios features a sound-activated built-in light effect, and a raised cable input.

THE ELDER BASS GUITAR
Commissioned by Benjamin Ensor of the band Mungus from celebrated creator Molly "Porkshanks" Friedrich, it has added tentacles (emerging top left).

STEAMPUNK GUITARS

Since its inception in the mid-20th century, the electric guitar has liberated the basic design of the instrument, now unencumbered by its previous acoustic requirements. Names like Telecaster and Stratocaster sounded straight out of sci-fi, and Steampunk musicians have helped perpetuate the tradition. There are many distinguished specialists producing these steamy axes to commission, either for performers on stage or for collectors to hang on their wall, and the ultimate recognition has been given to esteemed maker Tony Cochran, whose work has found a place in the Guitar Hall of Fame. One-of-a-kind custom guitars are the antiques of the future—or the past, depending on the direction you are traveling in.

See also page 246 👈

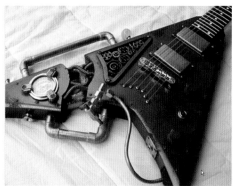

THE VILLANIZER
Thunder Eagle Customs created this rusty, copper-gilded, gear-enhanced V-shaped number from an original Jackson Randy Rhoads model, known to the world as the legendary "Flying V."

SONIC AMPLIFICATION EQUIPMENT

Powerful amplification devices that throw sound to the back of any hall (or even an outdoor stadium) are essential pieces of equipment for musicians playing the latest popular music. The best hardwood casings embellished with filigree brass set the right tone.

THE FARQUHAR & SONS ORCHESTRAL ENHANCEMENT DEVICES

Sebastian Inkerman is the talented technician behind these beautiful devices. Shown here are the basic and the deluxe models. Modified from traditional vintage valve amplifiers, they have a full-bodied, steamy sound that surpasses the tinny noise achieved by the majority of 21st-century equipment.

SCHALTZENTRALE SEQUENCER

A modular synthesizer from Moritz Wolpert of Heckeshorn Design, utilizing repurposed elements.
See also page 246

TRICK DRUMS

Copper and brass colors, pipes, horns, gauges, and other contraptions give a steamy look to this custom set, which won best of NAMM 2010.

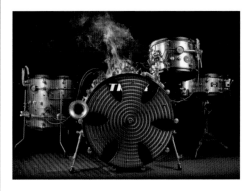

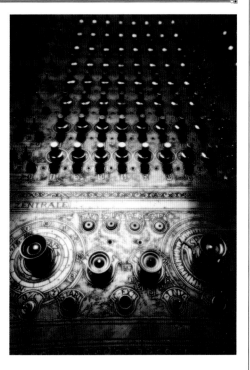

DANCE PERFORMANCE

From a ballet set in a clock tower to neo-Victorian cabaret kicks and professional ballroom dance displays, the best performances are out of this world. Dance starts with the professional skills showcased here, but it is also part of the participatory culture of extravaganzas, with classes being given at symposiums and balls encouraging visitors to take a spin on the floor.

HIGH KICKS AND MIDDLING WIGGLES

While there is an unmistakable steamy connection to burlesque, rooted in cabarets and nightclubs of the late 19th and early 20th centuries, the popularity of bellydancing is not so obvious. One trigger was in 2007, when Abney Park incorporated it into their stage show. Influenced by gothic dance and world music, this was a natural exploration for them. And "exploration" is a link back to the Victorian world, where 19th-century travelers had accounts of exotic dances in their travel journals, and Egyptian bellydancers performed at Chicago's Columbian World Exposition in 1893. *See also page 246*

STEAM UP DOWN UNDER
The Steam Up event in Melbourne, Australia, offered a spectacular night of magic, song, dance, and burlesque performances.

WHITE LIGHTNIN' BURLESQUE
Displaying her voluminous "clock face" underskirts, dancer and performer Sassy Frass of the White Lightnin' Burlesque troupe—formed in 2006 by Hellcat Harlow in Knoxville, Tennessee— in what has been described as a clockwork version of Parisienne fin de siècle Moulin Rouge style.
See also page 246

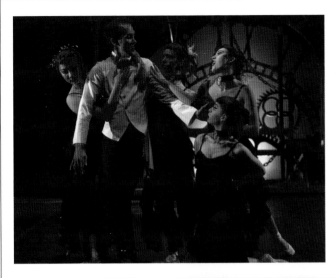

DRACULA, THE BALLET

Bram Stoker's immortal gothic horror story has long been a favorite for adaptation—on stage, screen, and as a graphic novel— and it was only a matter of time before a dance version appeared. In 2011 the Ballet Pensacola, under the artistic direction of Richard Steinert, produced its own. Set in the clock tower of an abandoned church, it utilized clockwork imagery to suggest the vampiric Count Dracula's battle with time, and had the corps de ballet dressed as bats.

ABBIE RHODE'S PSYCHEDELIC SPECTACLE

A monthly show in St. Paul, Minnesota, with a core cast of burlesque and bellydancers, musicians, and comedians, all inspired by different themes.
See also page 246 ☞

TEMPEST

Steampunk bellydancing is very popular at conventions, with artist Tempest of Nouveau Noir Dance being the best known exponent in North America.
See also page 246 ☞

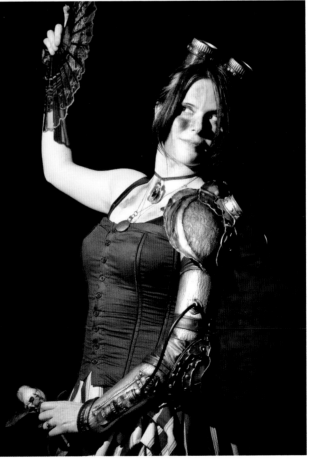

CINEMATIC AND TELEVISUAL ENTERTAINMENT

Not since the popularity of the magic lantern has there been such a cornucopia of visual excitement on offer, courtesy of the cinematic devices pioneered by men like the Englishman William Friese-Greene, America's Mr. Edison, and the Lumiere Brothers—and later via the domestic delights of the television receiver, first developed by the ingenious Scotsman John Logie Baird.

MOVING PICTURES

With the modern marvel of the moving picture, dreams and fantasies that have long been just the stuff of books can now be realized visually. Like alchemists of old, the modern magicians of the film factories—an army of talents ranging from directors, writers, and actors to camera operators, sound technicians, electrical engineers, wardrobe custodians, carpenters, designers, and makeup specialists (plus a battalion of transport operatives and food caterers when the cinematography is done "on location") conspire together to bring us experiences beyond our wildest imaginings. With the motion pictures projected by a light-emitting machine onto a vast silver screen, the spectators

CAPTAIN NEMO AND THE UNDERWATER CITY

Taking the Nemo character from Jules Verne's 20,000 Leagues Under the Sea, *a British-made cinematic saga from 1969 features a sleeker version of his Nautilus submarine, Nautilus II.*

——◦◦◦——

can gaze in awe at the spectacle acted out in front of them in the darkened auditorium. And technology has now progressed such that, in more and more picture theaters in towns and cities across the world, the long-trusted "projector," with its cogs and wheels and spools of film, has given way to the even more magical and mysterious process of screening the films digitally, without any actual machinery being involved at all.

A TRIP TO THE MOON

Made in 1902, long before the advent of talking pictures, Georges Méliès' silent epic was based on From the Earth to the Moon *by Jules Verne, and H.G. Wells's* The First Men in the Moon.

STRANGE ADVENTURES

A typical sci-fi magazine of the 1950s, featuring a cover picture from the 1950 film Destination Moon, *produced by George Pal, who went on to adapt two Wells classics,* The War of the Worlds *and* The Time Machine.

20,000 LEAGUES UNDER THE SEA

A 1954 version of the classic underwater tale, featuring some of the finest thespian talent from the Hollywood film studios, including Kirk Douglas, Peter Lorre, and James Mason as Captain Nemo.
See also page 181

THE TIME MACHINE

A replica of the device in the 1960 film that whisks our hero back and forth in time, at the Muzeo in Orange County, CA.
See also page 180

FIRST MEN IN THE MOON

Adapted from a fantasy novel by Wells, published in 1901, this 1964 sci-fi film added the intriguing opening gambit of modern astronauts landing on the moon, only to find a British Union Jack flag planted on the surface—they had been beaten there by a previous expedition that had successfully made a lunar landing during the reign of Queen Victoria.

CHITTY CHITTY BANG BANG

Set in the Edwardian era, the 1968 musical film with its iconic flying and amphibious car is based on a novel by James Bond author Ian Fleming.

WAR OF THE WORLDS

Relocated to modern America rather than Wells's English town of the late 19th century, the Mars-invasion epic released in 1953 won an Academy Award for its realistic—and then state-of-the-art—special effects.

AROUND THE WORLD IN 80 DAYS

Another amazing travel saga from the pen of Jules Verne, this time an around-the-world trip by hot-air balloon. The blockbuster 1956 film starred David Niven as English gentleman Phileas Fogg, who circumnavigates the globe in order to win a bet.

INFINITE POSSIBILITIES

In one of the infinite number of parallel universes, whatever bizarre combination of circumstances you care to choose will actually occur. Sometimes beyond the realms of physical possibility, the fantasy creations of novelists and other dreamers were windows on these other worlds, though only accessed through the written word. Even the recent past was reduced to a faded black-and-white photo here, an inanimate found object there. But cinema technology has made anything possible, including the time-bending Steampunk universe.

THE LEAGUE OF EXTRAORDINARY GENTLEMEN

Based on comic books by Alan Moore, the film features various fictional characters such as Captain Nemo, Dorian Gray, Dr. Jekyll and Mr. Hyde, and H. Rider Haggard's adventurer, Allan Quartermain.

SHERLOCK HOLMES

The subject of scores of films over the years, the 2009 take on the Conan Doyle character was probably more to the liking of Steampunk afficionados than most of its predecessors. With a plot involving secret societies, magic rituals, bizarre gadgets, and a fiendish plot to overthrow the British Empire, then the United States, and then the world, the outlandish tale—with Robert Downey, Jr. as Holmes and Jude Law as Watson— seems to take place in some alternative universe rather than the fog-laden London streets of the well-loved detective yarns.

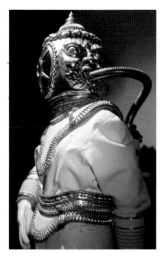

WILD WILD WEST

This western with a difference was based on a 1960s television series. With fabulous weaponry, the two heroes battle an inventor who threatens to destroy the USA unless his wishes are met. An arsenal of gadgetry is brought into play, including spring-loaded notebooks, a nitroglycerine-powered penny-farthing bicycle, bulletproof chainmail, and even a steam-powered tank.

THE CITY OF LOST CHILDREN

A bizarre French film from 1995, the fantasy of a mad scientist stealing children's dreams is set in a sinister post-apocalyptic dystopian future.

THE GOLDEN COMPASS

In a parallel universe, children are abducted by evil forces, with a malevolent combination of witchcraft and implausible mechanical inventions.

MUST-SEE FILMS

A Trip to the Moon 1902
Things to Come 1936
The War of the Worlds 1953
20,000 Leagues Under the Sea 1954
Around the World in 80 Days 1956
From the Earth to the Moon 1958
Journey to the Center of the Earth 1959
The Time Machine 1960
The First Men in the Moon 1964
The Wild Wild West 1999
League of Extraordinary Gentlemen 2003
Sherlock Holmes 2009

TELEVISION: THE MAGIC BOX

When John Logie Baird tinkered with his electric lights, revolving discs, and a ventriloquist's dummy (the first TV star!) straight from the local music hall, little did anyone imagine that the instrument "receiving" the blurred image—which he fashioned with an old hatbox, a pair of scissors, some darning needles, a few bicycle light lenses, a used tea chest, and sealing wax and glue— would revolutionize home life just as the cinema had changed public entertainment. Now the magic box of television can bring into every home world events as they happen, the latest dramas from leading playwrights, documentaries on the natural and scientific world, and even parlor games turned into national contests, with prizes worth millions.

DOCTOR WHO

Doctor Who *made his first appearance on British television in 1963. Time-traveling though a myriad of parallel universes, his vehicle the Tardis looks from the outside like a London police telephone booth of the early 1960s. Among the Doctor's many foes, the most consistent have been the dreaded Daleks, who look as if they were put together in some mad professor's laboratory.*
See also page 246

RIESE: KINGDOM FALLING

In this ten-part online series, later broadcast on terrestrial stations, the heroine Reise travels with her wolf, Fenrir, across war-ravaged Eleysia, fleeing The Sect, a mysterious religious group intent on killing her. The series has spawned an alternate reality online game called "The Sect, and Reise: Battle for Eleysia," a game for iphones.
See also page 246

THE WILD WILD WEST

The precursor of the 1999 movie, the TV series ran from 1965 through to 1969. Ross Martin played inventor Artemus Gordon, and Robert Conrad his sharp-shooting sidekick James West, both agents of the Secret Service protecting the President Ulysses S.Grant from various threats. A western-themed story in an alternate universe, with all sorts of gadgetry at hand, it has been hailed as a Steampunk saga ahead of its time.

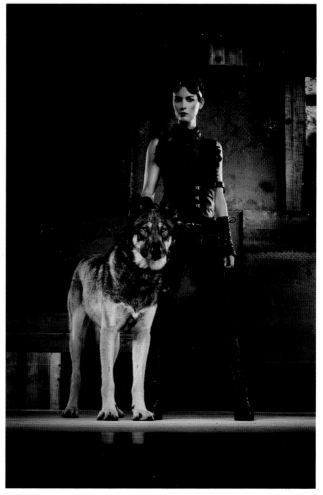

PRINTED MATTER

Steampunk was born out of science fiction novels and magazines, the name coined in K.W. Jeter's letter to *Locus* magazine in the 1980s: "Personally, I think Victorian fantasies are going to be the next big thing, as long as we can come up with a fitting collective term for Powers, Blaylock, and myself. Something based on the appropriate technology of the era; like 'Steampunks,' perhaps …"

PRECURSORS

Long before Steampunk, since Mary Shelley's Frankenstein in 1818, creatures like vampires and zombies have featured in fiction. Then Jules Verne and H.G. Wells combined science fact and fiction, introducing space and time travel to the popular novel. Other early Steampunk tropes include Arthur Conan Doyle's Sherlock Holmes stories, the works of H.P. Lovecraft, particularly those spreading the Cthulhu mythos, Jean de la Hire's creation of the first pulp fiction superhero in *Nyctalope*, and Bernhard Kellermann's *Der Tunnel*, which tells of an engineer who wants to build a tunnel between America and Europe.

H.P. LOVECRAFT
The Cthulhu myths developed from Lovecraft's 1928 story in Weird Tales *magazine and describe an evil, tentacled cross between a dragon, human, and octopus. His major works include* The Call of Cthulhu, *and from 1936,* The Shadow Out of Time.

H.G. WELLS
One of the founding fathers of science fiction, H.G. Wells is best known for The Time Machine *(1895),* The Island of Doctor Moreau *(1896),* The War of the Worlds *(1898),* The Invisible Man *(1897),* The First Men in the Moon *(1901), and* The Shape of Things to Come *(1933).*
See also page 175 *See also page 175*

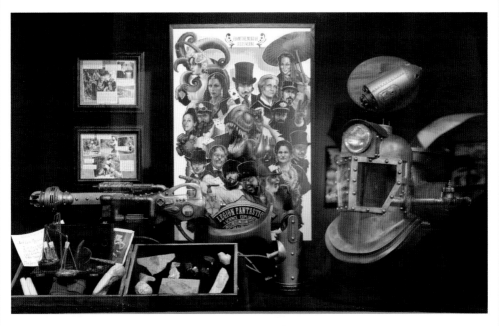

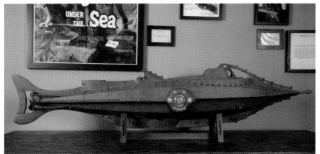

JULES VERNE

Verne's visionary works of speculative fiction A Journey to the Center of the Earth *(1864),* 20,000 Leagues Under the Sea *(1870), and* Around the World in Eighty Days *(1873) have also inspired movies and TV shows; some of the props and posters are shown above and left.*

MERVYN PEAKE

In his Gormenghast novels, Peake anticipates Steampunk in featuring an alternate timeline for technology, influencing later writers such as China Meiville.

HUGO GERNSBACK

Founder of Amazing Stories, *the world's first sci-fi magazine, in 1926, Gernsback helped the genre grow via the letter pages of his magazine. The Hugo sci-fi awards are named after him.*

K.W. JETER

A 1987 classic written by the man who coined the term Steampunk, and subtitled "A Mad Victorian Fantasy," Infernal Devices *tells the sinister story of George Dower, an idle young gentleman who has inherited his father's watchmaking business despite having little inclination for clockwork. Set in 19th-century London, it features time travel, automatons, fish people, and sexual intrigue.*

THE BOOK GROUP

In addition to other titles here, reflect on:
Homunculus by James Blaylock
Soulless by Gail Carriger (from "The Parasol Protectorate" series)
Perdido Street Station by China Miéville
The Alchemy of Stone by Ekaterina Sedia
The Diamond Age: Or, a Young Lady's Illustrated Primer by Neal Stephenson
The Anubis Gates by Tim Powers
Clockwork Angel by Cassandra Clare (from the *Infernal Devices* trilogy)
The Golden Compass by Philip Pullman
The League of Extraordinary Gentlemen by Alan Moore / Kevin O'Neill
Mortal Engines by Philip Reeve (from the "Hungry City Chronicles" series)
The Half-made World by Felix Gilman
Retribution Falls by Chris Wooding
Steampunk: An Anthology by Ann and Jeff VanderMeer
Morlock Night by K.W. Jeter
Warlord of the Air by Michael Moorcock
The Steampunk Trilogy by Paul Di Filippo (the first book with "Steampunk" in its title)
Mainspring by Jay Lake
Larklight by Philip Reeve
Queen Victoria's Bomb by Ronald W. Clark

SCOTT WESTERFELD
Leviathan, Behemoth, *and* Goliath *are a trilogy of novels aimed at young adults, set in an alternate version of the First World War—"The Great War" as it became known among the generation that survived it. Charles Darwin, Hapsburg princes, and Winston Churchill are all thrown into the mix and reinvented.*

ROBERT RANKIN

Pictured with his wife, famed musician Rachel Hayward, the author of "far-fetched fiction," Robert Rankin is a Fellow of the Victorian Steampunk Society. See also page 246 See also page 246

TOBY FROST

Inspired by UK heroes Biggles and Dan Dare, Frost's Space Captain Smith *stories are a romp through an alternate universe.* See also page 246

CHERIE PRIEST

Boneshaker *is an alternate reality story that mixes mad scientists, airships, and the living dead.* See also page 246

WILLIAM GIBSON

An icon of Steampunk literature, The Difference Engine *is set in an alternate London of 1855, where the computer age has begun after the invention of a revolutionary analytical engine.* See also page 246

"A steampunk-zombie-airship adventure of rollicking pace and sweeping proportions, full of wonderfully gnarly details. This book is made of irresistible."
—SCOTT WESTERFELD

CHERIE PRIEST

BONESHAKER

SciFi
A SCI FI ESSENTIAL BOOK

GRAPHIC NOVELS AND COMICS

Comic strips—and their more literary-sounding offshoot, the graphic novel—explore alternate worlds where science, steam, clockwork, industry, and invention abound. In the much-revered 20th-century tradition of pulp comics, but with a Steampunk twist, heroes and heroines battle against authority, save the world, and often find romance along the way. Many are subsequently turned into other forms of entertainment, such as cinema films, anime movies, or role-playing games.

STEAMPUNK SUPERHEROES

In its "Elseworlds" series, DC comics transport their superheroes into alternate realities, some of which chime with Steampunk. Others could be labeled differently; for example, *Superman's Metropolis*, based on German Expressionist cinema, could be called dieselpunk. The first title, *Gotham by Gaslight*, sees Batman in 1889, in a Gotham City stalked by Jack the Ripper. Later ones include *Batman: Leatherwing*, in which the super-hero is a pirate employed by the British Crown.

GIRL GENIUS

These gas lamp fantasies by Phil and Kaja Foglio, with airships, monsters, a dashing hero, and a brilliant heroine, started life as a web comic.
See also page 246

LE REGULATEUR SERIES

Aristide Nyx, the hero of this comic by writer Eric Corbyran and illustrators Eric and Marc Moreno, has nerves of steel and reinforced concrete technique.
See also page 246

LADY MECHANIKA

At the turn of the 20th century, Joe Benitez's heroine, the sole survivor of a serial killer's rampage, is found in a laboratory, with no memory of her capture or her former life. During her forced incarceration her limbs have been replaced by mechanical components. She builds a new life as a private detective, going out to solve supernatural or scientific cases that the police cannot unravel themselves. See also page 247 ☞

IRON WEST
Doug TenNapel's graphic novel describes an old West with robots and other new-fangled devices.

THE LEAGUE OF EXTRAORDINARY GENTLEMEN

Alan Moore and illustrator Kevin O'Neill tell the story of a team of famous characters hired by the Crown to protect London from an airship invasion in 1898. See also page 177 ☞

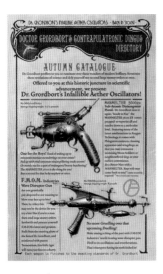

DOCTOR GRORDBORT'S CONTRAPULATRONIC DINGUS DIRECTORY

The New Zealand–born artist Greg Broadmore has created an imaginary catalog of amazing scientific contraptions including ray guns, metal men, rocketships, and a comic strip of the Venusian exploits of naturalist adventurer Lord Cockswain. Broadmore also designs for the special effects company Weta Workshop, with whom he has worked on 2005's King Kong. *See also page 247*

See also page 247

TIME LINCOLN

Juxtaposing a array of historic characters and circumstances, this comic strip take on an alternative history pictures Abraham Lincoln at the moment of his assassination, standing up to the evil Joseph Stalin. The Russian communist dictator is traveling in time with the aid of the most iconic of vehicles, the Time Machine from the novel by H.G. Wells. See also page 247

See also page 247

STEAMPUNK COMIC SERIES

By Chris Bachalo and Joe Kelly. Cole Blaquesmith awakes in a high-tech Victorian London with a mechanical arm.
See also page 247

SEBASTIAN O

Grant Morrison's Sebastian O is a trained assassin living in a technologically advanced model of Victorian London.
See also page 247

THE ADVENTURES OF LUTHER ARKWRIGHT

Bryan Talbot's adventurer made his first appearance in the 1970s as a comic strip in underground magazines and was then published in the 1980s as a comic book series, and again in 2006 as a webcomic. Luther Arkwright can move between parallel universes by force of will, working with agent Rose Wylde to defeat the Disruptors in different parallels.
See also page 247

THE FULL METAL ALCHEMIST SERIES

Hiromu Arakawa's manga series, which is set in an alternative universe, introduces the brothers Alphonse and Edward Ulric, who live in a society consumed with alchemy and the pursuit of immortality. While he attempts to bring back the soul of their dead mother with advanced alchemy, Edward's soul becomes trapped in a suit of steel, and he is forced to use his new-found powers to act as an agent of the government.
See also page 247 👉

THE LEGACY OF ILLUSTRATION

Classic 19th-century novels, and not just those designed for children, were more often than not supplemented by illustrations (and often were sold in serial form, but that's another story). Some, like John Tenniel's celebrated illustrations for *Alice in Wonderland* or Arthur Rackham's for Grimm's fairy tales, brought lasting fame for the illustrators. For much of the 20th century, illustrations had disappeared from all but a minority of works for adults; although some were commissioned, they were an exception rather than the rule.

TALES FOR ALL AGES

One such was Mervyn Peake, who in the 1940s and '50s, in addition to illustrating his own novels, was commissioned to produce illustrations for editions of the classics *Bleak House* and *Treasure Island*. Today, Steampunk artists are in no small part helping to revive the marriage of words and pictures in tales for folks of all ages, whether it be disseminated in print or on the aethernet. And in recent years, some classic 19th-century works of fiction have been reworked in graphic novel form.

STEAMPUNK POE

Poe's stories and poems are illustrated here by Zdenko Basic and Manuel Sumberac. Among delights included are clockwork gears, hot-air balloons, top hats, parasols, eerie architecture, spooky settings, and bizarre characters. They are presented as traditional plates, rather than as the more conventional comic strip in graphic novel format.

NEOTOPIA

Rod Espinosa's comic explores a utopian future where magic, nature, and humans live in harmony. Evil threats are fought off by the plucky heroine Nalyn.
See also page 247

GRANDVILLE

Award-winning Brian Talbot's graphic novel is set in a world of anthropomorphic animals, in which France won the Napoleonic wars and invaded Britain.
See also page 247

LES CITES OBSCURES

Cities of the Fantastic is a graphic novel series by Belgians François Schuiten and Benoit Peeters, set on a counter-earth where humans live in city states.
See also page 247

CLOCKWORK ANGELS

Lea Hernandez's supernatural story takes place in a neo-Victorian Texas.
See also page 247

EXCLUSIVE COMIC STRIP

Illustrator and scientist, founder of the *Steampunk Literary Review*, and creator of alternative comics, Geof Banyard is otherwise known as Doctor Geof. His visual musings on Steampunk and science, along with tea, trousers, and other distractions can be found at The Island of Doctor Geof situated on the aethernet. *See also page 247* ☞

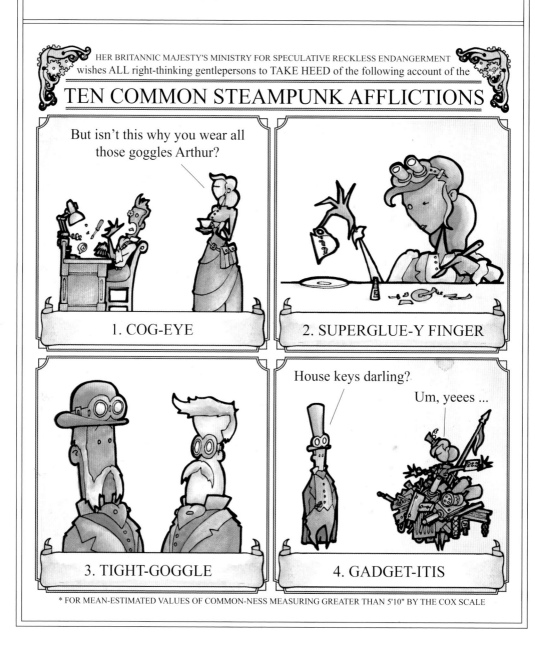

HER BRITANNIC MAJESTY'S MINISTRY FOR SPECULATIVE RECKLESS ENDANGERMENT wishes ALL right-thinking gentlepersons to TAKE HEED of the following account of the

TEN COMMON STEAMPUNK AFFLICTIONS

But isn't this why you wear all those goggles Arthur?

1. COG-EYE

2. SUPERGLUE-Y FINGER

3. TIGHT-GOGGLE

House keys darling?

Um, yeees ...

4. GADGET-ITIS

* FOR MEAN-ESTIMATED VALUES OF COMMON-NESS MEASURING GREATER THAN 5'10" BY THE COX SCALE

5. RAY GUN MISHAP

GIVE ME BACK MY CAKE!

6. SENTIENT MECHANISM

It's the third pocket watch they've had off me this week, the little blighters!

7. HAT MAGPIES

Aaar, sixty years in the service right enough!

8. ZEPPELINEERS' LUNG

I don't know, Matthew. I was thinking we could go for some tea with the Reverend before smashing the system?

9. PUNK

OW!

10. STEAM

THE VIRTUAL WORLD

The aethernet is home to virtual worlds, not unlike the Metaverse recorded in Neal Stephenson's *Snow Crash*, that enables users to journey to fantasy locations. Some of these worlds include regions that merge Victorian aesthetics with alternate technology, like New Babbage in Second Life, while others, such as Entropia Universe, allow the user to travel through space between worlds.

SECOND LIFE

A desk-bound chance to role-play, users interact through avatars ("residents") and can immerse themselves in exploring, trading in virtual property and services, and even building virtual objects. When first launched in 2003, there were widespread misgivings that some of its visitors might prefer it to the real world, and never return. And things can seem pretty real. In the marketplace linden dollars can be exchanged for anything from a dirigible to a top hat, and residents can explore Steampunk cities such as NeoVictoria, with its cobbled streets modeled on Victorian London, or take in the 19th-century American-Victorian Steelhead Port Harbor. Find more guidance from active travelers and traders, such as Steampunk Adventures in Second Life, in their online e-zines.

THE NEW WORLD

Explore alternate worlds online, where you can design your own appearance and build houses and businesses—the only limit is your imagination.

NEW BABBAGE

New Babbage is Second Life's Steampunk city, a Victorian area lavishly equipped with airships, clockwork devices, submersibles, and the like. It has an Academy of Industry to instruct builders in Steampunk, neo-Victorian, and retro-futurist building styles, and even its own militia. For those content to enjoy the Steampunk experience via their home computer or mobile device, this is an alternative to the full-on pleasures of an extravaganza.
See also page 247 🖝

⨠ ACADEME BY MIKE PERSCHON ⨠

Five years ago, searching "Steampunk" in my University's databases turned up only one article. Now, I am certainly not the Lone Scholar anymore. Steampunk studies are certainly a growing specialization, as evidenced by the Chair of my department's willingness to let me attend Steampunk conventions instead of academic conferences.

BIBLIOGRAPHY OF ACADEMIC ARTICLES

Alkon, Paul. "Alternate History and Postmodern Temporality." Time, Literature, and the Arts: Essays in Honor of Samuel L. Macey. Ed. Thomas R. Cleary. Victoria: University of Victoria, 1994. 65-85.

Barratt, Caroline Cason. "Time Machines: Steampunk in Contemporary Art." NVS 3:1 (2010): 167-188.

Blair, Kirstie. "'The Steam Arm': Proto Steampunk Themes in a Victorian Popular Song." NVS 3:1 (2010): 196-207.

Bowser, Rachel A. & Croxall, Brian. "Introduction: Industrial Evolution." NVS 3:1 (2010): 1-45.

Bullen, Elizabeth, and Elizabeth Parsons. "Dystopian Visions of Global Capitalism: Philip Reeve's Mortal Engines and M.T. Anderson's Feed." Children's Literature in Education. 38.2 (2007): 127-139.

Fast, John. "Machinery of Blood: Melville's 'The Bell Tower' as Ambiguous Steampunk Horror." New York Review of Science Fiction 20.1 [229] (2007): 18.

Forlini, Stefania. "Technology and Morality: The Stuff of Steampunk." NVS 3:1 (2010): 72-98. Web. 22 Jan. 2012.

Gamble, Sarah. "You cannot impersonate what you are": Questions of Authenticity in the Neo-Victorian Novel." LIT: Literature Interpretation Theory 20.1/2 (2009): 126-140.

Good, Joseph. "God Save the Queen, for Someone Must!": Sebastian O and the Steampunk Aesthetic." NVS 3:1 (2010): 208-215.

Gordon, Joan. "Hybridity, Heterotopia, and Mateship in China Miéville's Perdido street Station." SFS 30.3 (2003): 456-476.

Hantke, Steffen. "Difference Engines and Other Infernal Devices: History According to Steampunk." Extrapolation (Kent State University Press) 40.3 (1999): 244-254.

Heilmann, Ann. "Doing It With Mirrors: Neo-Victorian Metatextual Magic in Affinity, The Prestige and The Illusionist." NVS 2:2 (Winter 2009/10): 18-42.

Hendrix, Howard. "Verne among the Punks," Or "It's Not Just a Victorian Clockwork." Verniana. 2 (2009).

Jagoda, Patrick. "Clacking Control Societies: Steampunk, History, and the Difference Engine of Escape." NVS 3:1 (2010): 46-7.

Jones, Jason B. "Betrayed by Time: Steampunk & the Neo-Victorian in Alan Moore's Lost Girls and The League of Extraordinary Gentlemen." NVS 3:1 (2010): 99-126.

Kelleghan, Fiona. "Interview with Tim Powers." SFS 25.1 (1998): 7-28.

Kendrick, Christopher. "Monster Realism and Uneven Development in China Miéville's The Scar." Extrapolation (University of Texas at Brownsville) 50.2 (2009): 258-275.

Latham, Rob. "Our Jaded Tomorrows." SFS 36.2 (2009): 339-349.

Llewellyn, Mark. "Neo-Victorianism: On the Ethics and Aesthetics of Appropriation." LIT: Literature Interpretation Theory 20.1/2 (2009): 27-44.

Munford, Rebecca, and Paul Young. "Introduction: Engaging the Victorians." LIT: Literature Interpretation Theory 20.1/2 (2009): 1-11.

Nevins, Jess. "The Nineteenth Century Roots of Steampunk." New York Review of Science Fiction 21.5 [245] (2009): 1.

---. "Prescriptivists vs. Descriptivists: Defining Steampunk." SFS 38:3. (2011): 513-518.

Onion, Rebecca. "Reclaiming the Machine: An Introductory Look at Steampunk in Everyday Practice." NVS 1:1 (2008): 138-163.

Partington, Gill. "Friedrich Kittler's 'Aufschreibsystem.'" SFS 33.1 (2006): 53-67.

Perschon, Mike. "Finding Nemo: Verne's Antihero as Original Steampunk." Verniana. 2 (2010).

---. "Steam Wars." NVS 3:1 (2010): 127-166. Web. 22 Jan. 2012.

---. "Steampunk: Technofantasies in a neo-Victorian Retrofuture." Postmodern Reinterpretations of Fairy Tales: How Applying New Methods Generates New Meanings. Ed. Anna Kérchy. Lewiston: Edwin Mellen Press, 2011. 83-106. Print.

Pike, David L. "Afterimages of the Victorian City." Journal of Victorian Culture 15.2 (2010): 254-267.

Quigley, Marian. "A Future Victorian Adventure: the Mysterious Geographic Explorations of Jasper Morello." Screen Education 54 (2009): 125-129.

Rose, Margaret. "Extraordinary Pasts: Steampunk as a Mode of Historical Representation." Journal of the Fantastic in the Arts 20.3 (2009): 319-333.

Sakamoto, Michaela. "The Transcendent Steam Engine: Industry, Nostalgia, and the Romance of Steampunk." The Image of Technology. 124-131. Pueblo, CO: Society for the Interdisciplinary Study of Social Imagery, Colorado State University-Pueblo, 2009.

Voigts-Virchow, Eckart. "In-yer-Victorian-face: A Subcultural Hermeneutics of Neo-Victorianism." LIT: Literature Interpretation Theory 20.1/2 (2009): 108-125.

Yasek, Lisa. "Democratising the Past to Improve the Future: An Interview with Steampunk Godfather Paul Di Filippo." NVS 3:1 (2010): 189-195. Web. 22 Jan. 2012.

NVS=Neo-Victorian Studies
SFS=Science Fiction Studies

EXTRAVAGANZAS

Around the world, all manner of gatherings including conventions, festivals, exhibitions, balls, picnics, and a host of other delightful events are bringing the Steampunk community together to exchange views, admire costumes and props, purchase specially made wares, and even enjoy performances from musicians, comedians, burlesque artists, circus acts, and many other intriguing performers. At these various soirées and get-togethers you will find dedicated events, as well as the broader conventions that cater to wider groups and communities, such as science fiction fans or comic enthusiasts. The rising popularity of these events coincided with revivals in burlesque and cabaret nights both in Europe and in North America, plus an increase in the participation in immersive events across the board. Murder mystery weekends and themed evenings such as the Secret Cinema events in London have brought the whole idea of immersion experiences to a much wider public, and spiked public interest in dressing up and exploring the edges of the role-playing genre. For many new inductees, this has been only a step away from entering the Steampunk universe.

PERFORMANCES

Steampunk events offer a broad range of entertainment, from folk groups to heavy metal, to goth or electronic music—plus dance, movies, and comedy turns. Along with gentlemanly pursuits like falconry and fencing, you can take in burlesque, belly dancing, fire-eating, and other esoteric performances. Whether at an evening ball or a weekend convention or symposium, you will certainly be entertained, enlightened, and amused.

THE SOUR MASH HUG BAND

With claw-hammer banjo, fiddle, guitar, and bass, performing in New Orleans, their music embraces muzica lautareasca, New Orleans jazz, old-time fiddle music, and Yiddish theater. See also page 247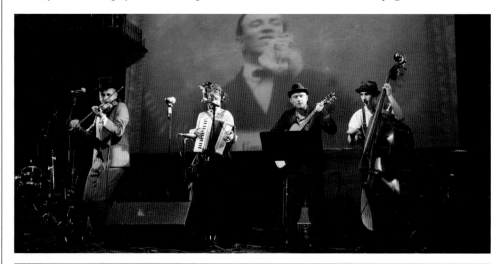

THE LARP EXPERIENCE

The LARP genre as it exists today grew out of a number of activities, including historical reenactment, improvisational theater, and the hugely popular tabletop role-playing games like Dungeons and Dragons. If you have not experienced a LARP—live action role-playing game—a Steampunk setting is the perfect place to do so. A game-master decides on a fictional setting and rules, while the players decide what character they are going to adopt and follow the agreed-on rules to act out their character's actions and achieve the preset goals. To enhance the "reality" of the situation, a player may dress in character—half the fun for most participants—and also include appropriate props in the game. In comparison to the great majority of video games, which are mostly male-oriented and involve either violent combat or sport, most LARPs are designed to appeal equally to both men and women.

Nine Paradoxes

CURRENCY

Money used in LARP (live action role-playing) game Deliverance.

WEEKEND AT THE ASYLUM

The annual Weekend at the Asylum is the largest Steampunk festival in Europe, attracting around 1,000 Steampunks from across the world. Events range from appearances by leading authors and performances by musical stars to a radio play, parasol and dance workshops, bazaars and markets, races and duels, a "Great Exhibition," and a costume competition.

A RECORD GATHERING

Asylum Steampunks gathered in the grounds in an attempt to set the Guinness World Record for a gathering of costumed Steampunks (with a head-to-toe outfit as well as headgear, and at least one wearable gadget). A grand total of 452 persons convened for the occasion.

CELEBRITIES

Stars at Asylum events in the past have included authors Robert Rankin and Wilf Lunn, and some leading Steampunk musical acts, including Abney Park, Thomas Truax, and The Men That Will Not Be Blamed For Nothing. Performances were given and signings were undertaken before the stars enjoyed the atmosphere, judged fashion contests and expositions, and met their adoring public. *See also page 247*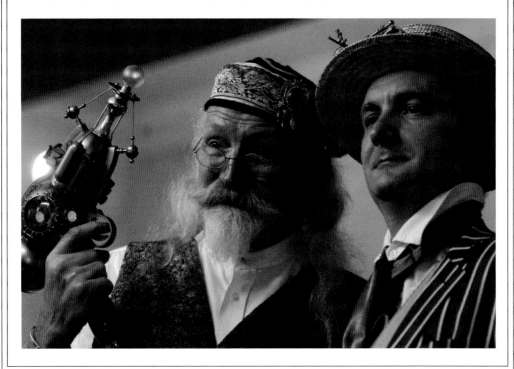

ROBERT RANKIN

Author Robert Rankin launched his book The Mechanical Messiah and Other Marvels of the Modern Age *at Asylum 2011 (pictured with Herr Döktor). See also page 247*

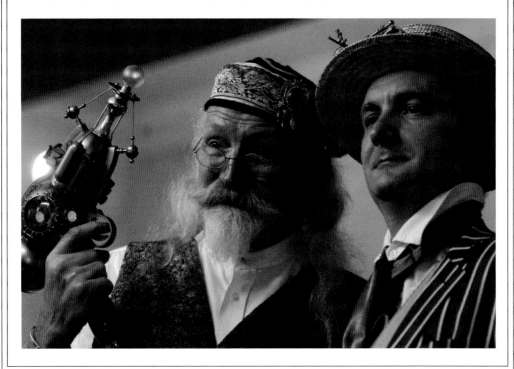

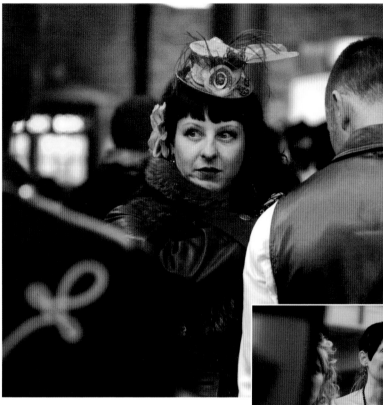

WILF LUNN

Inventor and all-around genius celebrating the publication of his book My Best Cellar, *an autobiography up to the age of eleven and other "stuff."*
See also page 247 👉

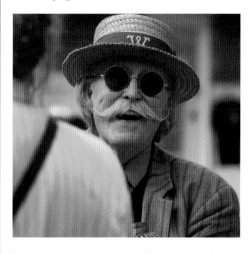

IN THE BALLROOM

At the center of the old Victorian mental asylum in Lincoln, England, that gave the Weekend at the Asylum event its name, is a grand ballroom that hosts celebrity signings, manufacturer's demonstrations, dance classes, evening soirees, and a very splendid Saturday night ball that is the highlight of the weekend.

MERCHANT QUARTERS

The Asylum is an opportunity to purchase wondrous Steampunk goods from around the world that you cannot find in your local market. Traders include jewelers, manufacturers of leather goods, corsetiers, dressmakers, apothecaries, hatmakers, purveyors of collector's curiosities, writers, artists, and other image makers.

BAZAAR ECLECTICA

Set in the old Lincoln Castle prison dating from 1787, each cell is transformed into a pop-up store, and customers stroll along to view all the wondrous wares for sale.

THE ILLICIT MARKET

Buyers were able to enjoy smuggled exotica at this undercover event. There were no tables or furniture, and everything sellers offered was carried in by them alone in a single trip and hidden from view. After forty minutes of frantic browsing and buying, there was a warning that "the authorities are on the way," and buyers were given just five minutes to leave. The Guild of

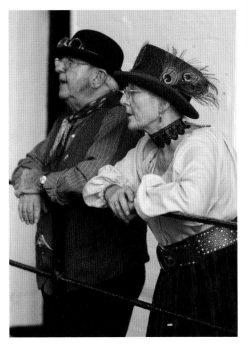

WATCHING THE WORLD
A couple in their casual day clothes pause to rest and view the crowd.

Privateers, Illicit Entrepreneurs, and Scoundrels (The Guild of PIES, or otherwise known as the "Piemen") were on the lookout for the authorities and enforced a nominal charge to sellers and to buyers exiting the event after the five minutes had elapsed. This was all in accordance with the rules governing such trading, which stipulate:

* Sellers are required to pay a single token for trading.
* People wishing to sell can enter from a set time.
* Buyers will be allowed to enter free of charge.
* Buyers who take five minutes and one second or more (with a countdown), to exit after the set time for the market to close, will be obliged to pay an exit fine.
* Any seller who has not exited the room will also be saddled with an exit charge.
* Everyone wishing to participate must agree to the terms and conditions.

PROMENADING
A quartet of gentlemen looking intently for some likely merchandise to purchase.

GEM SMUGGLER

Miss Lucy Fraser of Kind Cogs and Coronets had a sparkling selection of Steampunk jewelry hidden in her coat.

DONE DEAL

A military gentleman considers a purchase at the illicit market. Although officially not approved of, the clandestine bargaining and bartering added much to the shopping experience.

SAFEGUARDING THEIR WARES

Stalls at the Asylum were set in the old prison cells, providing reassuring security for all the vendors. Should there have been a threat of petty thieves, purse-snatchers, or pickpockets, the well-equipped guards proved an effective deterrent, armed with a veritable arsenal of steam rifles, ray guns, flintlock pistols, and reassembled blunderbusses. It would have taken a brave (or foolish) ne'er-do-well to invite the wrath of such a batallion.

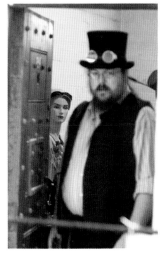

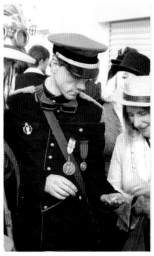

PERFORMANCES

Leading lights and rising stars of the musical world have performed at the Asylum. Saturday night ball guests were entranced by the singer Chandrika Nath and her talented band, Sunday Driver, playing songs from their debut album *In the City of Dreadful Night*, which takes its inspiration from Victorian London and Raj-era Calcutta. Then guests traveled to the future to listen to the alternative electronica from east London duo Stills—featuring Andree on vocals and Felix on keyboard, guitar, and electronic mixing. While in the hall, Thomas Truax, with his custom-designed steam-powered instruments, was followed by the entertaining band, The Men That Will Not Be Blamed For Nothing.

See also pages 162–163

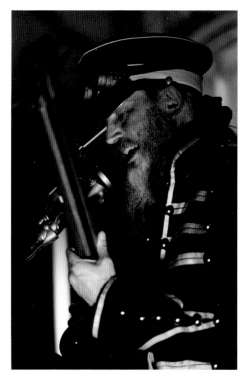

BB BLACKDOG
Dale Rowles (a.k.a. Lieutenant Jager Schnitzel) is the 4-string bass player and vocalist for Steampunk psychedelic rock band BB Blackdog.

THE GREAT EXHIBITION

Ingenious articles were on display for viewer's delectation, and prizes were awarded for ingenuity and innovation.

THE SARTORIAL RESPLENDATOR
Flattens with ease those tricky creases, from the delicate silk cravat to the dirigible envelope. Manufactured by Mr. Anonymous Bosche.

DR. ORLANDO WATT'S PORTABLE TISSUE REGENERATOR
Winner of the Jules Verne Award for Ingenuity, this marvelous machine, invented by Mr. Peter Harrow, will enliven any flagging human.

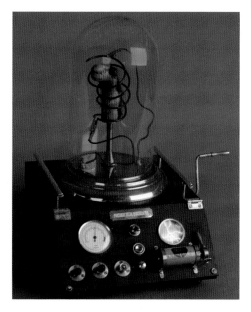

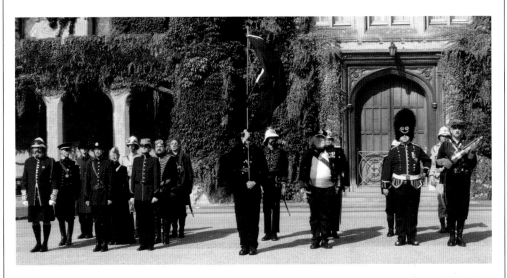

CEREMONIAL

Troops were inspected by Queen Victoria, a minute's silence was held for the 10th anniversary of 9/11, and the Ode to Remembrance was read (a UK honor to the dead of the Great Wars).

THE MILITARY PARADE

Members of the Steampunk forces gather in the Lincoln castle grounds for a Sunday morning parade. Participants come from many regiments and regions, both within the British Isles and the far-flung corners of the Empire, drawn together by a common love of the pomp and circumstance of uniformed ceremony, and ranging from the traditional foot soldiers to gallant space warriors.

THE 3RD (FOOT AND MOUTH) REGIMENT

The regiment gets its name from the classic "Carry On" movies, recreating soldiers of this fictitious outfit at various events to raise money for charities. The kit worn by the 3rd Foot and Mouth on screen, however, is not accurate for the assumed period, set in 1895. Principally they are equipped as soldiers of the 2nd South African (Boer) War, but wearing the white helmet without a cover, and with Edwardian 1902 pattern tunics.

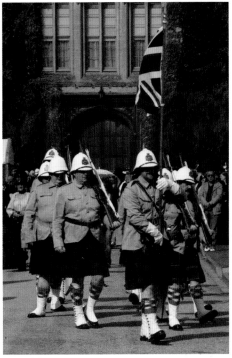

SOLDIERS OF THE QUEEN

Just as the womenfolk at these events enjoy the chance to dress up in all the finery of their Victorian sisters of yesteryear, so the gentlemen (and, it has to be said, a few ladies) take pride in wearing the uniform of soldiers of the Queen.

HER ROYAL MAJESTY'S STEAMPUNK SYMPOSIUM

All aboard the steamship Queen Mary, docked at Long Beach, California. Her Royal Highness Queen Victoria invited all the subjects of the realm to a public symposium of the latest steam inventions and contraptions by some of the finest minds around the world. Adventures abounded; teas, dinners, and entertainments were plentiful; and the select group of subjects invited on board strolled the decks and salons of this sumptuous sailing ship.

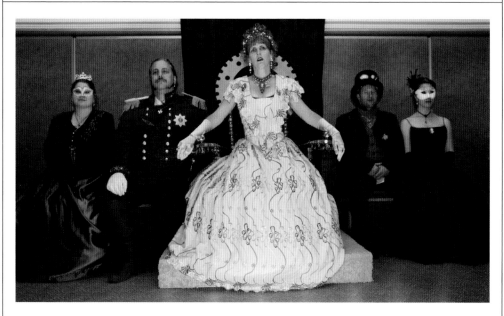

THE QUEEN'S THRONE

Made from the finest hardwood, velvet, and brass by master craftsman David Hunter-Inman, the throne was the centerpiece in the Queen's salon.

THE COURT OF STEAM

Prince Albert of Saxe-Coburg, crown prince of steam, presented his lovely wife with a wonderful throne for the cruise. He can be seen above sitting at his queen's right hand, along with a select group of her courtiers (left to right): Princess Beatrice, Prince Arthur, and Princess Alice.

See also page 247 *See also page 247* ☞

ROYAL ETIQUETTE

On presentation to the Queen, gentlemen should bow from the neck while ladies should perform a small curtsy. Once you are acknowledged, you may address her as "Your Majesty" and subsequently "Ma'am." For male members of the Royal Family, the same rules apply, with the title used being "Your Royal Highness" and subsequently "Sir." Always remember that it would be unseemly to show Her Majesty your back.

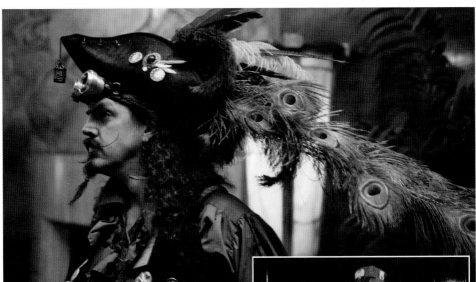

BEWARE OF PIRATES!

Vaudeville pirate Thee Bluebeard has snuck on board for the amusement of guests.

SHIP'S DOCTOR

It might be best to stay in good health if this quack is the only doctor on board—just the sight of the bag of potions and his butcher's apron could bring on a cry for smelling salts.

KEEP WATCH

This resourceful lady has interrupted her stroll on the promenade deck to put her brass binoculars to good use scanning the horizon for marauders.

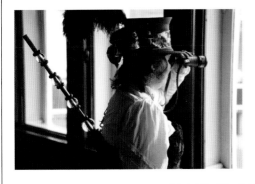

ON DECK

The Queen Mary has an ample outdoor sun deck and a generously wide covered promenade deck that connects the Royal Salon, the Boardroom, and the Queen's Salon. Other decks house staterooms and passageways that are panelled in magnificent wood and floored with the finest carpet.

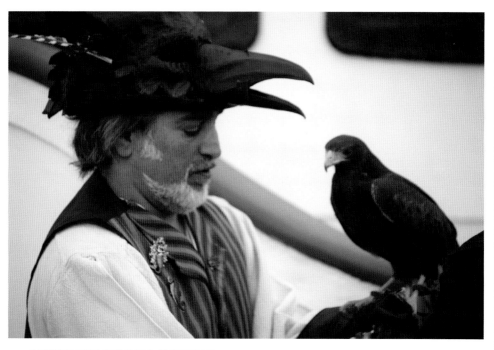

GENTLEMEN'S PASTIMES

Follow in the footsteps of the esteemed explorer Sir Richard Francis Burton, the translator of *The Arabian Nights* (or *1001 Nights* as it is known in some quarters), and the *Kama Sutra*, and learn the elegant arts of falconry and fencing. Classes and demonstrations of both activities—once the

PLAYING WITH STEAM

From Blood and Cardstock, purveyors of good games. The cards shown above depict everything from a monocle to a clockwork governess.

SKY KINGS FALCONRY SERVICE

The team and their falcons and raptors provided flight demonstrations and educational advice.
See also page 247 ☞

―――――≫・≪―――――

preserve of the highest echelons of society—were given at the symposium, adding to the wealth of participatory diversions, as well as the spectator entertainments on offer, to be enjoyed by one and all during the proceedings.

―――――≫・≪―――――

ALL SORTS OF GAMES

LARPs (Live Action Role-Playing Games) are a convivial way to pass the time on a short cruise or long weekend. Everything from the Wild West to alternate worlds can be explored—a Cthulhu experience was one of the games enjoyed by the symposium guests. Much fun was had with the Deliverance game, with murder mysteries and a treasure hunt for a stolen gift also on the agenda, as well as shuffleboard and croquet tournaments. See also page 195 ☞

COUTURE CATWALK

A parade of the most stylish attire, and some surprising fashion pairings designed by the vendors at the symposium, took place in the Royal Saloon, in the august presence of Her Majesty the Queen. While the glamorous models took to the stage, the attendees enjoyed a seated luncheon, which was accompanied of course by plenty of tea. Befitting a royal spectacle of this kind, the most original costumes and unique combinations of styles imaginable were paraded in front of the assembled onlookers, with garb for both ladies and gentlemen on show.

VENDORS GALORE

Merchants from far and wide offered a range of dry goods, including attire for both ladies and gentlemen for all occasions, millinery, footwear, and other sartorial accoutrements. There were even some wedding dresses on sale: the Queen Mary is licensed for weddings, and wedding and vow renewal packages can be provided, custom-designed for couples who were often brought together by Steampunk events.

See also pages 234–235

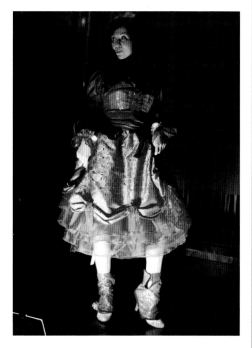

THE RED ROSE LOLITA

Created by Steamtropolis, this Edwardian-style ensemble is a seven-piece habiliment complete with bustle petticoat and metal bone corset, plus matching spats and hair establishments.

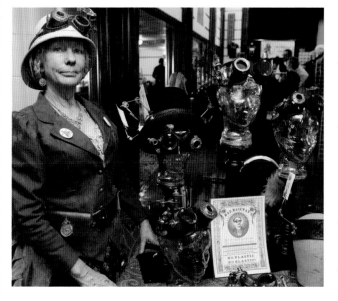

VENDOR'S STALL

Shanti MacEwan of Daylight Artworks is seen here with her display of splendiferous goggles that incorporate vintage objects with hand-stitched cowhide. Beautifully crafted—as are most items offered for sale at such events—the individually designed eyewear, worn as much for decoration as practicality by her customers, are carefully drilled and bolted—with filigree accents, studs, and fasteners in brass—and are fitted with standard ultraviolet-filtered working lenses.

HONORARY SEAT

As always on cruise liners, it comes as the high-light of a trip to be invited to the Captain's table.

THE MASQUERADE BALL

A tasty midnight gastronomic event, pulsing beats from Jon the Magnificent—international Steam-punk band of 2011—amusing belly dancing, and other magnificent performances added up to a great evening. Topped off by a special appearance by the Queen and her court, the Ball was certainly the high point of a highly entertaining weekend.

STEAM COCKTAIL

1 ½ oz (44 ml) gin
Cranberry juice
1 splash Blue Curacao liqueur
1 splash sweet and sour mix
1 splash soda water

To ensure that the drink would steam and not be in any way hazardous to the imbiber, we used food-grade dry ice and Misty Stix, a new product manufactured in Canada.

GREEN LADY

A glamorous dame in garb fit for the red carpet graces the Saturday night ballroom.

MAGIC AND MUSIC

Steamy stage entertainment included magician Dino; the original musical robots, Steam Powered Giraffe; belly dance troupes; plus piratical comedians and other talented entertainers. Meanwhile, at the Nickelodeon, moving pictures enthralled, and at the Masquerade, ball dancing was on the cards.

THE AMAZING, MYSTERIOUS, AND PREPOSTEROUS DINO

Dino Staats, a man recently enrolled in some of the finest institutions of scientific thought, demonstrated his theories in a manner so astounding that the crowd swore they were not watching science but magic!
See also page 247 🖝

INVITATION TO THE MASQUERADE BALL

Guests in their finery enjoyed an evening of dancing and delight at the Masquerade Ball.

———◈———

STEAM POWERED GIRAFFE

With their music, mime, and comedy, Steam Powered Giraffe describe themselves as "a one-way ticket with the robots on the road through an antique America."
See also page 247 🖝

EVENTS IN THE AMERICAS

Symposiums, conventions, and many other gatherings are to be found across the length and breadth of the Americas, where Steampunk started—from Vancouver in Canada to Brazil, and in North America on the West and East coasts, and all points in between. On these pages you will find but a small taste of the extraordinary amount of entertainment, and indeed enlightenment, to be had.

THE STEAMPUNK WORLD'S FAIR

Held annually in Piscataway, New Jersey, this fair claims to be the world's largest Steampunk event and is organized by the legendary Jeff Mach. Held over a weekend in May, it includes indoor panels, symposiums, performances, special guests, vendor's stalls, and an outdoor festival that showcases family-friendly acts by day and then transforms into a dark carnival by night.

STEAMCON

This large annual event is staged in Bellevue, Washington every October, organized around a particular theme. 2012 is Victorian Monsters. Frankenstein's Monster, Dracula, Dr. Jekyll and Mr. Hyde, Spring Heeled Jack, the Invisible Man, and Jack the Ripper, all emanate from that period.

Steamcon past and present:
2009, Steamcon I - no specific theme
2010, Steamcon II - Weird Weird West
2011, Steamcon III - 20,000 Leagues Under the Sea
2012, Steamcon IV - Victorian Monsters

ANACHROCON

Founded in 2009 and held in Atlanta, Georgia, AnachroCon is the premier place in the southern United States for people to celebrate historical reenacting, alternate history, sciences, horror, etiquette & indulgence, fashion, fabrication, and literature & media, and to socialize with people of like minds. Dedicated to "providing a safe social environment for the free exchange of ideas," its visitors gather annually to interact, share, dance, and explore the possibilities of matters historical, alternately historical, and fictional.

SOUVENIRS OF THE WORLD'S FAIR

A collection of paper souvenirs from the 2011 Steampunk World's Fair, including the Fair's own newspaper, The Leader and Ledger *(written and edited by Emily Tullis and Brian Siano), calling cards from various vendors at the Fair, an entry pass to the extravaganza, plus leaflets and flyers advertising some of the many events and meetings.*
See also page 248 ☞

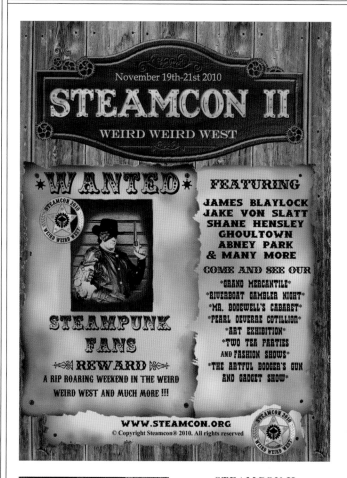

THE STEAMCON AIRSHIP AWARD

Each year, nominees are chosen in five categories marking the creativity of the Steampunk community, and the winners are decided by a vote of registered members of Steamcon. The results are announced at a banquet, and winners are presented with an award statue. The 2011 award, designed by Kyle Miller, is shown above.

STEAMCON II

The 2010 poster shows the range of attractions to be found at the Steamcon events, here reflecting the "Weird Weird West" theme.

VAUDEVILLE AND BURLESQUE SHOWS

Across the length and breadth of the Americas you can find amusing entertainment. On the right, a performer appearing at Chicago's Carnival Delirium, staged by Clockwork Vaudeville, a stunt show that combines humor, music, and theater.

A YEAR OF STEAM

January Steampunk Symposium: Long Beach, CA / Clockwork Con: Austin, TX
February AnachroCon: Atlanta, GA / TempleCon: Providence, RI
March AnomalyCon: Denver, CO / Alternative Living Expo: Philadelphia, PA
April Canadian National Steampunk Exhibition: Toronto, ON, Canada / Steampunk Empire Symposium: Cincinnati, OH
May Steampunk World's Fair: Piscataway, NJ / World Steam Expo: Dearborn, MI
June Steampunk Industrial Revolution: Nashua, NH
July Comic-Con: San Diego, CA / Portland Gear: Portland, OR
August DragonCon: Atlanta, GA
September Great New England Steampunk Exhibition: CT / Victoria Steam Exposition: Victoria, B.C., Canada
October Steamcon: Seattle, WA
November Teslacon: Madison, WI / Emerald City Steampunk Expo: Wichita, KS
December The Great Dickens Christmas Fair: San Francisco, CA
See also page 248

THE DALLIANCE SCAVENGER HUNT
Players enjoy a game of Dalliance, completing various tasks in order to fill out the address on a postcard.

IMMERSIVE EVENTS

From Jules Verne–themed conventions to Victorian murder mystery weekends, Steampunk events can transport you to another world. There is also a wealth of individual game and live action role-play experiences, including scavenger hunts, dangers to defuse, exorcisms, and more.

TESLACON

Named after the groundbreaking engineer and electricity pioneer Nikola Tesla, this convention

TESLACON 2011
A poster for the amazing Tesla-Con immersive science fiction and Steampunk event, which is held annually in Wisconsin. This was designed for the 2011 happening, entitled "20,000 Leagues Beneath the Aether." In 2012 the intrepid participants will be taking "A Trip to the Moon." The science fiction pioneer and speculative author H.G. Wells (whose First Men in the Moon *was one inspiration) would definitely sign up for this adventure if he could.*

BRAZILIAN ADVENTURES

A living clockwork doll emerges *in Brazil, advertised in the poster*
from a musical box at an event *shown on the right.*

is themed each year to produce a unique immersion experience
that includes specially crafted décor and props—even the food is
designed to reflect the theme. Previous TeslaCons have included
"20,000 Leagues beyond the Aether," where the attendees were
transported across the globe aboard a virtual submersible.
See also page 248

CANADIAN NATIONAL STEAMPUNK EXHIBITION

Held in Ontario, it included some wondrous gadgets,
superior performers and sideshows, a mad scientist evil laughter
contest, and lectures and demonstrations. There was even a
séance to connect attendees to travelers in other dimensions.
See also page 248

CONSELHO STEAMPUNK

The Conselho Brazilian Steampunk community is a network of
lodges throughout the country, hosting both real and virtual
Steampunk events, ranging from Steampunk conventions to
Victorian picnics.
See also page 248

VICTORIA STEAM EXPOSITION

A wealth of Steampunk art and
culture at Victoria's Empress
hotel, this major Canadian
event includes appearances by
revered authors and artists.
See also page 248

EUROPEAN ENTERTAINMENT

As the interest in Steampunk grows across Europe, social gatherings of enthusiasts are changing from informal groups meeting on the fringes of science fiction or cosplay conventions, to large dedicated events like The Weekend at the Asylum, where over a thousand Steampunks gather in Lincoln, England, to enjoy three days of purely Steampunk programming.

A FIESTA IN BARCELONA

The annual Spanish convention, Convention Steampunk y Retrofuturista, is held in a historic district where one of architect Gaudi's first buildings sits. Entertainment includes art and fashion exhibitions, games, ray gun duels, a tea saloon, and a "passage insolit" or extraordinary passage—a mix between theater, vaudeville, and freak show. *See also page 248*

See also page 248

FESTIVITIES IN FRANCE

In the home of the green fairy, absinthe was banned for almost 100 years from 1915, due to its alleged harmful effect. You can celebrate its return at cabarets and festivals as French Steampunk begins to flourish. Time travelers can explore cabarets du neant, 19th-century occult-themed clubs that were draped with shrouds and often decorated with skulls and bones, and where the clientele were served at coffin-shaped tables.

CONVENTION STEAMPUNK Y RETROFUTURISTA POSTER

An advertisement for the 2011 convention in Barcelona, Spain.

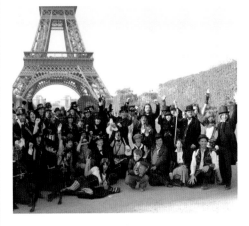

EIFFEL TOWER MEET-UP

A Steampunk group marvels at the engineering of the Eiffel Tower in Paris, built by Gustave Eiffel for the 1889 World's Fair. Only intended to stand for twenty years, the 1,063 ft (324 m) tower was retained because of the scientific experiments that the pioneering Eiffel encouraged—in particular, the first transmissions by radio, made in 1898.

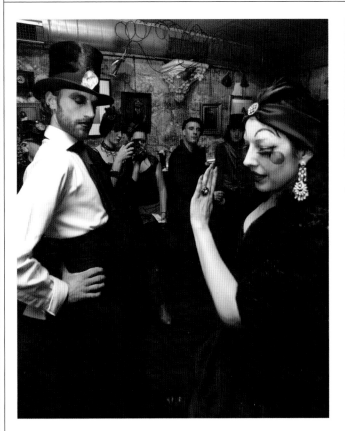

FETE 1900

Participants enjoyed absinthe, burlesque dance, corset and hat displays, and other delights at a cabaret du neant in Paris. The event was inspired by turn-of-the-century cabarets in the Paris of "La Belle Epoque."

GATHERINGS IN BELGIUM

Picnics, conventions, and other gatherings take place in Brussels and beyond. Steampunks can also be found at other alternative conventions like FACTS in Ghent, sharing space with comic and anime fans. And at this year's Christmas market in Brussels, there was an alternative carousel, with a steam-powered Pegasus, bugs, and a car. *See also page 248* *See also page 248*

ITALIAN ADVENTURES

Italian Steampunks can look forward to events by Steam Technological Italian Mercenaries (STIM). With the futurists their forefathers, STIM celebrate Steampunk literature in Italy, including *Alice in Steamland* by Francesco Dimitri, and feature at Steampunk nights in Turin and Milan. *See also page 248*

EVENT ORGANIZATION

The *Gazette* would like to encourage readers to start their own extravaganzas, especially in those regions devoid of such delights. But if there is competition, think about making your event stand out—decorations or activities that make it more immersive and original and will ensure that attendees tell others about it. Unless you have previous experience, start small with a club night in a modest-sized venue or a market in a hired hall. Plan ahead—you will need to ensure that your chosen venue is available and you have enough time to attract sufficient attendees. Make the most of social networks to publicize your event—specialist forums "The Steampunk Forum" and "Brass Goggles" have international lists of upcoming events. You should also make use of Meetup, Facebook, Twitter, and the like. *See also page 233*

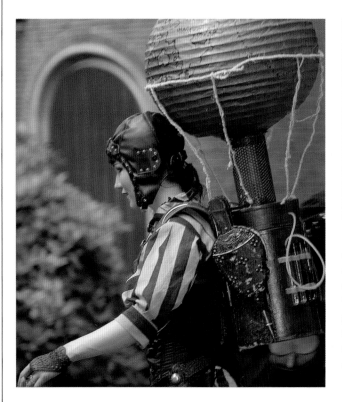

STEAM MEMORIES
A poster for the magnificent Steam Memories Steampunk and neo-Victorian photo day, which was held on 2011 at the grand Muzeum Kolejnictwa, the rail transport and locomotive museum located in the Polish capital Warsaw.

BALLOON PILOT AT CASTLEFEST, HOLLAND

This Steampunk traveler wearing an aeronaut's helmet and portable balloon has landed at Castlefest, Lisse, in the Netherlands.

NORTHERN EUROPEAN EVENTS

In Germany and the Netherlands (Holland) you will find many dedicated Steampunk events as well as a Steampunk presence at major fantasy festivals like Elf and Castlefest, held in the gardens of Castle Kuekenhof, Lisse, in Holland, and attracting more than 24,000 visitors. In Scandinavia, Steampunks attend Eurocon in Stockholm, and a Steampunk specific gathering is being planned called Fumoplacitum. Tea parties and other informal gatherings also happen across the Scandinavian region.

See also page 248 👉

EASTERN EUROPEAN ACTIVITIES

A very successful Steampunk Victorian Futurists Ball has been held in Prague, capital of the Czech Republic, in the city's Steam Technology Museum. In Hungary, the burgeoning Steampunk community meet up in Budapest to experience traveling on actual vintage steam trains, while in Poland the Mass festival now attracts thousands of visitors. And in Russia, "StimPank," as it is called, is now beginning to take off; evening Steampunk events are held at clubs in Moscow and elsewhere in Russia, where, among other new attractions, tea parties with steamy samovars are being planned. Meanwhile in Tallinn, the capital city of Estonia, the Puppet Theater Museum features a mechanical steam theater tableau. The unusual performance is set up in a window on Nunn Street and is repeated for passersby every half hour.

See also page 249 👉

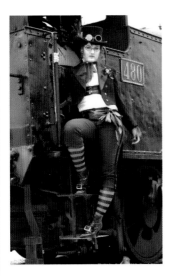

STEAM TRAVELER, HUNGARY

A participant in a Victorian steam railway journey, held in Budapest at the the Hungarian Railway Museum. Everywhere, steam trains have an appeal.

AETHERCIRCUS

Held in Stade, Germany, in a historic 19th-century Prussian fortress, with art exhibitions, live performances, a market, workshops, and contests.
See also page 249

• EINTRITTSKARTE •

CROSSOVER EVENTS FROM GRAPHIC NOVEL TO GOTH

In addition to its roots in science fiction and the well-established links with that particular community of enthusiasts, Steampunk has connections with a variety of other fantasy sub-cultures, particularly the Goth movement, as well as cosplay, graphic novel, comic, and anime fans, and reenactors. In fact, the famed American Steampunk band Abney Park started their musical career as a committed Goth band. In the United Kingdom, before the Asylum event started, Steampunks were first noticed congregating at events like the Whitby Goth fair, while in mainland Europe large festivals like the medieval and fantasy fair Castlefest now all have their Steampunk sections.

Here are five friendly festivals to explore in Europe:
Castlefest, Lisse, Netherlands
Elf Fantasy Fair, Haarzuilens, Netherlands
MCM Expo, London, UK
SFX Weekender, UK
DeepCon, Fiuggi, Italy

And below, a selection of welcoming events and conventions for the Steampunk explorer to visit in North America:
Comic-Con, San Diego, California
Omnicon, McAllen, Texas
Chicon/Worldcon, Chicago, Illinois
DragonCon, Atlanta, Georgia
CONvergence, Minneapolis, Minnesota

THE UK'S COMIC CON SHOWS

MCM

Midlands Comic Con - Telford Int Centre
18th February 2012
Birmingham Comic Con - NEC
31st March - 1st April 2012
London Comic Con - ExCeL
25th - 27th May 2012
Manchester Comic Con - Manchester Centre
21st July 2012
London Comic Con - ExCeL
26th - 28th October 2012

Comics - Movies - Games
Cosplay - Anime - Sci Fi
Fantasy - Manga - Steampunk

SNOW WHITE & the HUNTSMAN
JUNE 1

KIDS GO FREE!
BUY TICKETS ONLINE

WHITE MISCHIEF HALLOWEEN BALL

Founded by the tribal pop band Tough Love, White Mischief curates many events around London and its environs, and also at some of the UK's most popular music festivals. Live bands and DJs playing vintage music are interspersed with spectacular vaudeville and circus performers, featuring everything from aerial acrobats to upside-down escapeologists.

THE WHITE MISCHIEF EXPERIENCE

During 2009, White Mischief hosted events at everything from a 400-person capacity Georgian mansion, to the 1,100-person capacity former Art Deco cinema Scala, to the 30,000-person capacity festival Bestival. Unique live musical acts and DJs playing vintage music are interspersed with some of the most astonishing vaudeville and circus performers around: everything from aerial acrobats to upside-down escapeologists, and Guinness World Record-holding sword swallowers. Added to the mix are interactive theatrical experiences where guests might be taken on a trip around the world in a hot-air balloon, or on a journey through time with a space pirate. In the spirit of breaking down barriers between performers and audience, all are part of the show at White Mischief: partygoers

CHAINSAW JUGGLER

Guaranteed to keep the audience on the edge of their seats, a cutting-edge performer performs a nerve-jangling circus trick with an electric chainsaw, popularized by the French alternative troupe Archaos. See also page 249 🖙

PROFESSOR ELEMENTAL

Perhaps best known for his track in praise of tea, Cup of Brown Joy, the quick-witted British hip-hop Steampunk rapper known as Professor Elemental has performed at events around the world. Flamboyantly publicized with his byline of "fighting trousers at the ready," the good professor has a phonograph record album on the market, which enthusiasts can acquire easily by simply ordering online.

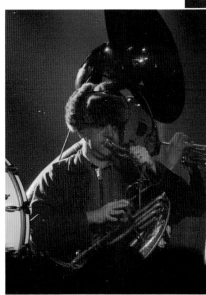

HACKNEY COLLIERY BAND

A contemporary urban take on the brass bands once affiliated with British collieries, the Hackney Colliery Band mixes Balkan brass, ska, and jazz influences to create high-energy, good-time music.

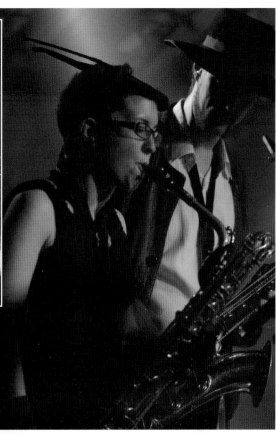

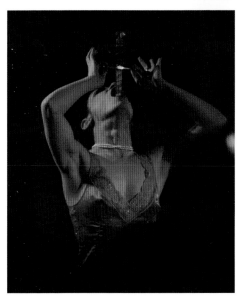

might find themselves at a radio show being broadcast live from the 1930s; they might be introduced to a talking leopard; or they might find themselves surrounded by Bluebeard's seven undead wives in the depths of his Forbidden Chamber. Some of the star names who have performed at previous White Mischief shows include David McAlmont, the Puppini Sisters, British Sea Power, Miss Behave (of La Clique), Mat Fraser, and BBC's The Penny Dreadfuls. And while it's not compulsory to dress up at White Mischief, guests are strongly encouraged to do so.

SWORD-SWALLOWER

Sword-swallowers, some of them Guinness World Record holders, have appeared at a number of White Mischief events.

EDWARDIAN BALL

Held in San Francisco, California, the Edwardian Ball is an elegant and whimsical celebration of art, music, theater, fashion, technology, and circus. The event takes much of its inspiration from the beloved, and often macabre, creations of the American author and artist Edward Gorey. In addition to the Ball itself, there are theatrical productions based on specific literary works by Gorey.

WORLDLY VISITORS
Costumed and enthusiastic attendees, traveling from as far and wide as Australia, Japan, and the UK, flock to this San Francisco tradition.

GOREY PERFORMANCE
A scene from a Gorey work, lovingly reenacted on stage at the Edwardian Ball. The Ball now operates with the official blessing of the Edward Gorey Charitable Trust.

THE EDWARDIAN EXPERIENCE

Set in an alternate version of "Edwardian" times, this extravaganza has grown from just a small underground club night into an internationally recognized event, featuring a delightful blend of ballroom dancing, live music, riveting stage shows, DJs, fine art galleries, a vending market-place, absinthe cocktails, steam machinery, parlor games, sideshows, and more. In this darkly humorous and elegant setting, literary aficionados rub elbows with insect-like creatures parading on stilts, Edwardian recreationists waltz by a steam-powered tea garden, and the only guiding rule is that you join in on the fun! Like its "Victorian" counterparts, the event celebrates the past with a modern time traveler's sense of wonder.

SCINTILLATING SIDESHOWS

The Museum of Wonders located in the opulent Regency Lodge is an "Edwardian Odditorium" full of curiosities, natural wonders, sideshow performances, fortune telling, tarot reading, and who knows what other distractions, diversions, and surprises.

THEATRICAL HAT

Dress can be as eccentric as the wearer wishes. Here, an amazing miniature theater, balanced precariously on a ball-goer's head, certainly helps raise the curtain in style.

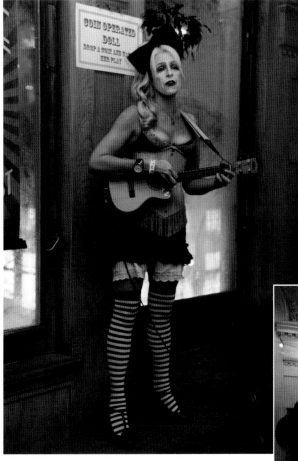

COIN-OPERATED DOLL

Drop a coin and and see her play. Unlike "living statues," this real-life mannequin actually performs.

MALVOYE THE MENTALIST

From the traveling carnivals of bygone America, a fully automated fortune-telling booth showing visions of the future. Malvoye's mentalist powers give you your own unique, and astonishingly accurate, fortune.

GUNS AND CORSETS
An aviator couple take time out from their duties securing the nation to see a musical performance.

SMOKING-HOT GENTLEMAN
Via Sherlock Holmes and the dens of Chinatown, a man sports a smoking jacket and elaborate pipe.

EDWARD GOREY PERFORMANCE
An original staging of **The Iron Tonic** *by Edward Gorey at the Edwardian Ball, San Francisco.*

EVENING QUARTET
Four elegantly dressed individuals in convivial surroundings at the Edwardian Ball, San Francisco.

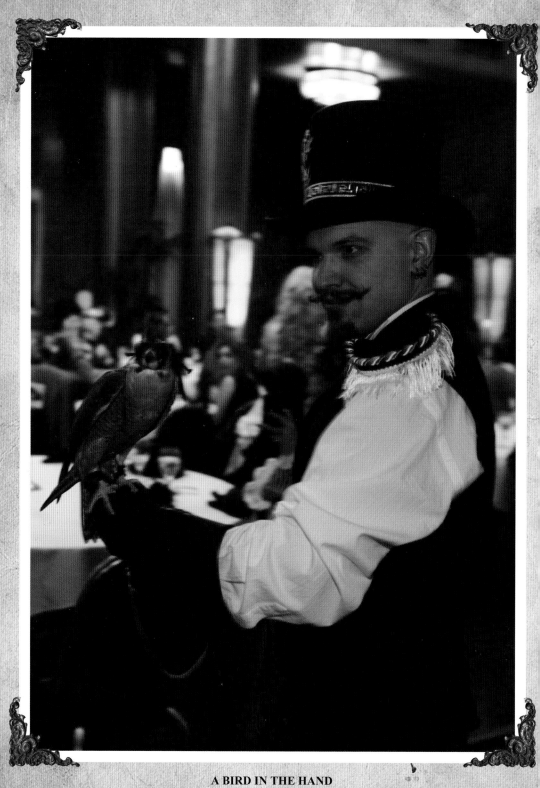

A BIRD IN THE HAND
Sky Falconry's displays delighted guests at the evening ball at Her Majesty's Steampunk Symposium on the Queen Mary, Long Beach, California.

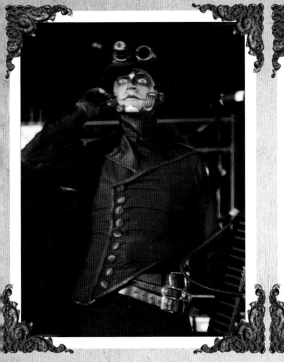

RABBIT, CLOCKWORK MAN
Melodica and accordion player with musical pantomime troupe Steam Powered Giraffe.

BALL-GOING PEACOCK
Elegant and exotic evening ball wear, with a silk turban trimmed with a peacock feather cockade.

FINE DINING
A handsomely hatted pair relax at the evening ball at Her Majesty's Steampunk Symposium.

CHAPTER 10 ✦
LEISURE

Steampunk social events range from celebratory occasions, such as the increasingly popular Steampunk weddings, to one-day events and other outdoor gatherings including picnics, galas, and the almost obligatory croquet match. Indeed, competitive games are, more often than not, a part of these events, and besides themed role-playing games (RPGs), which can be played inside and out, there are the indoor parlor, board, and electronic kind to play. Dating from before the electronic age, parlor games and other indoor pursuits of this kind were a key social diversion in the absence of radio or tele-visual broadcasts. For those individuals without an immediately close circle of Steampunk friends, all sorts of networking opportunities are afforded by the worldwide aethernet, enabling any like-minded Steampunks to connect and take part in a range of activities, from playing games remotely to organizing costumed face-to-face meet-ups. As always, the qualities of friendliness and politeness of manner are valued as a top priority in the Steampunk community, and any newcomers are given a warm and cordial welcome.

INDOOR AND OUTDOOR GAMES

Parlor games at Steampunk events, or just among Steampunk friends at their homes, include the traditional pursuits such as dominoes, chess, or cribbage; revivals of Victorian favorites; card games; or newly invented challenges such as tea dueling. Card games played may include the traditional favorites or newly conceived adaptations of Steampunk literature—there is a card game available called "The Works," based on the *Girl Genius* comic, for example. Tarot card readings continue to be a popular feature at Steampunk events. The Tarot expert Barbara Moore has carefully reworked the usual card deck with some Steampunk artwork, for those looking to an alternate future. In the outdoor situation, various games such as croquet, quoits, badminton, and other fine recreational sports are pursued, often harking back to the more leisurely and slow-paced times of the Victorian era. *See also pages 184, 226 and 228*

TEA DUELING EQUIPMENT

A sturdy, green, baize-lined wooden box houses a set of the rules to the game, two custom-designed mugs with the handles resembling gun grips, and the requisite comestible equipment of crockery and cutlery items.

RPG EQUIPMENT

A theatrical treatment for a role-playing game at Her Majesty's Symposium on the Queen Mary, Long Beach, California.

SPLENDIFEROUS SOCIAL OCCASIONS

Steampunk brings its own unique sense of style to all sorts of occasions, including everything from birthday tea parties to more formal events such as a wedding celebration. From the specifically designed invitations to a steamy-inspired dress code, from the entertainments on offer to the specially selected décor, a delightful immersive experience can be created that will be equally enjoyed by those new to Steampunk, as well as seasoned old hands. Just a visit to a large Steampunk gathering such as a convention or extravaganza will give any newcomer a realistic first taste of what the Steampunk community is all about, but once involved on a regular basis the individual will find all kinds of situations where he or she can interact with fellow enthusiasts resident in their local area or even further afield. And the many social networking sites to be found on the aethernet, both regular and Steampunk-specific, can be used to organize meet-ups and picnics for like-minded folk to engage in retro-futurist discussion and activities. *See also page 233*

OUTDOOR SPORTS AND GAMES

There are various forms of relaxing (though sometimes quite strenuous) entertainment to be enjoyed at picnics, festivals, and other gatherings. These include clockwork races, badminton, quoits, and the like, and most frequently the long-established recreational lawn game of croquet, which involves using a mallet to hit balls through wickets or hoops embedding in grass.

CROQUET

From the old French game paille-maille, croquet took off in England in the 1860s and quickly spread across the Empire. There is also an American six-wicket version. The sport has been the subject of a work by H.G. Wells (*The Croquet Player*) and was a favorite of Edward Gorey.

GINGER LEMONADE

5 cups water
1½ cups sugar
ginger root, sliced
2¼ cups lemon juice
mint leaves (optional)

• Boil together 2½ cups water with sugar and ginger for around 10 minutes to form a syrup. Set aside to cool.

• When cool, add 2½ cups water and the lemon juice. Stir. To serve, add crushed ice and garnish with mint if desired.

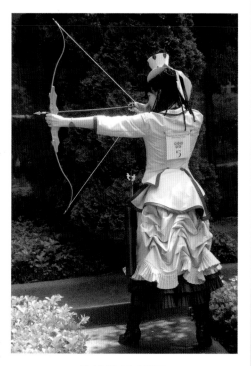

LADY ARCHER

One of the Steampunk World's Fair Ladies Sporting Team displaying her skills at the 2011 fair. This gold medal–winning group represented seven classic Victorian sports: shooting, tennis, swimming, riding, archery, croquet, and boating (see opposite bottom left).

SPORTY SKATECYCLE

Customized in aluminum, with a tail fin reminiscent of 1930s sci-fi, the Skatecycle by Brooklyn Workshop would grace any gadget race.

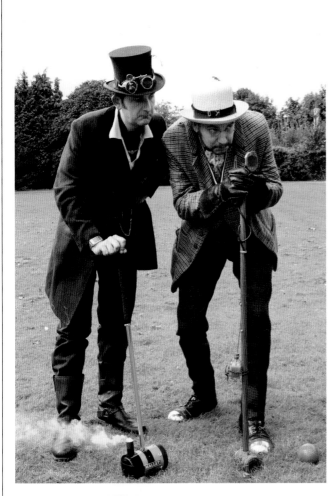

A STEAM MALLET
Not the eponymous two-engine US locomotive, but Smethick's Association Roqueting Cannon-neer #7 croquet mallet, made by Mr. Richard Woodruff.

GENTLEMEN PLAYERS
Pictured left, a steam mallet is pitted against the more conventional wooden variety.

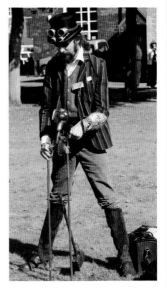

BOATING RIG
A member of the Steampunk World's Fair Ladies Sporting Team (see also opposite top), complete with straw boater and lifebelt, prepares to take a dive.

APPROPRIATE APPAREL
Right, a hat will protect against a rogue mallet swing, though boaters are more usual than top hats, while a striped blazer gives the air of a country house party to the occasion.

TEA DUELING

The noble sport of tea dueling provides ideal indoor entertainment in inclement weather. The rules of tea dueling (although here omitting the addenda on artificial handling aids, protective clothing, and other accessory items) are provided opposite for all our readers' information and edification. The appropriate equipment required for the pursuit is pictured on page 225.

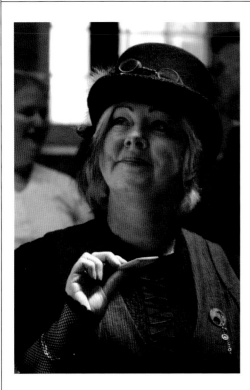

ARTICLES OF THE HONORABLE ASSOCIATION OF TEA DUELISTS

The articles cited below are extracted from the Third Edition of 1899, as was compiled by the signatories of The Hague Convention, December 1899. The letters IATD stand for the International Association of Tea Dueling. The brew martial (see rule 1.2 opposite) can be made from any blend of chai as supply allows. Both chocolate and coffee are strictly prohibited. Please note that in North America, the appointed cookies or "biscuits" are ordinarily "Nutter Butters," otherwise known as "butter cookies." With agreement of all parties these may be substituted for "Ginger Snaps," known as "gingers." On the other hand, in the United Kingdom the designated biscuits are "Malted Milk," otherwise known as "cows," with "Nice" biscuits, known as "nickies" as usually acceptable substitutes. Those honorable snacks— "brown biscuits" and "fruit biscuits"—are forbidden under Queen's regulations. All other varieties are known as "fancies" and are prohibited under the Hague Convention.

THE RULES OF TEA DUELING

1.1 A duel as constituted under the auspices of the IATD shall be known as a "Tiffin Party."

1.2 The only permissible drink is tea. Combatants may add milk and sugar to taste. The beverage should be no less than 65 degrees at the time of competition. The beverage should be known as the "brew martial."

1.3 Upon the agreement of all parties, an alcoholic tipple may be added to the brew martial on the understanding that it does not unduly reduce the temperature of the beverage. This shall be known as the "toddy."

1.4 The drinking vessel, known as "the keg," shall be no less than 3¼ in (8 cm) deep.

1.5 The provision of the Brew Martial along with approval of Kegs shall be the responsibility of the "Pot Master" (PM). (See 2.1 below.)

2.1 The duel shall be facilitated by the appointed officer, known as the "Pot Master," responsible for Kegs and Brew Martial (see 1.5). The PM is also responsible for the supply of biscuits (see 3.)

2.2 The duel shall be presided over by a president/umpire known as the "tiffin master" (TM). When honor requires satisfaction and insufficient suitably qualified officers are present, the PM and TM may be embodied in one person.

3. The TM shall supply biscuits, following Queen's regulations.

4.1 Each duel should be attended by the two protagonists, or "dunkers," and their seconds.

4.2 Should a dunker suffer crisis of confidence and withdraw prior to the duel, their second should step into the breach. The second will be afforded full honors.

5.1 The duel will start with laying out the biscuits by the TM. Six biscuits will be lain upon a white napkin on a serving plate. The laying-out of the biscuits will be done in the presence of the seconds, or in the case of a full tournament by officers known as "cosies."

5.2 The PM will supervise the provision of the kegs of brew martial ready for the duel to commence.

6.1 The dunkers will take their kegs of brew martial, placing them on the table between them.

6.2 The TM will place the biscuits on the table between the dunkers.

6.3 On the command "choose your weapons," the dunkers will each select a biscuit, with no handling of biscuits permitted.

6.4 The dunkers will hold the biscuit in one hand, finger and thumb no further than ½ in (1 cm) from one edge.

6.5 On the TM's order "ready," both biscuits will be positioned over the appropriate keg no further than 6 in (15 cm) above the lip.

6.6 On the command "dunk," both dunkers will swiftly lower their biscuit into the brew martial. The TM may declare a penalty, "a bagging," against any dunker who delays their dunk, with biscuits removed and discarded. Replacement biscuits will be chosen by both dunkers from the remaining four. If a dunker is penalized twice, then he or she shall forfeit.

6.7 If the TM sees there has been a clean dunk, he counts to five. Dunkers shall not remove their biscuit before he calls "five."

6.8 On the count of five, with the biscuit removed, the dunkers shall try to eat the biscuit. 94% must end up in the dunker's mouth for a clean "nom."

7.1 If a biscuit falls back into the brew martial (a "splash"), the dunker is considered beaten.

7.2 If a biscuit falls onto the table or floor (a "splatter"), the dunker is considered beaten.

7.3 If a biscuit falls onto the dunker's person (a "splodge"), the dunker is beaten with credit.

7.4 Where both dunkers manage a clean nom, the dunker who last mouthed their biscuit is the victor, their opponent defeated.

FANTASTICAL GAMES

Unlike games of the past, such as the property-developing Monopoly or murder mystery Clue, modern-day pursuits have taken on a second life, with tabletop and computer-operated role-playing games all given a Steampunk spin. You will find steam-powered contraptions, gaslight, airships, pirates, robots, and ray guns galore at the click of a mouse, press of a button, or throw of a die.

ROLE-PLAYING GAMES (RPGs)

If you are new to the world of RPGs, you would not go wrong by starting with the highly respected game, 1889. Other entertainments worthy of exploration include Abney Park's Airship Pirates, Victoriana, and Call of Cthulhu. And ingeniously devised contests to test the imagination are also to be found, such as The Great Air Kraken Hunt of 2012 in New Zealand.

BOARD GAMES

Vintage and customized versions of games like Clue, Monopoly, and Scrabble can be bought. Or, like Antibromide on Instructables, create your own—he shows how to Steampunk a Monopoly set, adding a Community Chest, a water tower (water company), a Ray Gun (Chance cards), a train (railroads), and street lights (electric company).

See also page 249 ☞

COGGY DICE

These originally designed Steampunk die are manufactured by Mechanical Oddities—sister company of the magical and medieval-oriented Magical Oddities and Roundtable Productions— and decorated with gears rather than the usual pips, and available in an iron or a bronze finish.

See also page 249 ☞

TYPOGRAPHY SCRABBLE

A wonderfully crafted limited edition Scrabble set created by Winning Solutions and inspired by traditional typefaces. The exquisite solid walnut tiles are stored in a matching walnut case complete with drawers; the board is made in walnut, too, and the accompanying tile racks are fashioned from metal.

See also page 249 ☞

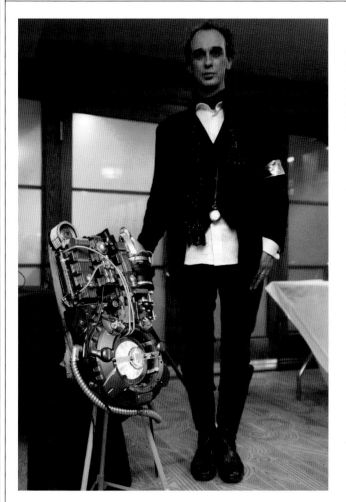

SPACE 1889

Created by Frank Chadwick, this role-playing game involves Victorian spaceships, colonies on Venus and Mars, and remote communication by means of orbital heliograph stations.

EOLLIS: PIRATES DES VENTES

An immersive board game in which you can upgrade from being a base pirate to a lord of the winds, while dividing up loot and frequenting taverns.

ROLE-PLAYING DEVICE

Some role-playing games will involve using elaborate devices, such as the complicated-looking contraption shown here, which was utilized by participants at Her Majesty's 2012 Steampunk Symposium.

MURDER MYSTERY

An Eastern gentleman taking part in a murder mystery game at Her Royal Majesty's Steampunk Symposium on the Queen Mary.

SENSATIONAL STEAM GAMES

The Chaos Engine (UK)/Soldiers of Fortune (USA)—featuring a steam-driven computer that is seeking world domination, bands of mutants, and a team of Victorian mercenaries.

Steel Empire—a dirigible war game.

Skies of Arcadia—an RPG set in a Jules Verne–inspired world of airships, uncharted continents, and lost cities.

Arcanum: Of Steamworks and Magic Obscura—where technology is pitted against magic.

Wachenroder—a German game that includes a character named Titus Groan, after Peake's novel.

An Adventure with Therion—a 19th-century setting with Nordic myths, mysticism, and airships.

ELECTRONIC GAMES

Computer games, whether accessed online or software-based, along with video games and games for electronic devices and gaming consoles, all now feature a multitude of Steampunk offerings. Some are based on fantasy novels, like *The Golden Compass* or *Alice in Wonderland*, or recent films like *Wild Wild West* and *Sherlock Holmes*. Others are puzzle games—for example, Cogs, where users build machines from sliding tiles. Role-playing games include Skies of Arcadia, which revolves around Vyse, a young pirate in a Jules Verne–inspired world of dirigibles and forgotten cities; the Final Fantasy series, set in the imaginary world of Gaia; and Rise of Nations: Rise of Legends, a "real-time strategy game" in which magic and futuristic technology co-exist in a fantasy world.

STEAMPUNK GAMEBOY
This hand-painted version of a 1989 DMG-01 Gameboy by Thretris is fully functional. *See page 249* 🖝

**THIEF II:
THE METAL AGE**
A sequel to the popular Thief: The Dark Project, the game of stealth is set in an alternate Steampunk metropolis.

SOCIAL NETWORKING

On the aethernet you can find many places to connect with other Steampunks, share views and photographs, and find out about events and arrange meetings. In addition to groups gathering on Facebook, Flickr, LiveJournal, and other general sites, there are specialist forums for sci-fi fans, such as *www.tor.com*, and sites specifically geared to Steampunk, a selection of which are featured here. And there are Twitter streams for Steampunk, where you can follow bands like Abney Park, authors like Gail Carriger, or creative gadget makers like Jake von Slatt.

ENGLISH-LANGUAGE SITES

Brass Goggles
Based in the UK, it welcomes members from all Anglophone territories to exchange information for general edification.
www.brassgoggles.co.uk/forum

Steampunk Empire
The crossroads of the aether, this American-based site has thousands of citizens, offering an active forum, areas to post photos and videos, a musical box, event listings, a zone for blogs, and an area for citizens to join and interact in groups that range from local societies through Steampunk singles to Steampunk fans of the railroad. An annual symposium also takes place.
www.thesteampunkempire.com

Steampunk Canada
A place for all Steampunks across Canada to come and share information, events, stories, and ideas. The site also invites visitors to place their calling card on the silver platter and make themselves at home.
www.steampunkcanada.ca

Airship Ambassador
Masses of information for the Steampunk community, with very useful listings of groups and societies, artists, and vendors from around the world.
www.airshipambassador.com

The Steampunk Writers and Artists Guild (S.W.A.G.)
A community for writers and artists that includes a forum for in-depth discussions and a chat area for tea and cake.
www.steampunkwriters.ning.com /?xg_source=badge

Australian Steampunk
Neo-Victorian Antipodean discussions.
www.aus-steampunk.livejournal. com

A New Zealand Ministry Telegraph
In Oamaru, the kiwi "Steampunk capital," The League of Victorian Imagineers organize an online spot where New Zealand Steampunks can get together, exchange information, and help publicize each others' events.
www.steampunknz.co.nz

A SMATTERING OF FOREIGN-LANGUAGE SITES

Steampunk-fr.com
For the Francophone community in France, Canada, and elsewhere around the world.
www.steampunk-fr.com

SteampunkSP
From Spain, Spanish language.
www.steampunksp.4rumer.net

Steampunk Brazil
From Brazil, in Portuguese.
www.steampunk.com.br

Laboratory of Time
Italian society and forum.
www.steampunk.forumcommuni ty.net

Gear and Goggles
A Danish-language site.
www.gearsngoggles.proboards. com

Clockworker
German social site and forum.
www.clockworker.de

Sztimpank
Hungarian networking site.
www.sztimpank.freeblog.hu

TWITTER

Steampunk Chat
Concise conversations take place on Fridays; tune in at 6 pm PST and 9 pm EST.
www.steampunkchat.com

STEAMY WEDDINGS

Whether the happy couple first met through the Steampunk community or simply love the style, romantic Victoriana with a contemporary clockwork twist is an ideal theme for a memorable and atmospheric wedding. Everything from the wedding party's garments to the decor, and even the table decorations, can be spectacularly transformed with some imaginative Steampunk styling.

MARTINE AND JIM'S WEDDING

Martine had noticed the spread of Steampunk, and Jim had worked on various films that borrow from the genre, from *Harry Potter*, to *Stardust* and *Hellboy II: The Golden Army*. Both loved the style and decided it was perfect for their wedding, with its combination of fantasy, science, and romantic Victoriana. Martine wore a silk gown from Bound by Obsession, Jim a custom-made leather frock coat. The reception was held at Kew Bridge Steam museum, home of the biggest steam engine in the world, with atmospheric lighting, music from Steampunk movie soundtracks, and actors in Victorian garb. Jim made working lamps for each table, including the Teslatic Teleportal Transmuter Coil, the Photonglobe Illuminator, and The Luminous teleglow Projector.

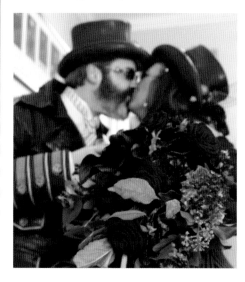

SPREADING THE WORD

A Steampunk wedding is a great way to introduce friends and family to the delights of dressing in retro-future Victorian-influenced clothing.

A PAIR OF TOPPERS

Matching leather hats, blending in with their outfits, were chosen by this well-matched couple. Martine said, "We completely loved and relished our day, though it all happened too quickly. Our only regret was that we didn't have more time! We highly recommend Steampunk as a wedding theme."

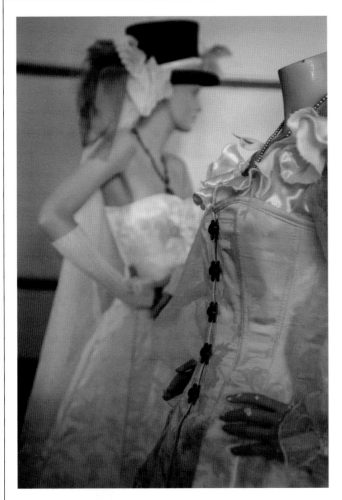

INGENIOUS INVITATION

A USB stick with a distressed tag attached combined to make a highly original invitation. The USB-stored PDFs contain information about both Steampunk and Martine and Jim's wedding.

CLOCKWORK CAKE

For the wedding, in order to continue the Steampunk theme into every area of the happy day's celebrations, the artful cake decorator Debbie Rose crafted this spectacular tiered and iced confection.

DRESSES ON DISPLAY

Corseted brocade designs by Pendragon Costumes, seen at Her Majesty's Steampunk Symposium. See also page 249

TRANSPORTED WITH LOVE

The bride and groom traveled to the wedding venue in a state-of-the-art horseless carriage, of the kind pioneered by the inventive genius of the American Mr. Henry Ford.

UP TO STEAM WITH THE FAMILY

Steampunk exhibitions and events can be enjoyed with your children or "coglings" as they are known in the community—they will enjoy dressing up, viewing the exhibits and performances, and learning about the Victorian age along the way. Many events are designed to be family-friendly. And at home, there is plenty of Steampunk children's literature to amuse and entertain them.

COGLINGS

From its first derigible-decorated onesie, the arrival of a child needn't compromise the parents' cultural tastes or activities. Children will enjoy dressing up in neo-Victorian outfits and will be amused by some of the entertainment on offer at the extravaganzas, like magicians and circus acts. Events like the annual Steampunk City weekend at the Charles River Museum of Industry and Innovation in Waltham, Massachusetts, are geared to appeal to families. Steampunk themes are very inspiring for baby showers and kids' parties and a great way to introduce friends and family to the scene. There are even themed recipes for steamy treats like marshmallow top hats online.

ALBERT ALOYISUS PYWACKET
The latest trend in toys is for bears inspired by President Roosevelt's nickname "Teddy." This fine example of a plaything is manufactured by Victoria "Tatter Demalion Tinker" Bragy.

TOYING WITH STEAM

Trains, pirate ships, miniature Daleks, robots, Nerf guns—what's not to like? There are books giving instruction in making Steampunk softies and dolls that represent characters from much-loved stories. And kids of all ages are making LEGO models of airships and submarines.

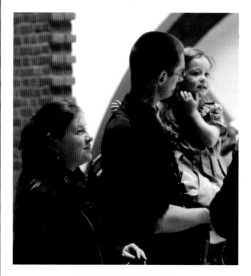

FAMILY DAY OUT
A family enjoy a day out at the Kew Bridge Steam Museum Steampunk Exhibition in west London.

See also page 113 👉

STEAM SCOOTER

A brassy finish turns a scooter into the perfect Steampunk plaything, with the obligatory helmet decorated too.

NERF GUN

Originally designed as children's playthings, a Steampunked Nerf gun can be the ideal accessory for a cogling— as seen here roaming the prison precincts during the Asylum weekend.

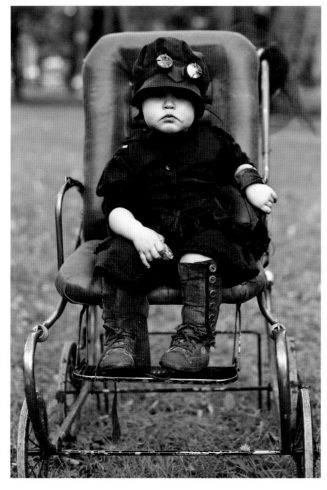

HEAD START

Top hats are made in all cogling sizes, as are goggles—but make sure lenses are adequate, with no tricky parts to cause injury.

LUNA IN HER STROLLER

Artisan leatherworker Sebastien Bergeron of Sebal modified a 1950s stroller for daughter Luna and made the goggles. Her chic costume is by Luna's mother, Odree Roy-Lavallee, of Zoluna. See also page 249

CLASSIFIED

Advertisements in this "Classified" section of the *Steampunk Gazette* take the form of comprehensive listings of aethernet sites of the artists, designers, manufacturers, museums, and other organizations that have been featured in the book's previous chapters. The advertisements are arranged in sections, by the chapter that the originator was featured in. Here, we take the opportunity to address all our readers and to reassure them that there are no announcements for any get-rich-quick schemes, quack medicines, or ladies of the night contained in the pages of this prime-quality publication. If the stores and retail suppliers featured here do not answer your particular supply needs, then a simple aethernet search for "Steampunk" on the art and craft merchant sites such as Etsy and DeviantART will yield a wide choice of makers and designers for your relaxed perusal and potential purchase. As far as quality control is concerned, we have done our utmost to ensure that the goods featured throughout are as described by their originators on their particular websites. For a full list of Steampunk social networking sites, see page 233.

THE FRONT PAGE
See pages 10-15 ☞

Kamila Gawronska
www.kamilagawronska.com

Tony Cochran
www.tonycochranguitars.com

Professor Maelstromme
www.etsy.com/shop/ProfMaelstromme

Tim Wetherell
www.platypusart.com/wetherell

Defensive Ladies' Corset
www.bruteforcestudios.com

Art Donovan
www.donovandesign.blogspot.co.uk

Bartitsu Martial Art
www.bartitsu.org

Lomography Cameras
www.lomography.com

NEWS FROM EVERYWHERE
See pages 16-35 ☞

UNITED STATES OF AMERICA
Pop Haydn
www.pophaydn.com

Charles River Museum of Industry
www.crmi.org

The Way Station
www.waystationbk.blogspot.co.uk

Dr. Evermor
www.worldofdrevermor.com

Mercer Museum
www.mercermuseum.org

The Edison
www.edisondowntown.com

Deluxe Station Diner
www.deluxestationdiner.com

The East Side Showroom
eastsideshowroom.com

Grim's Butterfly Lounge
www.grimseattle.com

Scholz Beir Garten
www.scholzgarten.net

Villains Tavern
www.villainstavern.com

Apotheke
www.apothekenyc.com

Ninth Ward Bar
www.ninthwardnyc.com

The Steampunk Café
www.thesteampunkcafe.com

The Lizzie Borden Bed & Breakfast Museum
www.lizzieborden.com

Jules Undersea Lodge
www.jul.com

Dunton Hot Springs
www.duntonhotsprings.com

UNITED KINGDOM
Sherlock Holmes Museum
www.sherlock-holmes.co.uk

A Child of The Jago
www.achildofthejago.com

Wilton's Music Hall
www.wiltons.org.uk

Kew Bridge Steam Museum
www.kbsm.org

The Dr. Who Experience
www.drwhoexperience.com

Osborne House
www.english-heritage.org.uk

Newcomen Engine House
www.devon.gov.uk/newcomen_engine_house

Ironbridge Gorge Museum
www.ironbridge.org.uk

Holmwood House
www.nts.org.uk/Property/Holmwood

FRANCE
Les Fous Volants
www.fous-volants.ovh.org

Nantes Elephant
www.lesmachines-nantes.fr/english/elephant.html

Ukronium 1828
www.ukronium1828.fr

Vert d'Absinthe
www.vertdabsinthe.com

Librairie Jules Verne
www.librairiejulesverne.com

Au Gobelin Vapeur
gobelinvapeur.unblog.fr

Ciel Rouge
www.ciel-rouge.fr

Spats (Professor Maelstromme)
www.etsy.com/shop/ProfMaelstromme

AROUND EUROPE
The Zeppelin Museum
www.zeppelin-museum.de

Golden Gear
www.thegoldengear.com

The Museum of Spectacles
www.brilmuseumamsterdam.nl

Szabo Ervin Library
www.fszek.hu

Tempio Voltiano
museicivici.comune.como.it

Burg Frankenstein
www.frankenstein-restaurant.de

H.R. Giger Museum
www.hrgigermuseum.com

Typewriter Museum (Museo della Machina da Scrivere)
www.umbertodidonato.org/museo

Neuschwanstein Castle
www.neuschwanstein.de

The Leathercraft Museum (Deutsches Ledermuseum)
www.ledermuseum.de

Cinevilla
www.latvia.travel/en/movie-town-cinevilla

The Fotoplastikon
www.fotoplastikon.stereos.com.pl

Maison d'Ailleurs
www.ailleurs.ch

Lilla Lugnet
www.lillalugnet.net

AROUND ASIA
MadArtjewelry
www.etsy.com/shop/MadArtjewelry

Lao Hat
www.augustphoenix.com

AUSTRALASIA
Oamaru Exhibit, Forrester Gallery
www.forrestergallery.com

The Manufactory
www.themanufactorythornbury.blogspot.co.uk

Spirit of Distinction
www.spiritofdistinction.org

MODE
See pages 36-87 👉

LADIES' CLOTHING
Katazyna Konieczka
www.kkonieczka.istylist.pl

Steampunk Couture
www.steampunkcouture.com

Ghoulina Von Royal
www.ghoulinavonroyal.deviantart.com

Spyder Designs
www.spyderdesigns.ca

Bibian Blue
www.bibianblue.com

Mayfaire Moon
www.mayfairemoon.com

Black Cat
www.blackcatcorsets.com/site

Dark Garden Unique Corsetry and Couture
www.darkgarden.com

MEN'S CLOTHING
Tobias Harboe
www.thankyouforclapping.com

Lastwear
www.lastwear.com

The Steampunk Overlord
www.steampunkoverlord.deviantart.com

LEATHER
Skinz-N-Hydez
www.skinznhydez.net

Brute Force Studios
www.bruteforcestudios.com

ACCESSORIES
Steampunk Hatter
www.steampunkhatter.com

Two Weevils
www.etsy.com/shop/chaosdoll

Harvy Santos
www.harvash.com

Lock and Co.
www.lockhatters.co.uk

Atomefabrik
www.atomefabrik.com

Daylight Artworks
www.daylightartworks.com

Mad Uncle Cliff
www.austeampunk.blogspot.co.uk

Steamtropolis/Hades
www.steamtropolis.com

Demonia
www.demonia.co.uk

Jenna Hewitt
www.etsy.com/shop/UncommonFolk

Daniel Proulx
www.danielproulx.blogspot.co.uk

Olga Narozhna
www.olgaclockworks.com

Swiss Time
www.swisstime.ch

FURNISHING
See pages 88-109 👈

The New English
www.thenewenglish.co.uk

Fornasetti
www.fornasetti.com/en
www.bardelli.it

Salon de Ning
www.salondening.com

Roger Wood
www.klockwerks.com

ModVic
www.modvic.com

FURNITURE AND FITTINGS
Restoration Hardware
www.restorationhardware.com

Dome Chair
www.roomservicestore.com

Andrew Chase
www.andrewchase.com

Three Rings Office
www.becausewecan.org

Bob "Stig" Campbell
www.stig-art.co.uk

The Steamed Glass Studio/Tim Witteveen
www.etsy.com/shop/SteamedGlass

Scott Campbell/Mama Tried Studios
www.scottcampbelltattoo.com

Dale Mathis
www.dalemathis.com

ArtAkimbo
www.etsy.com

Marine Mines (Mati Karmin)
www.marinemine.com

Watermark Designs
www.watermark-designs.com

SOFT FURNISHINGS
House of Hackney
www.houseofhackney.com

Anthropologie
www.anthropologie.com

Thomas Paul
www.thomaspaul.com

PillowPillow
www.etsy.com/shop/PillowPillow

Allegra Hawksmoor
www.etsy.com/people/HauntedSummer

Utilitarian Franchise
www.etsy.com/shop/utilitarianfranchise

LIGHTING
Frank Buchwald
www.frankbuchwald.de

Art Donovan
www.artdonovan.typepad.com/blog

McLain Wiesand
www.mclainwiesand.com

Adam Wallacavage
www.adamwallacavage.com

Chris Osborne
www.steampunklighting.com

WALLPAPER
Matchsticksandflames
www.matchsticksandflames.deviantart.com

Barneby Gates
www.barnebygates.com

Phillip Jeffries
www.phillipjeffries.com

Andrew Martin Wallpaper
www.shackinteriors.co.uk

House of Hackney
www.houseofhackney.com

House Couturier
www.housecouturier.eu

DISPLAYS
Viktor Wynd's Little Shop of Horrors
www.viktorwyndofhackney.co.uk

GEAR
See pages 110-131 ☞

Les Fous Volants
www.remue-menage.net

Land Cruiser
www.jl421.com

Vrbanus
www.vrbanus.com

Rocket Car
www.baronmargo.com

The Black Widow
www.steampunkholmes.com

Segway
www.instructables.com/id/Steampunk-Segway-Legway-

Morgan Three Wheel
www.morgan3wheeler.co.uk

Manucycle
www.propmonster.com

Tom Sepe
www.tomsepe.com

Empire of Steam
www.empireofsteam.blogspot.co.uk

The Nautilus One-Man Band
www.nautilusonemanband.nl

Nautilus Viewer
www.etsy.com/shop/WillRockwell

Navigating the Depths
www.rc-sub.com

Captain Nemo #3
www.nemomatic.com

Datamancer
www.datamancer.net

Jake Hildebrandt
www.jakehildebrandt.com

Smithsonian National Air and Space Museum
www.airandspace.si.edu

Jake von Slatt
www.steampunkworkshop.com

Andy Aaron
www.aaronaddingmachines.com

Richard Clarkson
www.richardclarkson.com

RPG Gamers Phone
www.tart2000.com

Bill Gould
www.gouldstudios.com

Redmer Werkstatt Handy
www.redmer.com.pl

Webcam
www.modvic.com

Electro Iconograph
www.herrdoktors.blogspot.co.uk

Metapen
www.mental-design.blogspot.co.uk

Sewing Machine
www.sternlab.org

The Globe
www.knightandsontemporalengineers.word-press.com

Brute Force Studios
www.bruteforceleather.com

Tom Banwell
www.tombanwell.daportfolio.com

Bob Basset
www.bobbasset.com

SCIENCE AND MANUFACTURING
See pages 132-143 ☛

Bill Gould
www.gouldstudios.com

League of Steam
www.leagueofsteam.com

Waltz on the Wye
www.wyewaltz.org

James Richardson-Brown
www.sydeiancreations.com

Herr Döktor
www.herrdoktors.blogspot.co.uk

Tom Hardwidge
www.arthrobots.com

Two Altered Visions
www.etsy.com/shop/TwoAlteredVisions

The Gentlemen's Gadgeteer Society
www.facebook.com/pages/The-Gentlemens-Gadgeteer-Society-of-London/116853635074859

Weta Workshop
www.wetanz.com/weta-workshop-services

Dr. Grordbort's Laboratories
www.drgrordborts.com

Nicholas Rebatto, Rubbertoe Ray Guns
www.etsy.com/shop/rubbertoerayguns

NATURE
See pages 144-151 ☛

Ed Kidera Canes
www.thesteamemporium.com
www.etsy.com/shop/edkidera

Amanda Sutton
www.amandasautopsies.com

Kerin Wolfe
www.etsy.com/people/kerinwolfe

Direct Pet Urns
www.directpeturns.com

Kraken Collar
www.krakenleather.com

MODPawed
www.etsy.com/shop/MODPawed

George Maridakis
www.spell-online.com

CULTURE
See pages 152-193 👉

Harry Shotten
www.harryshotton.com

ART AND PHOTOGRAPHY
Michael Pukac
www.michaelpukac.com

Aurelien Police
www.aurelienpolice.com

James Ng
www.jamesngart.com

Dan Hillier
www.danhillier.com

Wayne Haag
www.ankaris.com

Peter Nappi Handmade Photography
www.peternappi.squarespace.com

Alessandro Rota
www.alessandrorota.com

Wayne Martin Belger Boy of Blue Industries
www.boyofblue.com

Lex Machina
www.lexmachinaphoto.com

Dave Stagner
www.davestagner.smugmug.com

Engineered Artworks
www.engineeredartworks.com

Kinetic Steam Works
www.kineticsteamworks.org

The Academy of Unnatural Sciences
www.neverwashaul.com

Edouard Martinet
web.me.com/edouard.martinet/

Daniel Proulx
www.etsy.com/people/CatherinetteRings

Pierre Matter
www.pierrematter.com

Stéphane Halleux
www.stephanehalleux.com

Red Sea Tattoo
www.redseatattoo.co.uk

Salvation Tattoo Gallery
www.salvationgallery.com

Doktor A
www.spookypop.com

POPULAR MUSIC
Sunday Driver
www.sundaydriver.co.uk

Thomas Truax
www.thomastruax.com

Professor Elemental
www.professorelemental.com

The Men That Will Not Be Blamed For Nothing
www.myspace.com/blamedfornothing

Abney Park
www.abneypark.com

Unwoman
www.unwoman.com

Jon the Magnificent
www.deltatone40.com/jonmagnificent/1024/index.html

Arthur and the Nautilus
www.nautilusonemanband.nl

Pocketwatch
www.pocketwatchtheband.com

Thin Gypsy Thief
www.thingypsythief.com

Molly Porkshanks Friedrich
www.porkshanks.deviantart.com

Tony Cochran Guitars
www.tonycochranguitars.com

Thunder Eagle Guitars
www.thundereagleguitars.com

Moritz Wolpert
www.mowolpert.de

Trick Drums
www.trickpercussionproducts.com

DANCE
Steam Up
www.facebook.com/events/220407614702152

White Lightnin' Burlesque
www.facebook.com/pages/White-Lightnin-Burlesque/358607297211

Ballet Pensacola
www.balletpensacola.com

Abbie Rhode's Psychedelic Spectacle
www.abbierhode.com

Tempest
www.darklydramatic.com

TV
Doctor Who
www.bbc.co.uk/doctorwho/dw

Riese: Kingdom Falling
www.syfy.com/riese

PRINTED MATTER/GRAPHIC NOVELS
Robert Rankin
www.sproutlore.com

Toby Frost
www.spacecaptainsmith.com/toby.php

Cherie Priest
www.cheriepriest.com

William Gibson
www.williamgibsonbooks.com

Scott Westerfield
www.scottwesterfield.com

Girl Genius
www.girlgeniusonline.com

Le Regulateur
www.bdparadisio.com

Lady Mechanika
www.joebenitez.com/mechanika.htm

Doug Tennapel
www.tennapel.com

Alan Moore
www.alanmoorefansite.com

Fred Perry
www.fredgdperry.deviantart.com

Dr Grordbort
www.drgrordborts.com

Time Lincoln
www.antarctic-press.com

Steampunk Comic Series
www.chrisbachalo.net
www.joekellyillustration.com

Bryan Talbot
www.bryan-talbot.com

Sebastian O
www.grant-morrison.com

The Fullmetal Alchemist
www.fullmetalalchemist.com

Neotopia
www.rodespinosa.com

Les Cités Obscures
www.urbicande.be

Lea Hernandez
www.webcomicsnation.com/divalea

The Island of Doctor Geof
www.islandofdoctorgeof.co.uk

EXTRAVAGANZAS
See pages 194-223 ☞

The Sour Mash Hug Band
www.sourmashhugband.com

WEEKEND AT THE ASYLUM
Weekend at the Asylum
www.steampunk.synthasite.com

Robert Rankin
www.thegoldensprout.com

Wilf Lunn
www.wilflunn.com

BB Blackdog
www.myspace.com/bbblackdoguk

HER ROYAL MAJESTY'S STEAMPUNK SYMPOSIUM
Thee Bluebeard
www.theebluebeard.com

Blood and Cardstock
www.blood-and-cardstock.com

Sky Kings Falconry Service
www.skykingsfalconry.com

Steamtropolis
www.steamtropolis.com

Daylight Artworks
www.daylightartworks.com

MistyStix
www.mistystix.com

Steam Powered Giraffe
www.steampoweredgiraffe.com

Dino Staats
www.dinostaats.com

EVENTS IN THE AMERICAS

The Steampunk World's Fair
www.steampunkworldsfair.com

Steamcon
www.steamcon.org

AnachroCon
www.anachrocon.com

Chicago's Carnival Delirium
www.facebook.com/events/165945396816117

Chicago Group
www.steampunkchicago.com

Conselho Steampunk
www.pr.steampunk.com.br

Her Royal Majesty's Steampunk Symposium
www.hrmsteam.com

Anomaly Con
www.anomalycon.com

Alternative Living Expo
www.altlivingexpo.com

Canadian National Steampunk Exhibition
www.cnse.ca
www.steampunkcanada.ca

Steampunk Empire Symposium
www.thesteampunkempire.com/events

World Steam Expo
www.worldsteamexpo.com

Steampunk Industrial Revolution
www.steamrevolution.com

Comic-Con
www.comic-con.org

Dragon Con
www.dragoncon.org

The Great New England Steampunk Exhibition
www.facebook.com/pages/The-Great-New-England-Steampunk-Exhibition/122212211187343

Victoria Steam Exposition
www.victoriasteamexpo.com

Emerald City Steampunk Expo
www.emeraldcitysteampunkexpo.com

The Great Dickens Christmas Fair
www.dickensfair.com

TeslaCon
www.teslacon.com

Conselho Brazil
www.steampunk.com.br

EUROPEAN ENTERTAINMENT

Convention Steampunk y Retrofuturista
www.steampunkspanishcon4.blogspot.co.uk

Cabaret du Néantes
www.cantada.net

FACTS
www.facts.be

Steam Technological Italian Mercenaries (STIM)
www.steampunkitalia.com

The Steampunk Forum at Brass Goggles
www.brassgoggles.co.uk/forum

Elf
www.haarzuilens.elffantasyfair.com

Castlefest
www.castlefest.com

Eurocon
www.zagreb-eurocon2012.com

Steam Memories
www.steammemories.pl

Museum Kolejnictwa in Warsaw
www.muzkol.pl

Steampunk Ball
www.socialdance.stanford.edu/balls/steam-punkball.htm

Puppet Theatre Museum
www.nuku.ee/english

Hungarian Railway Museum
www.mavnosztalgia.hu/en/menu/102

Aethercircus
www.aethercircus.blogspot.co.uk

MCM Expo
www.londonexpo.com

SFX Weekender
www.sfxweekender.com

DeepCon
www.deepcon.it

Omnicon
www.omnicononline.com

Chicon/Worldcon
www.chicon.org

CONvergence
www.convergence-con.org

White Mischief
www.whitemischief.info

Professor Elemental
www.professorelemental.com

Hackney Colliery Band
www.hackneycollieryband.co.uk

Archaos
www.archaos.info

LEISURE
See pages 224-237 👉

Coggy Dice, Mechanical Oddities
www.etsy.com/shop/MechanicalOddities

Space 1889
www.heliograph.com/space1889

Scrabble
www.winningsolution.com
www.drewcapener.com

Thretris
www.thretris.blogspot.co.uk

Eollis Board Game
www.hazgaard.com
www.uk.asmodee.com

Pendragon Costumes
www.pendragoncostumes.com
www.vimeo.com/marcwyndham

Wedding Stationary
www.royalsteamline.com

Stroller
www.sebbal.deviantart.com
www.zoluna.deviantart.com

INDEX

ACKNOWLEDGMENTS

Fil Rouge Press would like to thank the Gazette team: Janis Utton for her splendid design labors, Dave Jones for initial design work, Mike Evans and Julia Halford for invaluable editorial assistance, Sally Claxton for magnificent picture research, commissioned photographers Bruce Fleming (USA), and Allan Titmuss (UK). In addition, heart-felt thanks are due to our very special correspondents Bruce and Melanie Rosenbaum and Kim Burk of ModVic, Thomas Willeford and Sarah Herrick of Brute Force Studios, Steampunk Scholar Mike Perschon, and cartoonist Geof Banyard. We would also like to thank our interviewees for their time and inspiring answers: Herr Döktor (Ian Crichton), Nicolas le Feu, Harvy Santos, Amanda Sutton, Robert Brown, Roger Wood, and Tom Sepe. Thanks are due, too, to the organizers of our featured extravaganzas: Tobias Slater of White Mischief; Kimberley Maita of Her Majesty's Steampunk Symposium; and Justin Katz, Mike Gaines, and Karin Conn of the Edwardian Ball. Also due thanks are Peter Overstreet and Cat Taylor of Aeronaut Productions, Duncan Newham, Nick Robatto, and all the magnificent Steampunks whose persona and works are featured—too numerous to name, but applauded nonetheless.

PICTURE ACKNOWLEDGMENTS

Anthropologie: 101 TR; Artakimbo: 99 TL; Lady Asprin: 201 T; Aurelian Police 154 BL; Ceramica Bardelli: 90 BL; Barneby Gates: 105 TL; Wayne Martin Belger: 157 BL, 157 BR; Bibian Blue/Photo by Marcela Patino (Model: Irene Suarez, Hair by Jose Ventura for Avance Estilistes, Makeup by Mireia Sangalo): 49 TL; Design by Greg Broadmore, Photo by Steve Unwin, copyright Stardog 2012: 143 T; Frank Buchwald: 102 T; Cantada II: 213 TR; Andrew Capener: 230 B; Breezy Carver: 192 BL; Charles River Museum of Industry and Innovation: 19 BL; Tribal Fusion/Photo: Ciel: 211 TL; Tony Cochran: 12 TR; Compagnie Remue Menage: 24, 112 BL; Conselho Steampunk: 211 TR; Culture Label/The New English: 90 TL; Katie Davis: 161 TR; Doctor A: 226 BL; Art Donovan: 15 TR, 103 TL; jjdoyle.com: 162 TR; World of Dr. Evermor: 20 TL; Dalliance/Eyespraykers: 195 B, 210 TR; Kimberley Fenwick: 19 BR; Mark S. Fisher (Deluxe Station Diner): 20 TR; Olga Gail (Narozhna): 82 TL; Roberto Gandola (Model: Roberto Chiaramonte-NovaScrimia): 12 BL; Stefania Gualandia: 112 TR; Quang Guang: 213 TL; Wayne Haag: 155 B; Stéphane Halleux: 160 BL; Evelin Hantel: 215 TR; Tobias Noe Harboe: 43 TR; Allegra Hawksmoor/Haunted Summer (Design by Urban Threads): 100 BL; Dan Hillier: 155 TL; Natalie Keyssar: 91 T; Ed Kidera/Maets Foundation: 145 TR; Kaleena Kiff & Ryan Copple creators, produced by Galen Fletcher & Nichola Humphries: 179 T; Katerina Konieczka/Maciej Boryna (Model: Paulina Klimczak/New Age): 43 TL; Ruud de Korte: 151 BL, 214 TL; Yann Langeard: 25 T; TeslaCon/Eric Larson: 210 BR; Library of Congress: 180 BL; Lomography UK: 10, 13 BR; Eric Long/National Air and Space Museum, Smithsonian Institution: 18 TR; Maduncle: 59 BL, 59 BR; Professor Maelstromme/Amanda Scrivener: 13 Br, 13 TL, 25 BR; Baron Margo/Lynne Balvin: 115 BL, 115 BR, 115 C; Andrew Martin: 105 TR; Bob Martin: 121 BL; Edouard Martinet/Sladmore Gallery: 159 TL; Dale Mathis: 98 BR; Pierre Matter: 159 BL; George Melies: 174 BL; Leo Merriman, MODPawed: 151 BR; Gilles Michel: 64 BL, 212 BL; Kyle Miller/Thin Gypsy Thief: 169 BR, 170 TR; Designed by Kyle Miller: 209 TR; Design: Steve Mitchell, Certifiable Genius: Pop Haydn: 18 BL; Myrmidon Books: 183 TR; Kevin Na: 227 BR, 227 TL; NAO Design: 114 BL; Peter Nappi, an artist working anachronistically in Brooklyn NY : 156 TR; Nemomatic: 121 BR; Photo: Philippe Nissaire (Model: Luna Bergeron), Design and Costume: Zoluna - Odree Roy-Lavallee, Stroller Mod: Sebbal - Sebastien Bergeron: 237 BL; syfy.com: 179 T; Chris Osborne/Steampunk Lighting: 103 BR; Thomas Paul: 101 BR; Ben Paynter: 31 BL; The Peninsula Hotels Group: 91 BL; Mike Perschon/Lex Machina: 153 BL; Created and photographed by Pixel: 113 BR; Arthur Van Poppel: 110, 120 TR, 165 T; Michael Pukac: 154 TR; Sr. Aguín for El Gabinete (Models: Lady Romana, Lady Elizabeth Wichester, Mayor Jacques Lovesteel and Doktor Schnabel von Rom): 27 TR; Julie Ray Photography (Model: Sarah Hunter, Hair and Makeup by Debra Weite, Image used with permission of F.J. Westcott Company): 14 TR; Red Bennies: 172 TR; Kuba Redmer: 125 BL; Rex Features/Peter Brooker: 177 BL, Rex Features/Warner Bros/Everett: 177 T Rex Features/New Line/Everett: 178 TL; Will Rockwell: 120 BL; Room Service: 96 TR; Alessandro Rotta: 157 TL; Tomek Slupski: 11 BL; Solifague Design: 116 T; Dave Stagner (Model: Abbie Rhodes): 173 BR; State Library of Victoria: 31 BR; Steampunk Couture/Kato: 43 BR; Martine and Jim Steel: 235 BL, Martine and Jim Steel/Royal Steamline: 235 TR; Kathryn Stelzer/Judy Smith: 226 TR, Kathryn Stelzer/: 227 BL; Victoria Steam Expo/Zandra Stratford: 211 BR; Eric Strom: 209 BR; Swisstime: 82 BL; Leticia Tatsch (Model: Lidia Zuin Alta): 47 BL, 50 BL; Tempest/Carrie Meyer, The Dancer's Eye: 173 TL; Ron Tencati: 172 BL; Morrigana Townsend/Spyder Designs/Photo by Anna Legault (Model: Lizz Estringe): 46 BR; utilitarianfranchise: 101 C; Vancouver Tourism: 21 BR; Designed by Diana Vick: 209 TL; Ghoulina VonRoyal: 46 TL, 215 TL; Sandro Vrbanus: 115 T; Adam Wallacavage: 103 TR; Tim Wetherell: 15 BL; Andrew Whitehead: 30 BL; Benjamin Whitehouse: 26; Designed by David Wiesand: 103 BL; Wilton's Music Hall/James Perry: 22 TR; Josie Withers: 31 T; Roger Wood: 93 B, 93 T; Marc Wyndham: 234 BL, 234 TR, 235 BR; Kotomi Yamamura: 82 BR, 82 TR.

Every effort has been made to acknowledge correctly and contact the source and/or copyright holder for each picture, and the publisher apologizes for any unintentional errors or omissions which will be corrected in any future editions of this book.